BEHIND THE SCENES

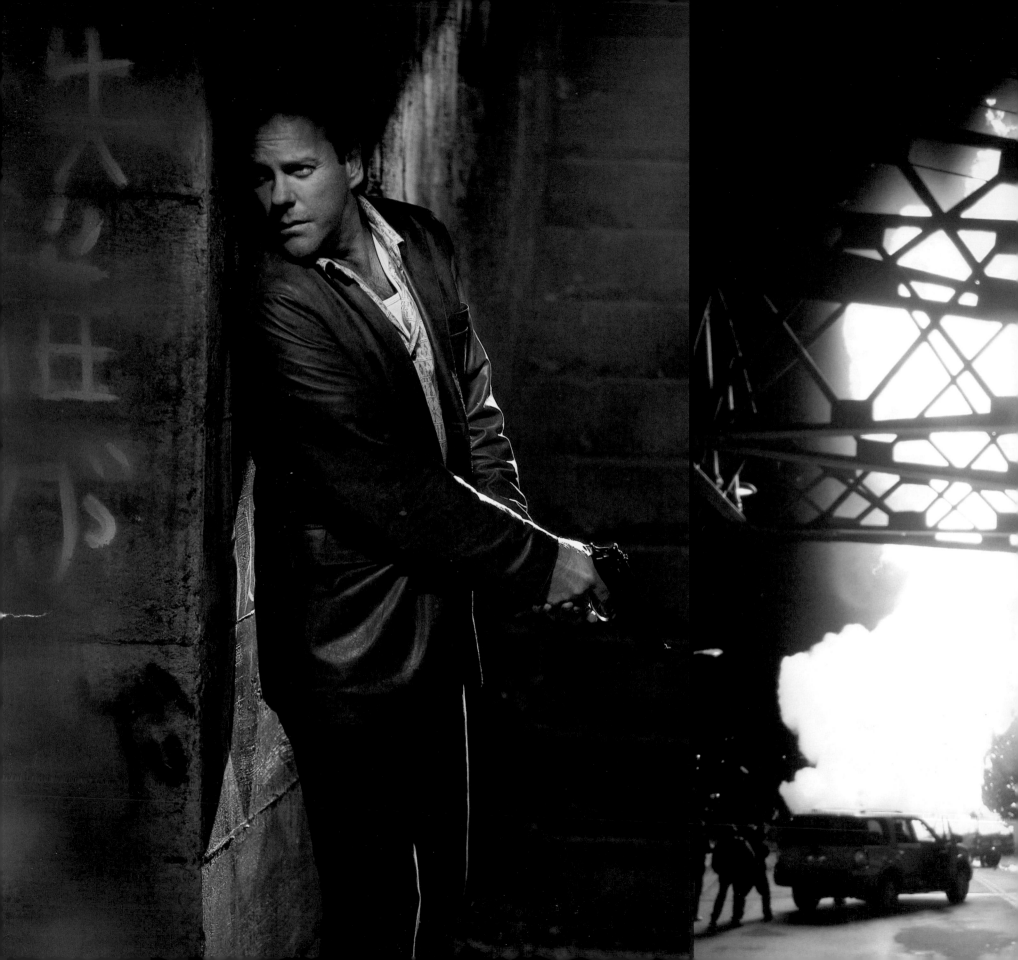

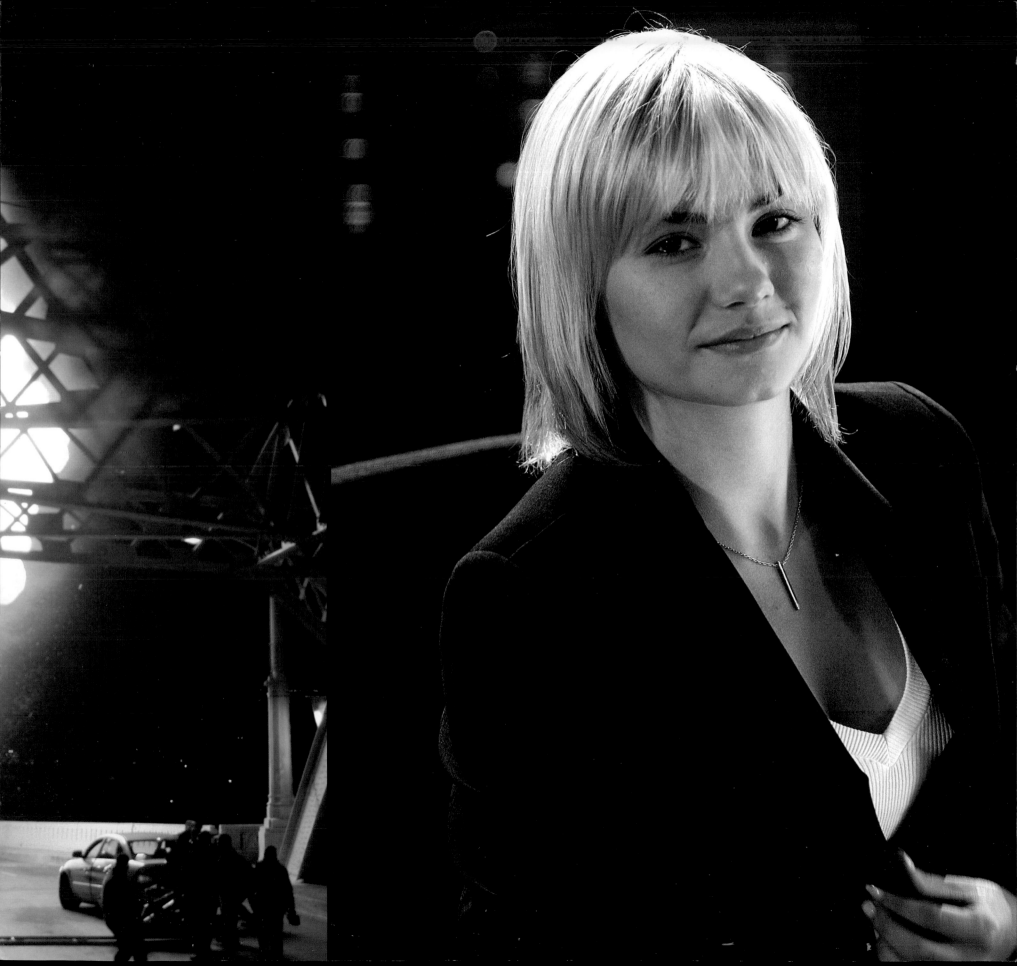

INSIGHT EDITIONS

Insight Editions
17 Paul Drive
San Rafael, CA 94903
www.insighteditions.com
415.526.1370

Library of Congress Cataloging-in-Publication Data available.

ISBN 1-933784-07-5

Palace Press International, in association with Global ReLeaf, will plant two trees for each tree
used in the manufacturing of this book. Global ReLeaf is an international campaign by American
Forests, the nation's oldest nonprofit conservation organization and a world leader in planting trees
for environmental restoration.

10 9 8 7 6 5 4 3 2 1

Based on the series created by Joel Surnow & Robert Cochran.
24 produced in association with REAL TIME PRODUCTIONS.

IMAGINE
TELEVISION

BEHIND THE SCENES

FOREWORD BY KIEFER SUTHERLAND

TEXT BY JON CASSAR

PHOTOGRAPHS BY JON CASSAR,
RODNEY CHARTERS, ASC CSC,
ISABELLA VOSMIKOVA,
AND THE FILMMAKERS OF *24*

INSIGHT EDITIONS

San Rafael, California

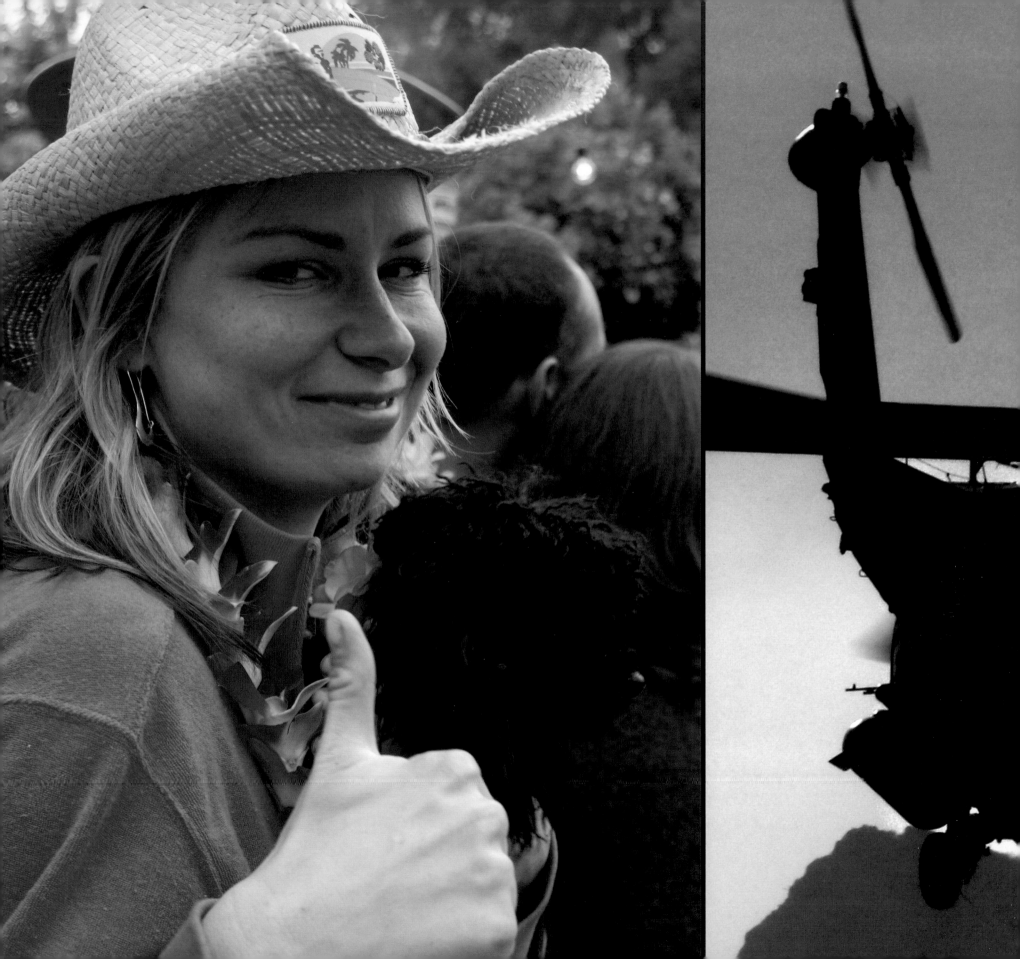

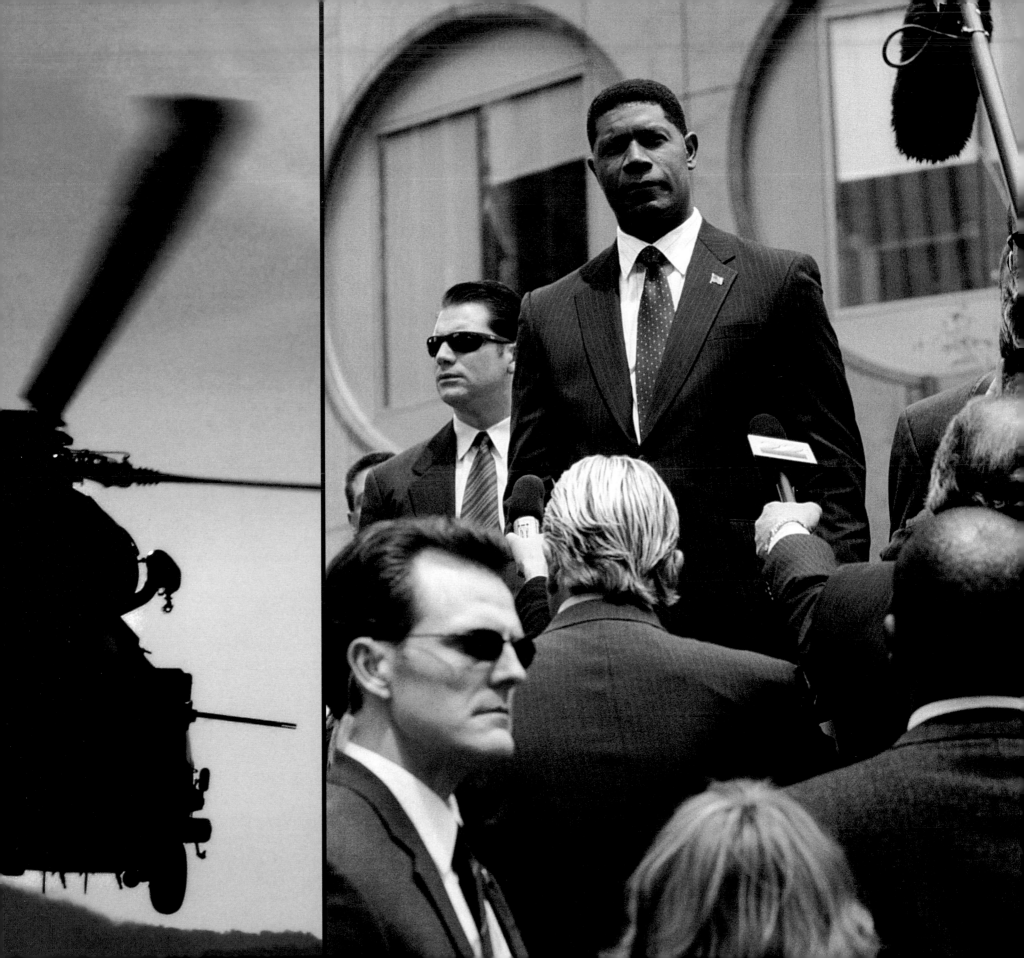

CONTENTS

FOREWORD

While sorting through these photos I reflected back on making five seasons of *24* and I realize that I don't break this experience down by seasons. I don't even break it down by episodes, which suddenly I find quite amusing given that *24* is the first real-time drama in television history. For me time seems to flow seamlessly while we are working. If I at all try to break down the experience that has been *24* it would be by the 315 days we are working together making the show and the 50 days we are waiting to start to work together again. The people photographed throughout this book are my best friends and chosen family. These pictures that have been beautifully taken by Jon Cassar, Rodney Charters, Isabella Vosmikova and other members of our crew show the unique and diverse perspectives of what it was like to be on the show over the last five years. I have tried with words to explain to people how special our crew is and that they are the reason why *24* is visually so exciting and what a huge contributing factor they have been to the show's success. These images convey that far better than my words ever could.

Jon Cassar, our lead director, started in the film industry as an A-list cameraman. His eye for detail and composition is startling. Our cinematographer Rodney Charters' understanding of light, balance, and yes, technology, for me make his photos so easily identifiable. Isabella Vosmikova, who is our onset still photographer, has such a desire for the best possible shot that she has often landed on my mark putting her literally in the scene with me.

I am grateful to these photographers and their photographs, for they are a perfect reminder of how special this experience has been and where words seem to fail me, their work never has.

~ Kiefer

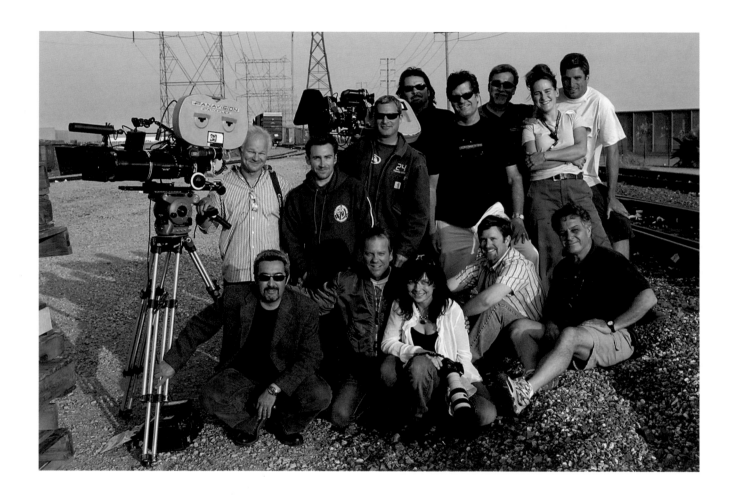

*"I dedicate this book and the images in it to all the below-the-line crew members
who have worked long difficult hours by me all these years.
You are my strength, my motivation, and most definitely my best friends."*

–Jon Cassar

INTRODUCTION

Welcome to *24: Behind the Scenes*. Consider this book a heartfelt thank-you gift, direct to our loyal fans, from those of us who make *24*. If you have managed to keep pace over these five frenetic seasons, through each of Jack Bauer's 24-hour sprints to somehow miraculously prevent ultimate disaster, then we're certain you will enjoy this photographic record of the people behind Jack's adventures.

This book is an intimate insider's view of what started out in the minds of some very creative people as a simple spy fantasy—a limited miniseries—but has now become, thanks to our millions of viewers and fans worldwide, a full-blown pop-culture phenomenon. With a few exceptions, none of these photographs have ever been published before. That's because most of them were not taken with the idea of ever publishing them. Rather, these slices of *24* life were taken by crew members such as myself and my colleague, the show's outstanding director of photography, Rodney Charters, largely for our own memories. Our intent was simply to record the people, places, and events that have become, over the course of the last five-plus years, central and meaningful to our own lives. It is my honor to present and describe them to you in the pages that follow.

Indeed, during the course of my tenure on *24*, I have seen marriages evolve out of our small and talented team, I've seen children born of those marriages, and I've seen lifelong friendships forged out of our late nights of hard work. At the end of the day, for the team behind the team at CTU, these friendships, experiences, and memories will outlive even the amazing, beyond-our-wildest-dreams success of the show itself.

That success, of course, wouldn't be possible without our legions of fans. That's why we wanted to share some of these moments with you—moments made possible by the advance of digital photographic technology. When I started in the television game far too long ago, it was rare for anyone but the publicity department to bring still cameras on set. It was rarely permitted, and even when it was, the light and conditions on set were, more often than not, all wrong for capturing quality still photographic images. That's all changed now, thanks to the evolution of digital cameras—an evolution that took off right around the time *24* first hit Fox's airwaves.

Therefore, from Rodney Charters on down, a small group of us over the years began photographing precious, candid moments whenever we could. As you flip through the following pages, you'll see that we have some fairly talented photographers in our little family.

And it is a family. Indeed, saying goodbye to the unbelievably gifted actors behind the characters offed by our bold writers each season—actors like Dennis Haysbert—has become the most painful part of doing this job. You'll see photos from some of those moments in the pages that follow. The good news, ironically, is that, while our cast features a large turnover each season as characters are sacrificed on the altar of good storytelling, our crew has remained remarkably stable for the last five years.

My sincerest thanks to my fellow photographers—Rodney Charters, David St. Onge, Isabella Vosmikova, Jay Herron, Michael Klick, Bruce Margolis, Zak Cassar, Alicia Bien, and Yoshi Enoki, Jr.—and to the entire team and staff behind *24* and this book. From the amazingly talented and hardworking Kiefer Sutherland to our visionary producers Joel Surnow, Robert Cochran, Howard Gordon, and Evan Katz, and our friends at 20th Century Fox Television, Fox and Imagine, Dana Walden, Gary Newman, Brian Grazer, and David Nivens, all the way down to every last grip and assistant to journey on and off our set over the last few years, I offer humble gratitude. For me, *24* has become far more than the most exciting, nail-biting show on television—it's become my second home and the most enjoyable experience of my career. And I'm confident that the people you see and read about in this book feel exactly the same way.

So without further adieu, feel free to turn the page and enter not only the world of Jack Bauer but also the world behind that world—the world of the hardest-working team of professionals on television. As you'll see, in terms of effort and excitement, our adventures, in their own way, mirror much of the high drama our team brings to your television screen each week.

Jon Cassar
Director/Co-Executive Producer

SEASON 1

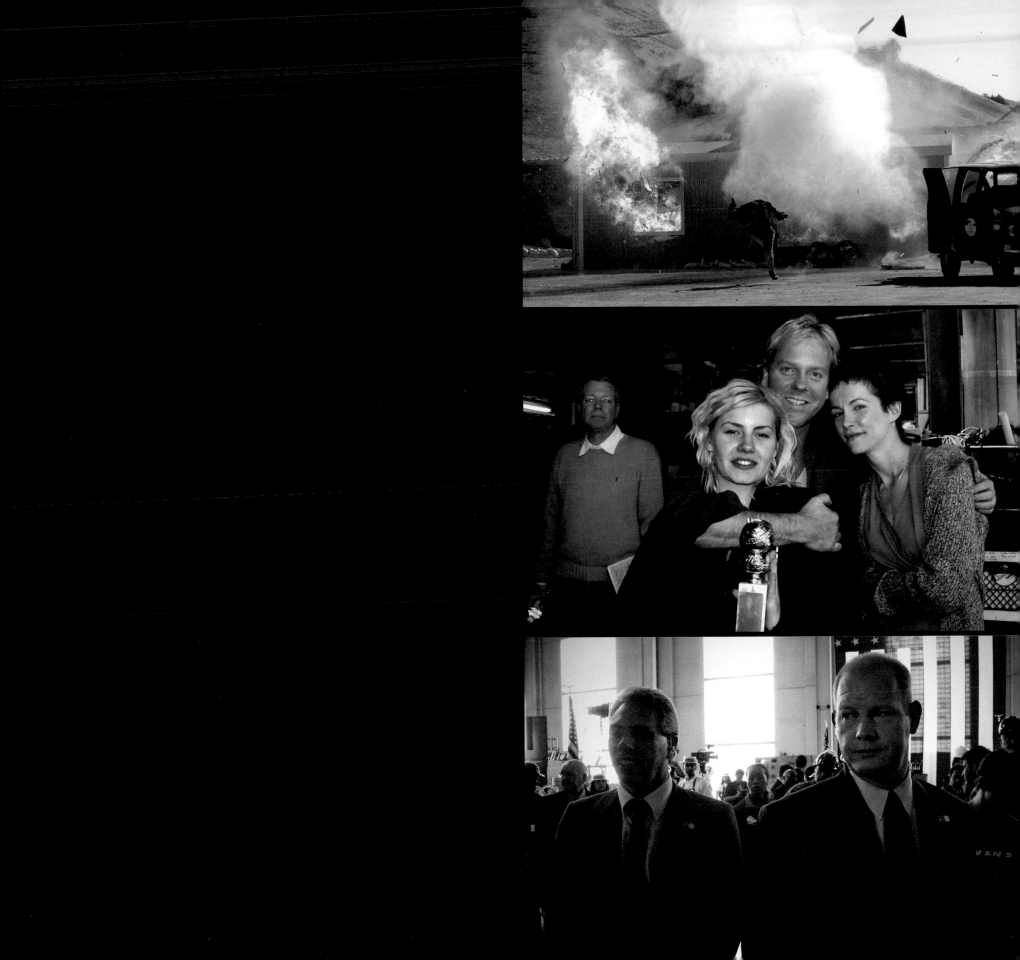

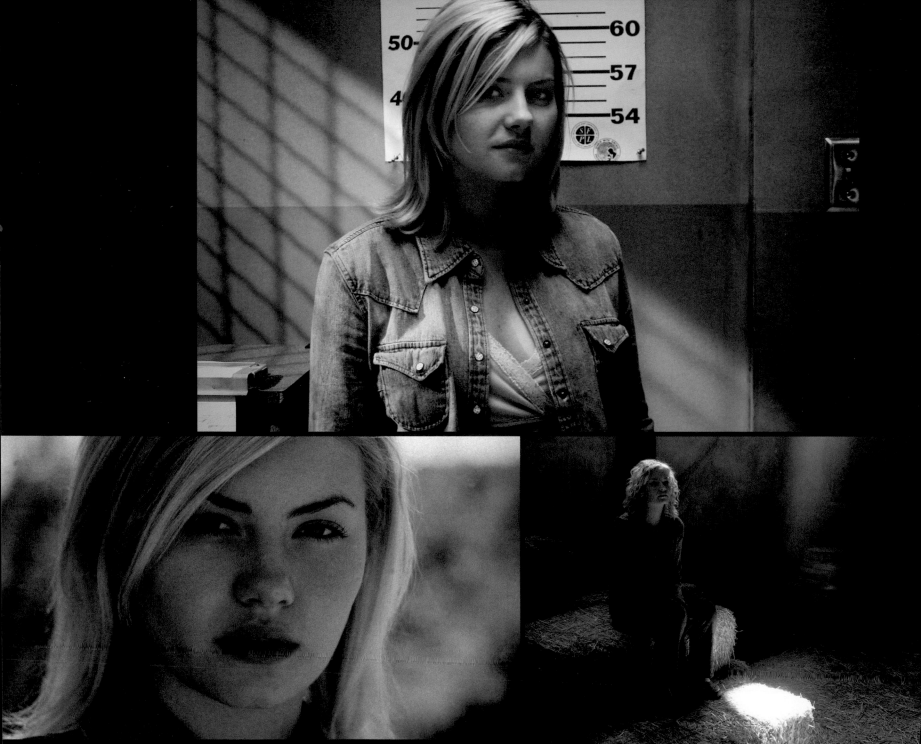

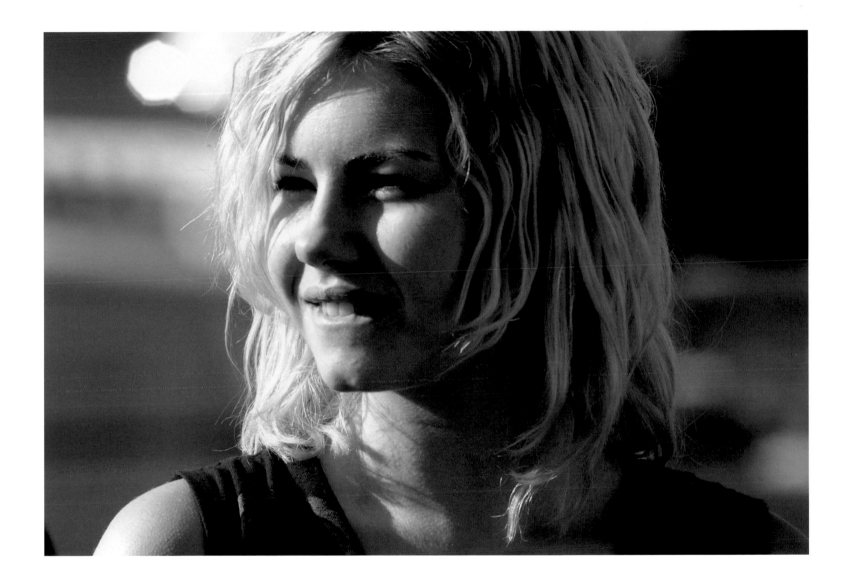

KIM BAUER

These portraits show Elisha Cuthbert as "young Kim" Bauer, as opposed to "mature Kim," and you can see how young she actually was. She really looks like a teenager, which she was when she first joined the show. Elisha grew up right before our eyes. In later seasons, you can see how quickly she matured. As our beautiful leading ladies, Elisha and Reiko Aylesworth were definitely the two actors whom Rodney Charters had the most fun photographing and lighting.

2:00 P.M.–3:00 P.M. / 24 STAGES
Above: Elisha Cuthbert and Leslie Hope help Kiefer celebrate
his Golden Globe Award. In the background, the Unit Production
Manager, Robin Chamberlin, looks on.

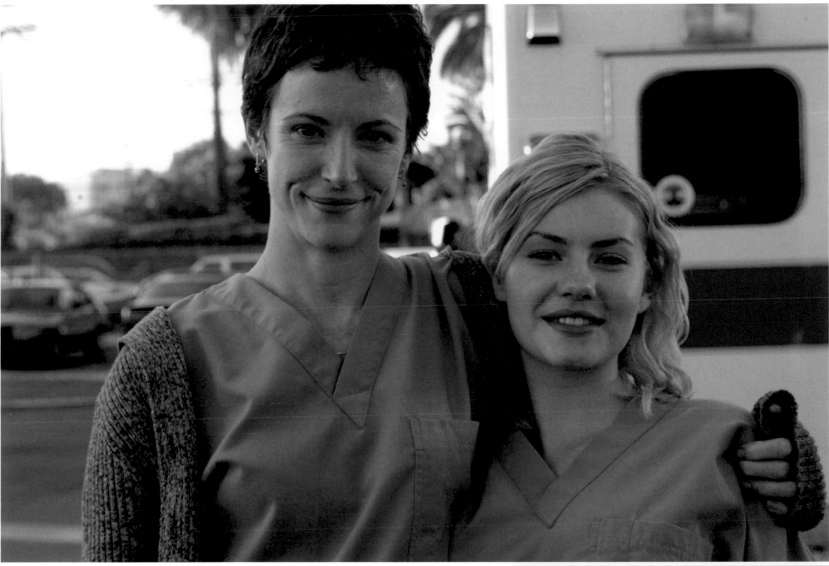

TERI BAUER

This is a sweet "mother and daughter" portrait of Teri (Leslie Hope) and Kim Bauer (Elisha Cuthbert). The shot wasn't taken for the show; the two were just hamming it up for the camera. Leslie is a particularly wonderful actress, and it wasn't only our fans who were shocked when her character was killed off—it was difficult for all of us at the show, as well. She was the first of the actors who had become our family to whom we had to say goodbye. As filmmakers, there is always a side of us that thinks, "That's a great story line." But in an instance like this, the colleague part of us thinks, "Wow, we won't see Leslie anymore," and that can be really tough.

VICTOR DRAZEN

This is a great shot of Dennis Hopper as the evil Victor Drazen—a man with a big grudge against Jack Bauer. Hopper was the first of several important film actors to join our cast. He and Kiefer are friends off-camera and have appeared in a couple of films together. Some people joked about his Serbian accent, but he really did an excellent job for us.

DEAD OR ALIVE?

This historic shot was taken during season one's final episode. We were filming Teri Bauer's (Leslie Hope) controversial death scene, and we couldn't decide whether to shoot an alternative ending, since at that time it wasn't clear which ending would be used. As this photo illustrates, there was great debate on this issue, even within the *24* family. Here you see our director/co-executive producer from the first season, Stephen Hopkins, engaged in an intense discussion with Kiefer on the old CTU set. They are debating whether to shoot the original ending, which would show Teri's death, or whether to use a different ending. At the time, Kiefer thought that airing a scene definitively showing Teri dead was a terrible idea, and in this picture we see him telling Stephen exactly where he stands on the issue. Stephen, an Emmy-winning director believed that killing Teri was the right way to go, and of course, that decision became one of the show's trademarks—its total willingness to kill off its main characters. But you can't force an actor to do a scene he doesn't believe in, because it won't work on screen.

2:00 A.M.–3:00 A.M. / BUILDING
Director Stephen Hopkins and actors Kiefer Sutherland and Michael O'Neill discuss the chase and gun fight that Jack and Richard Walsh will have.

REALITY INTERVENES

"*24* was well into production when the terrorist attacks on September 11 happened. Here the crew watches in shock at the images being fed out of New York and Washington D.C. Like most businesses, we went home at 10AM after a 7AM start. The effect of the terrorist attack on the show was that Fox's legal department reviewed the first few episodes and made us recut the sequence where the 747 blows up at 36,000 feet. Fox did not want to show the actual plane exploding in the air. It also meant that an extensive aerial sequence which was to have been shot by second unit downtown was shut down and we had to substitute Glendale for downtown." –Rodney Charters

7:00 A.M.–8:00 A.M. / SANTA CLARITA POWER PLANT, L.A.
Secret Service Agent Pierce heads up security before Senator Palmer gives his breakfast speech on the day of the California Primary.

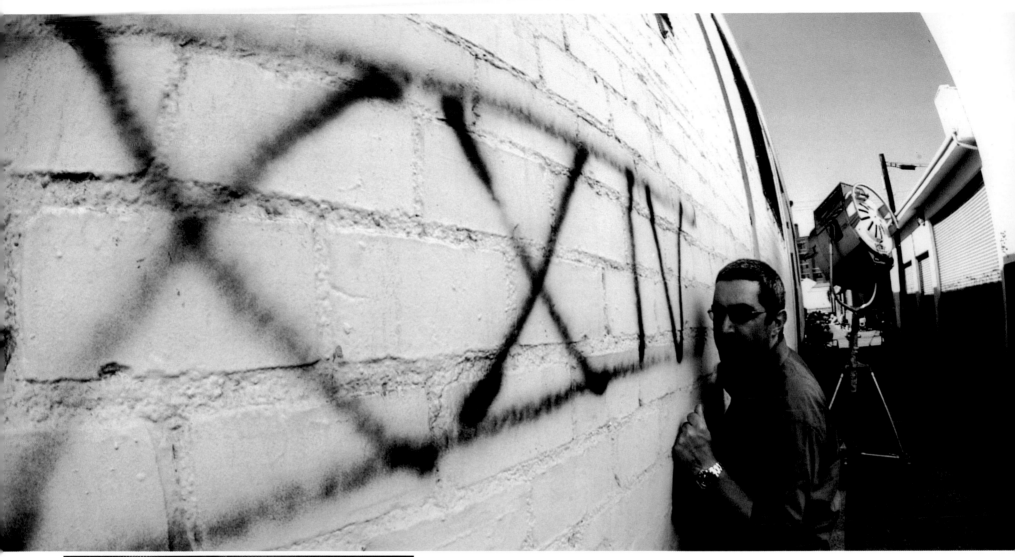

TRIVIAL PURSUITS

After Stephen Hopkins had used his gag of putting his sock puppet, Mr. Floppy, in episodes of season one, we started looking for fun images to put in season two. We decided to use variations on the number 24. Here I'm standing beside a wall with the Roman numerals for 24 spray-painted as graffiti, which is seen for a second or two in the first episode of season two. We wanted to sneak in the number 24 as much as we could, so that season we used it occasionally, such as on license plates. We eventually got tired of the gag, so we stopped doing it—I don't think the number 24 lived as long as Mr. Floppy did, but it was still fun!

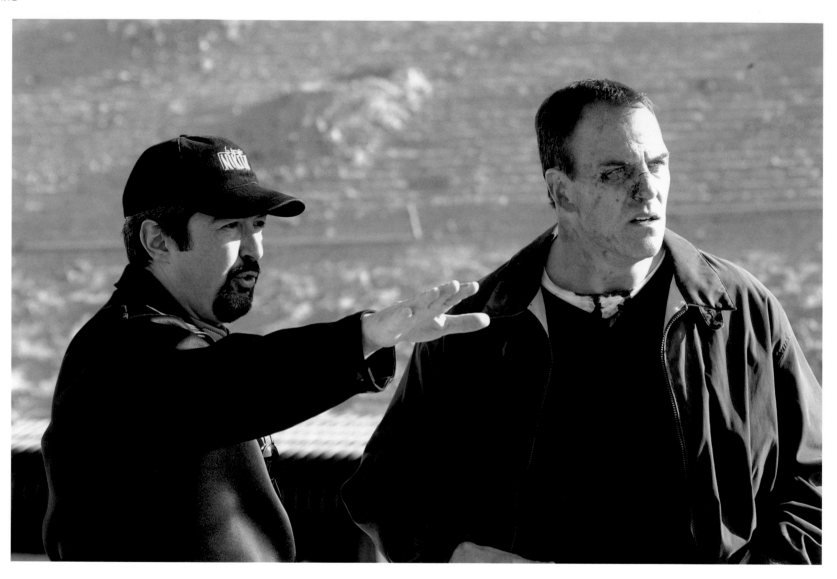

2:00 P.M.–3:00 P.M. / TRANSFER POINT
*Director Jon Cassar works with Richard Burgi who
plays Kevin Carroll, AKA Alan York.*

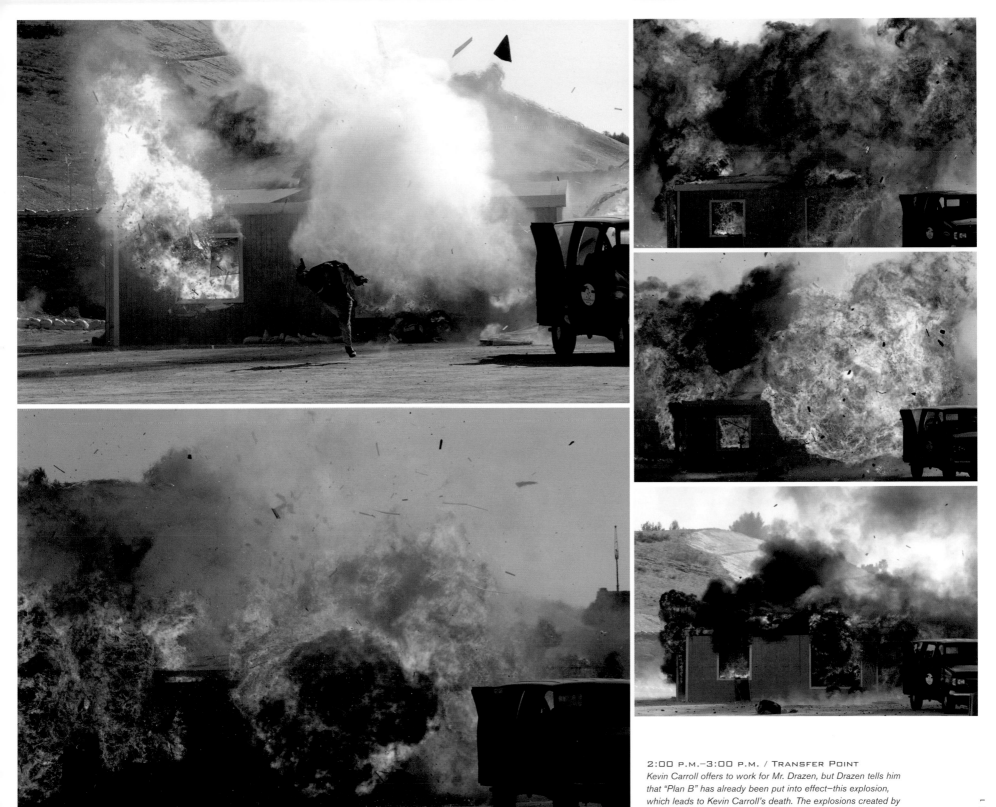

2:00 P.M.–3:00 P.M. / TRANSFER POINT
Kevin Carroll offers to work for Mr. Drazen, but Drazen tells him that "Plan B" has already been put into effect—this explosion, which leads to Kevin Carroll's death. The explosions created by 24's Stan Blackwell and his special effects crew are first class and add to the believability of our show.

24™

SEASON 2

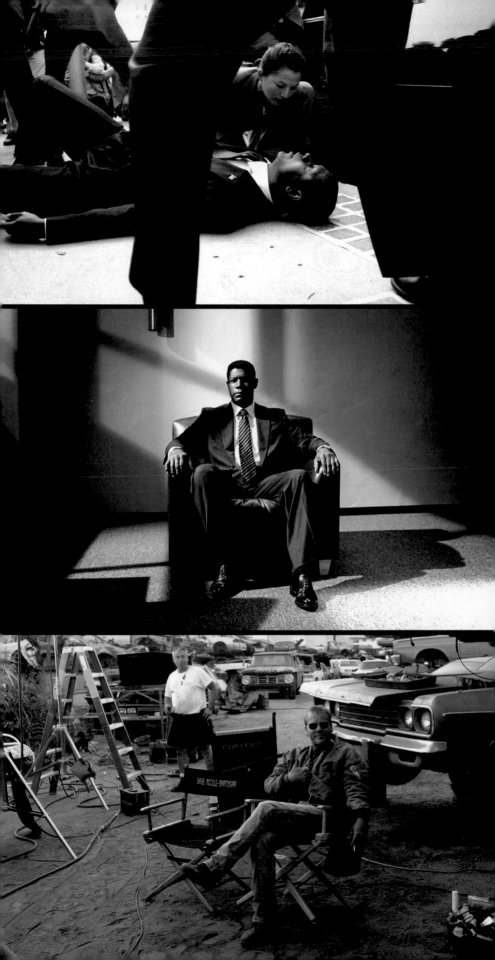

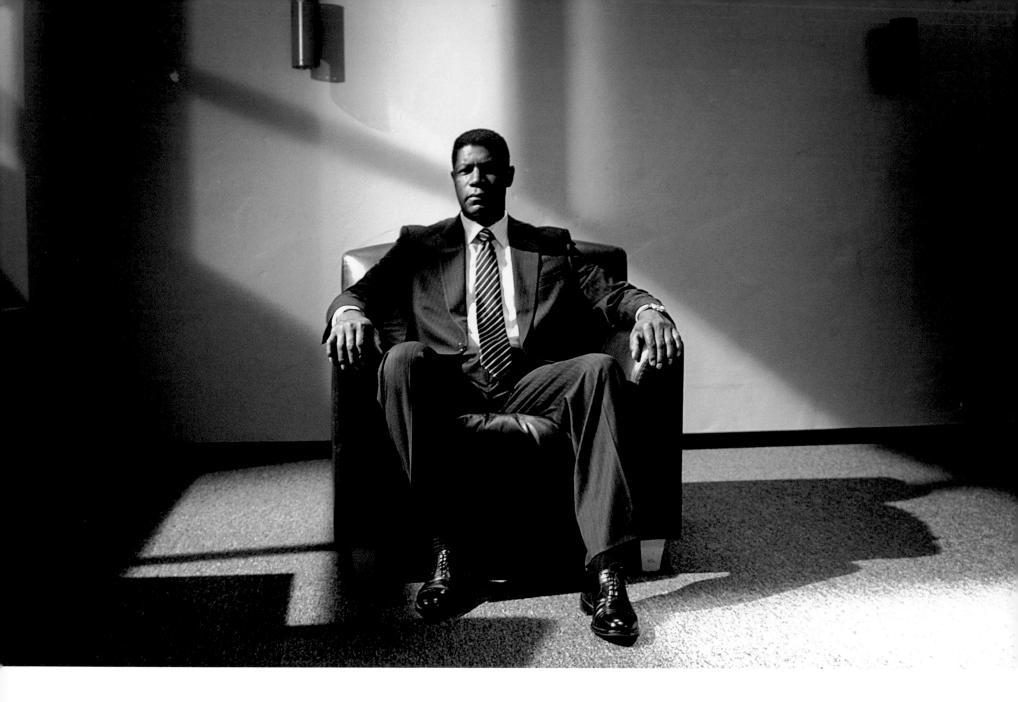

LINCOLN MEMORIAL

I call this the "Lincoln Memorial" photo, taken when President David Palmer (Dennis Haysbert) was removed from power and is being detained in this prison-like room. The photo was taken from the same angle from which we shot the scene, though this is wider than how it would have looked on a TV screen. I directed the scene with the Lincoln Memorial in mind. There was a painting that usually hung between two lights on the set, and I looked that it be taken away, because I was going for a stark, graphic look. It's a very pensive, dramatic time for President Palmer as a character, and we filmed this specifically for what we call the "final box"—where we show each of the main characters in a little box at the end of each episode to remind viewers how we are leaving each story line. I'm proud to say that fans did pick up on the image we were trying to evoke.

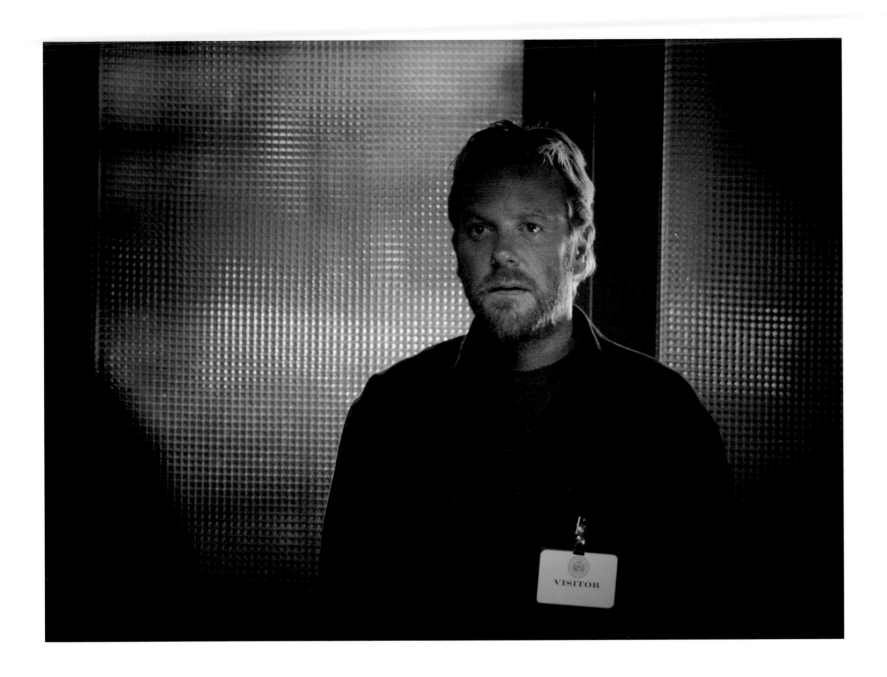

8:00 A.M.–9:00 A.M. / CTU
As a favor to President Palmer (Dennis Haysbert), Jack (Kiefer Sutherland)
returns to CTU to hear how the CTU needs his help in tracking a new
threat–a nuclear bomb.

SEASON 2

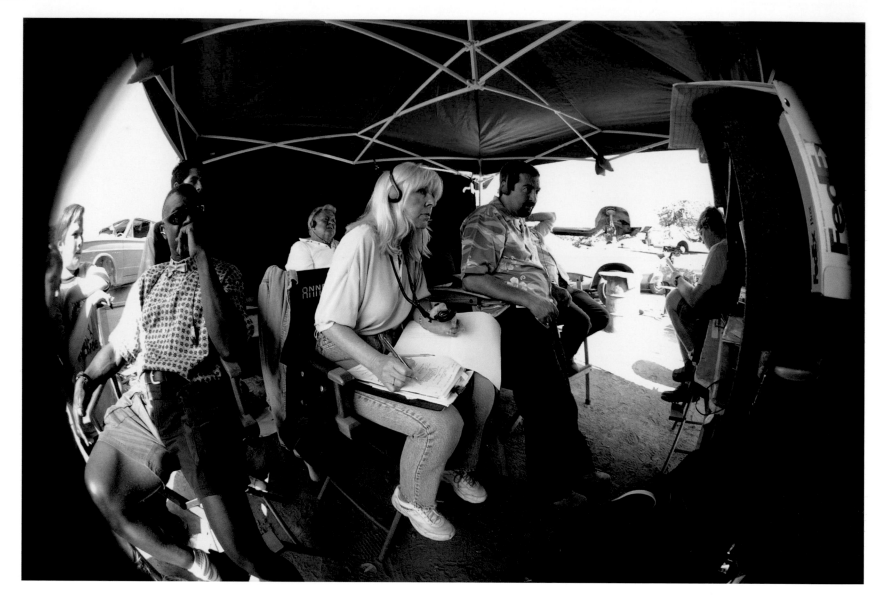

JON'S "RIGHT HAND": ANNE MELVILLE, SCRIPT SUPERVISOR

This picture was taken with a fish-eye lens—an interesting perspective of all of us crowded underneath a little pop-up tent while we shot part of the "Goren's head" sequence. We really needed that tent that day, since it was well over 100 degrees in Los Angeles. I call that nice lady next to me my right hand, not only because she always sits on my right when I'm directing, but also because I would be completely lost without her. Her name is Anne Melville, and she is the show's main script supervisor, which is a very important job. She monitors every line actors say during production, then she notes any changes, corrects any mistakes, and reminds actors what their lines are if they forget. One other note: I can tell right away that this picture was taken on a Friday, because I'm wearing a Hawaiian shirt. (Notice Christopher Whitman on the left is wearing a bow tie.) Friday is always casual day on the set; people can get a little silly with that theme, but it's always good fun and great for morale.

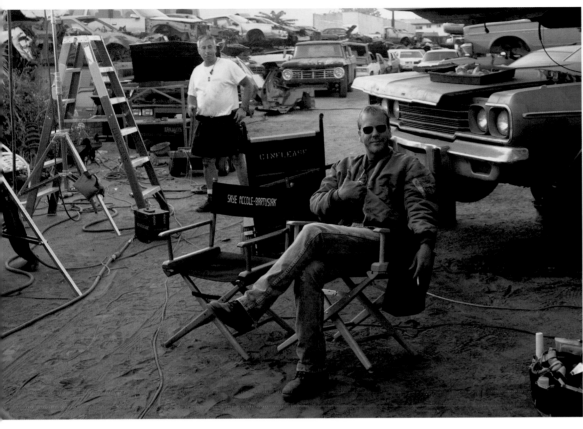

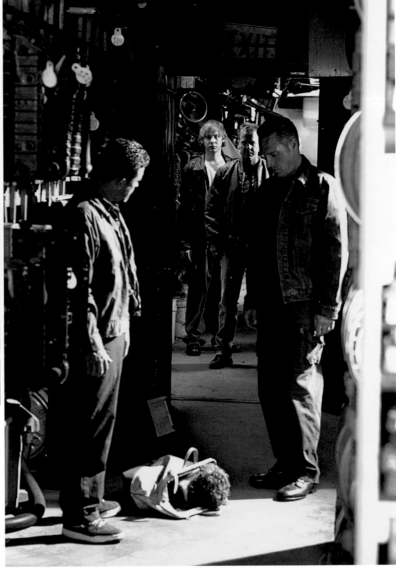

I'M GONNA NEED A HACKSAW

The photo on the right comes from the beginning of season two, when we were determined to kick off the year with something big. It led to probably the most famous line in the show's history, when Jack said at the end of episode one, "I'm gonna need a hacksaw." Here we see the scene from the subsequent episode when he shows up undercover with, as you can see on the ground, the head of an informant named Goren—in a bag—part of Jack's plan to infiltrate the gang by proving his loyalty to them. Obviously, we never showed him actually cutting off the head. At CTU Los Angeles he does the deed, and then, in the next episode, we see the head roll out of the bag when Eddie Grant (right, played by Douglas O'Keefe) looks inside the bag and drops it. A bit of the head is visible, but you never see the whole thing during that episode. Even though we never showed the head in its entirety, this once again illustrates how hard we work to make each scene as realistic as possible. Our special f/x team built a prosthetic head from a mold of the real actor's head, including a reproduction of his hair; the head had much more detail than the viewers ever saw.

Above: Kiefer is waiting to film the scene among a bunch of busted-up cars in a junkyard. We wanted a rough-and-tumble setting for the scene, and once again, this location typifies the gritty kinds of places we usually shoot.

9:00 A.M.–10:00 A.M. / SALVAGE YARD
Above left: Kiefer Sutherland (Jack Bauer) on location in not-so-glamorous Hollywood.

9:00 A.M.–10:00 A.M. / SALVAGE YARD
Above: Working undercover for CTU, Jack (Kiefer Sutherland) proves his trustworthiness to Eddie Grant (right, played by Douglas O'Keefe) by delivering him the hacked-off head of Goren (Carl Ciarfalio).

SEASON 2

SOLO ON THE ROOFTOP

This is a fantastic shot taken by our D-camera operator, Jay Herron. Once again, Kiefer is getting ready for a big scene. Kiefer is deep inside his own head, thinking about the scene in which he has to shoot a young man on a rooftop. This scene was shot in Los Angeles, although you'll notice there is almost no traffic on the street. (Where in L.A. do you ever see a street with no traffic?) In this photo, Kiefer, like Jack Bauer, is looking very solitary. At this point, Kiefer is entirely on his own with his work. No director or cameraman can help him—it's all up to him.

6:00 A.M.–7:00 A.M. / ROOFTOP, DOWNTOWN L.A.
"I'm proud to say this is one of my favorite photos I've taken. Actors need to rehearse, memorize lines, project feelings visually, and truly get 'into the moment' to make viewers belive they are the characters they are playing. Kiefer Sutherland is a master of his craft and I had the quiet opportunity to capture him preparing for his role as Jack Bauer for the finale." –Jay Herron

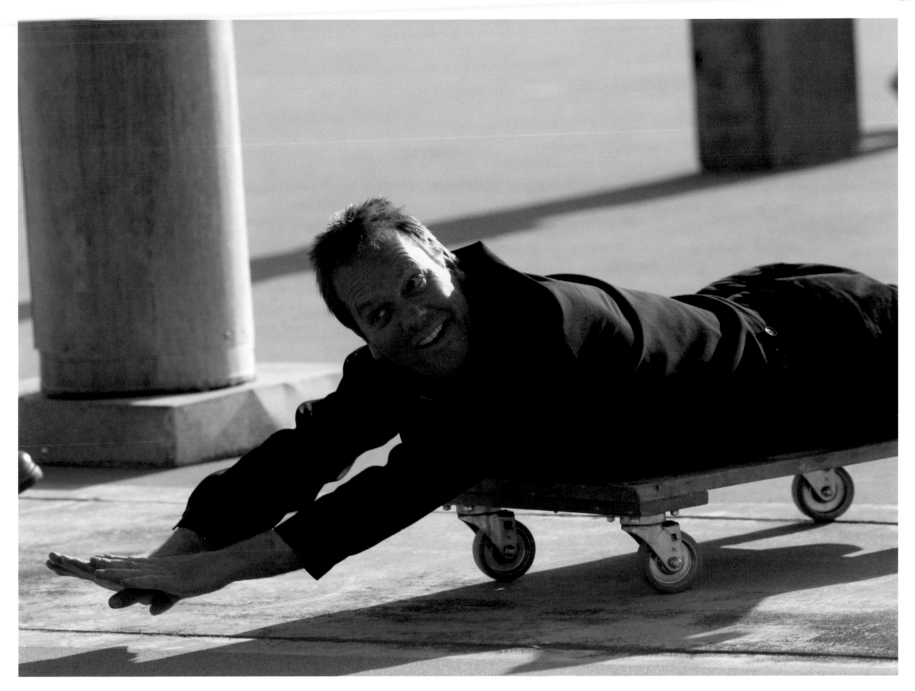

SURFIN'

One problem with Kiefer's job is that his tough, lone-wolf character doesn't exactly smile much—and neither does Kiefer when he's preparing for serious scenes. Between takes Kiefer can be very determined and deep into his character, but during more physical scenes, he can actually be in a pretty light mood. In fact, that's when you see him in his goofiest moments. In this case, we were shooting a rooftop scene, waiting for the cameras to be set up. Kiefer suddenly started riding this dolly cart around like Superman. Then we all got to see that wonderful Kiefer smile!

7:00 A.M.–8:00 A.M. / ROOFTOP, DOWNTOWN L.A.
Keeping it light between takes, Kiefer Sutherland (Jack Bauer) surfs on a set decorater dolly.

SEASON 2

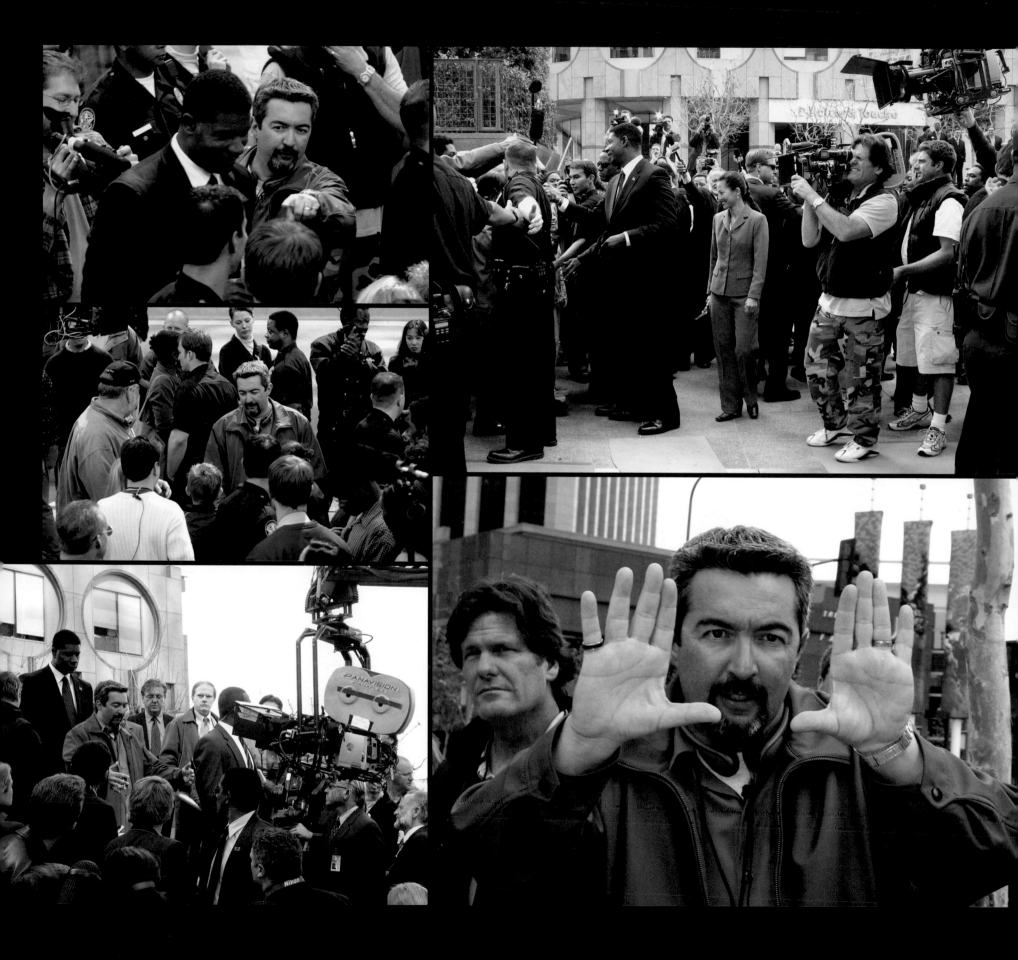

AS TALL AS LINCOLN (FILMING PALMER)

These shots illustrate how we block a scene—in this case, the scene showing the attempted assassination of President David Palmer. They are also interesting because they show how complicated it is to film an actor of Dennis Haysbert's towering 6'4" stature. In the five photos, (clockwise from top right) I'm walking Dennis through the scene in which he is to start out giving a statement to the public, and he is feeling on top of the world. Then he is to walk through the crowd shaking people's hands. In this shot, I wanted him to tower over everyone, so we picked a location on a staircase in downtown Los Angeles, with all those big buildings creating a real feeling of power and energy around him. Even on a normal plane, Dennis already towers over everyone else, but here we elevate him even more, to show his character's immense strength and power. This is a very unusual shot because in it we use a camera crane. Crane shots are rare in our show but in this case we used the crane so we could get right in front of Dennis and slide all the way down, backwards, as he walked down the stairs. The guy with the video camera behind Palmer is supposed to be a reporter, but he's actually part of the DVD crew that often comes to our set to shoot documentary material for our DVD releases. He's using his own video camera to shoot for the DVD, while we filmed him in the scene as a reporter. We needed some media characters and they were there and agreed to do it, so we filmed them filming us, so to speak, and paid them as extras for the day.

7:00 A.M.–8:00 A.M. / DOWNTOWN L.A.
Opposite: Jon Cassar explains a shot that he wants to film.

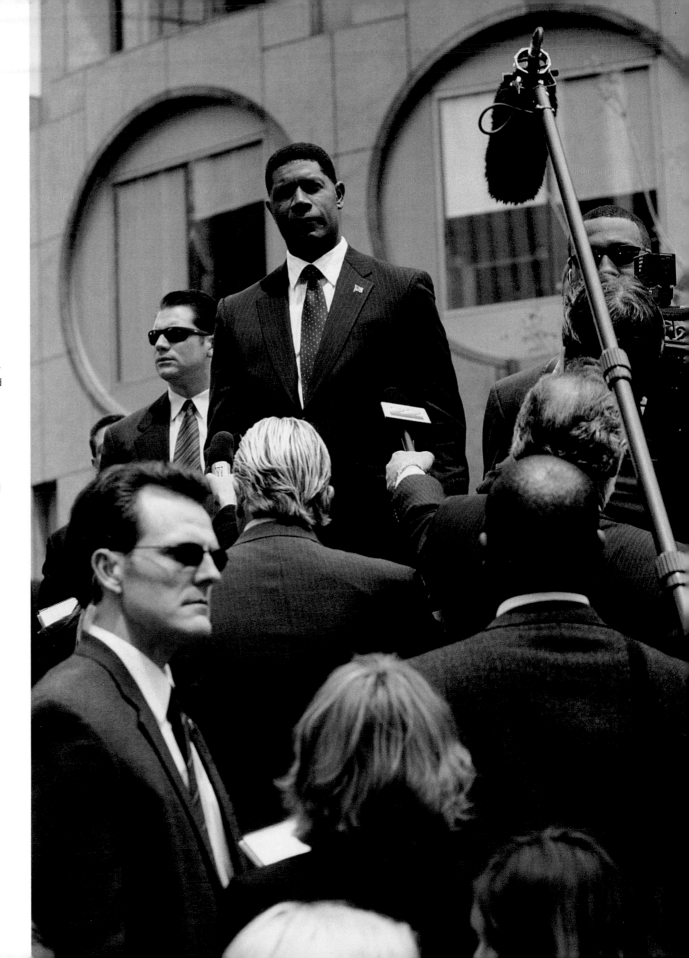

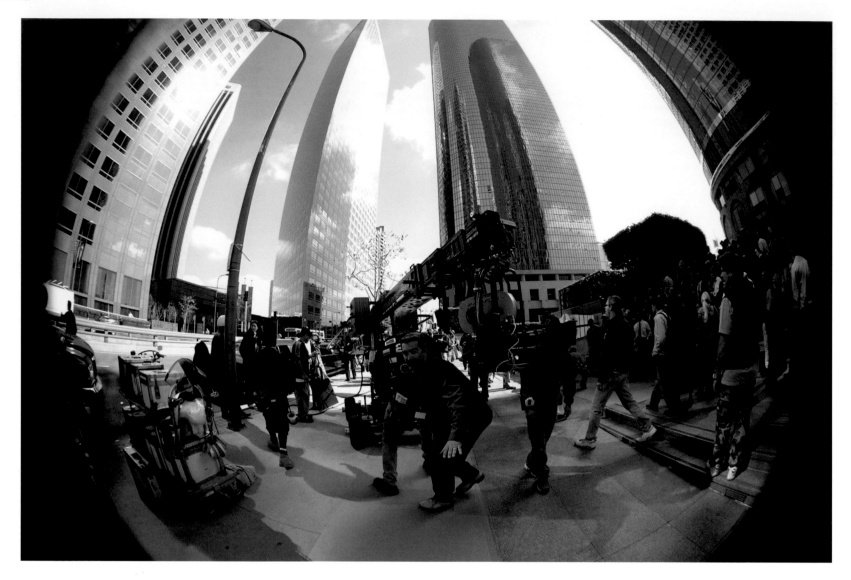

DOWNTOWN L.A.

A lot of people don't know this, but Los Angeles actually has a beautiful downtown, with lots of interesting, tall buildings. In this shot I'm directing a scene in the midst of a group of those huge buildings. Everyone with a camera took the opportunity to pull out their wide-angle lenses and shoot low, creating the effect you see here, with all those skyscrapers hovering above us. It makes a lovely still image, but what is ironic is that you will never see a shot like this on the show, even when we shoot in the middle of downtown L.A. Something like this is too luxurious, too rock-video for our style. We focus more on down-and-dirty, realistic shooting.

7:00 A.M.–8:00 A.M. / DOWNTOWN L.A. *Director Jon Cassar walks the route that the camera on the crane will make to get the final shot of President Palmer (Dennis Haysbert) collapsed on the ground.*

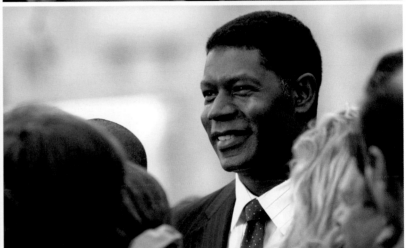

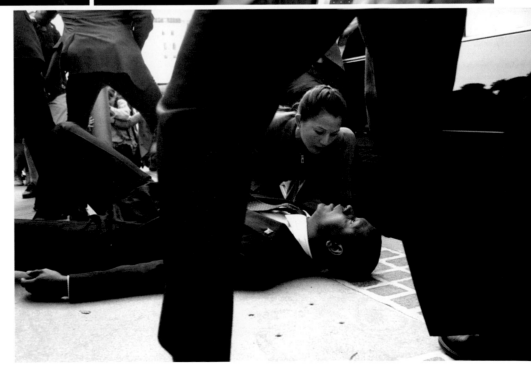

PALMER ASSASSINATION ATTEMPT

At the end of season two, the assassin Mandy, played by Mia Kirshner, poisoned President Palmer with a handshake, and by the end of that season he ended up almost dead. The photo to the right was taken through an actor's legs during the scene when Palmer falters and then finally goes down—a very dynamic shot that feels like you're on your knees watching the fallen president from behind a Secret Service agent. But for the scene that was actually aired, we used one of the only other crane shots we've ever done on the show. We started the shot looking right down on Palmer and then did a slow, building pull-up, almost like his spirit was ascending to heaven. We don't use cranes much, but for Palmer's poisoning, I wanted it to be the final image of the season and very different from what we'd ever done before.

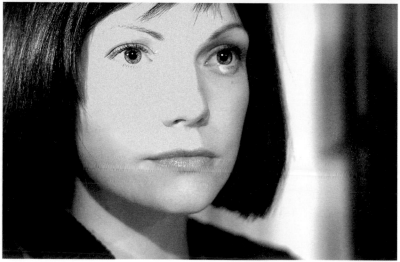

9:00 P.M.–10:00 P.M. / AIRPORT
Above: Jack (Kiefer Sutherland) interrogates Marie Warner (Laura Harris) for information about the nuclear bomb. From the beginning of this season, the writers knew they wanted the "bad one" in the Warner story to be Marie. Laura convincingly played both the innocent bride-to-be and the heartless terrorist.

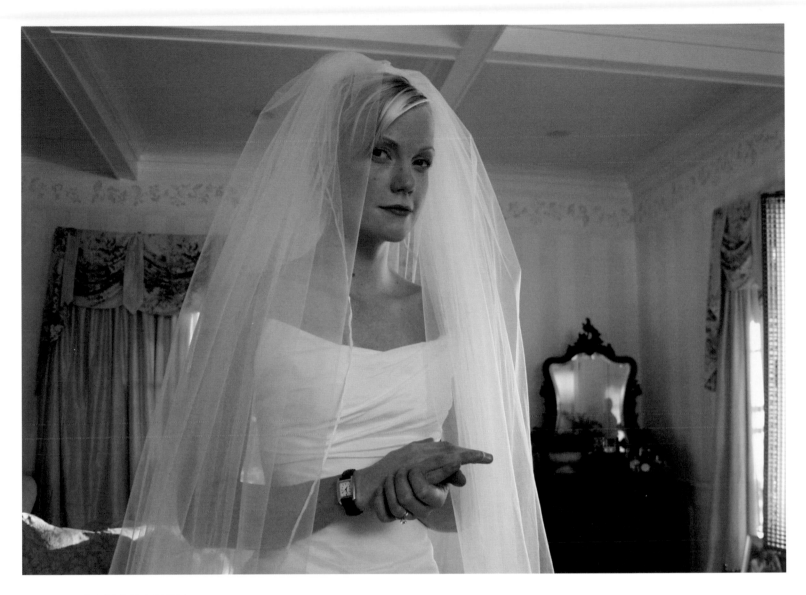

MARIE WARNER

This is a fascinating dichotomy that I think played out beautifully on the show. Pictured here is Laura Harris playing Marie Warner, sister of Jack Bauer's love interest and a very un-likely villainess. The season opens with her wedding preparations, and she looks innocent enough—just like a Valley Girl bride on her wedding day. The surprise, of course, is the fact that she is really a cold-blooded killer and a terrorist, yet another of our really evil characters, as you can see when Jack interrogates her later in the season. What's really interesting is that writers and producers knew her character was going to be revealed as an undercover terrorist, but Laura didn't know. We intentionally kept it secret from her because we were afraid her character might lose some of the innocence that was part of her cover. In fact, few people knew until we actually got ready to film her transformation into the evil Marie. When we finally told her, she was ecstatic. She went out that weekend to a gun range, where our prop assistant instructed her on how to shoot guns. We designed a different look for her for her terrorist scenes—at left you can see her in a dark brown wig—and it was very effective. Laura did a fantastic job with that transformation, helping us continue that ongoing shell game we play with our viewers. We like to throw them curveballs whenever we can.

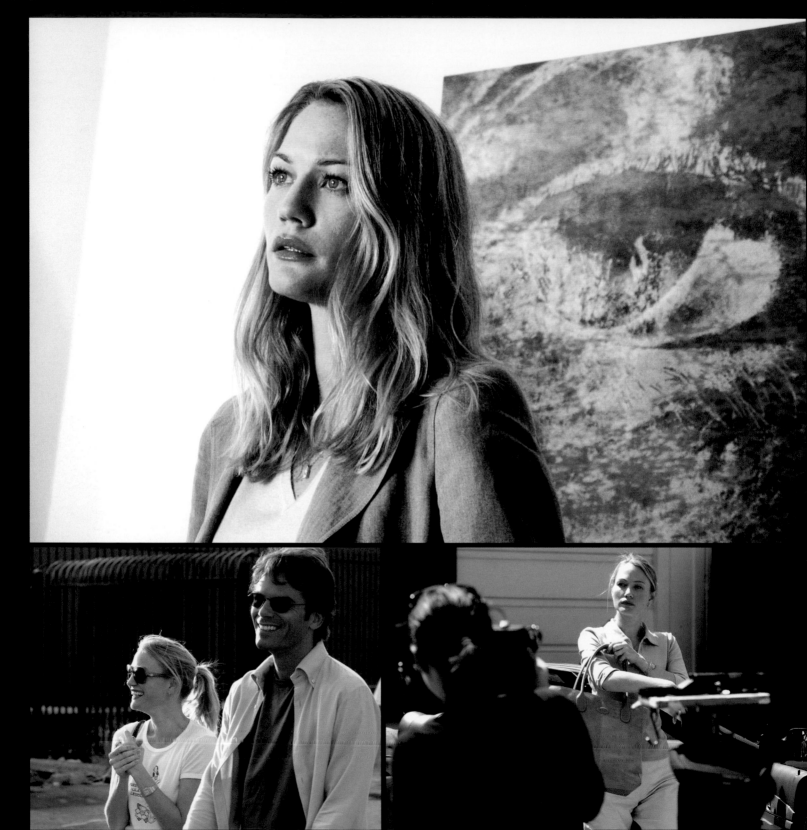

9:00 P.M.–10:00 P.M. / AIRPORT
Above: Sarah Wynter as Kate Warner tells her father that her sister Marie is involved with the terrorists planning to detonate a nuclear bomb.

6:00 A.M.–7:00 A.M. / MATHESON HOUSE
Top left: Kate Warner (Sarah Wynter) finds Kim Bauer in the Matheson house.

7:00 A.M.–8:00 A.M. / DOWNTOWN L.A.
Bottom far left: Sarah and Billy Burke share a smile while waiting to do a scene in downtown L.A.

12:00 P.M.–1:00 P.M. / WARNER HOUSE
Bottom left: Kate getting out of a car in front of the Warner house while Isabella takes a picture.

KATE WARNER

Sarah Wynter as Kate Warner was an early attempt to introduce a love interest for Jack. In their case, though, Jack met her during that day. There was a connection between the two, but obviously, with the events of the day, nothing was ever consummated between them. That's when we realized that we couldn't put Jack in romantic situations unless we had first established a preexisting relationship.

JACK AND NINA

Nina Myers (Sarah Clarke) is without a doubt Jack Bauer's No. 1 nemesis, and in season two, Jack finally gets his hands on the woman who murdered his wife. Naturally, however, his thirst for vengeance will have to wait, since Nina has information that CTU needs in order to prevent a massive nuclear terrorist attack. In the photo below, Jack watches her on a monitor at CTU as Nina waits for him in the interrogation room. It was an intensely dramatic moment, evident when the two characters seemed to stare at each other through the surveillance camera system. The black bar you see on the video screen is there because the video and the still photo were not in sync. That's ironic, because Jack and Nina are looking right at each other, and they certainly seem to be in sync. You might also notice that this shot looks very different from other shots you see in CTU, because of the white light streaming into the room from above. That's because in the bombing of CTU story line, a terrorist bomb had damaged the building and put a hole in the roof. That gave us the ability to change the lighting in the room and give CTU a completely new look. We used the bombing story line to our advantage by blocking scenes directly under that hot, white light, and in this way we were able to up the dramatic feel of scenes in CTU.

3:00 P.M.–4:00 P.M. / AIRPLANE
Jack escorts Nina Meyers to her seat. They're flying to Visalia to track a lead of Nina's.

3:00 P.M.–4:00 P.M. / EXT. CRESCENT COLLECTIBLES
Jack takes Nina Meyers to Visalia to find more information on the nuclear bomb.

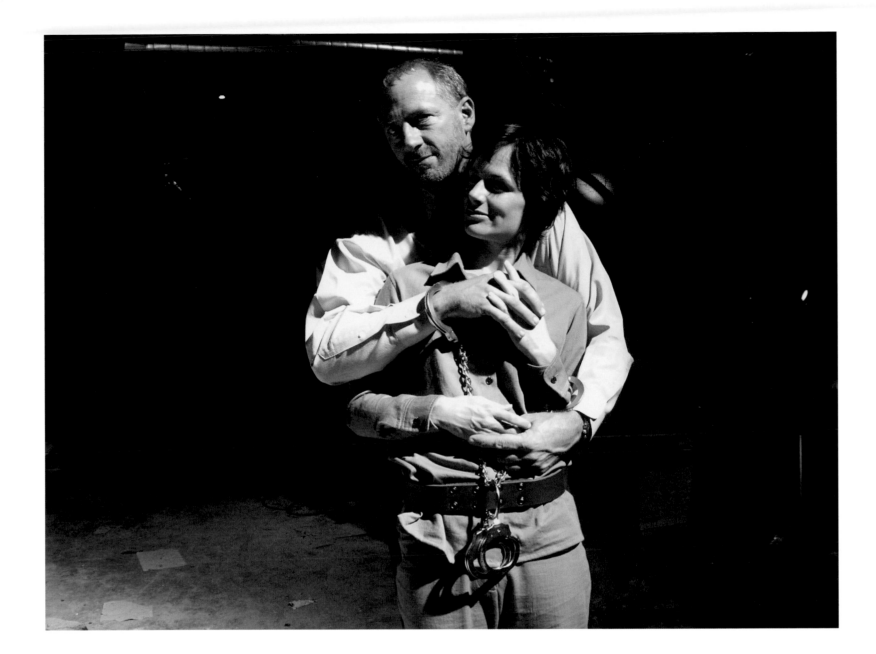

THE HAPPY COUPLE

This is a gag photo that Sarah Clarke and Xander Berkeley, who played George Mason, asked Rodney Charters to take for them. It's funny because she's in chains and he's in handcuffs, which had all sorts of meaning for them since they had gotten married shortly before this photo was taken. Sarah and Xander started dating after meeting on set during the show's first season, and by the time we brought her character, Nina, back during the second season, they were already married!

4:00 P.M.–5:00 P.M. / ANGELES NATIONAL FOREST
Nina Meyers (Sarah Clarke) after the plane crash.

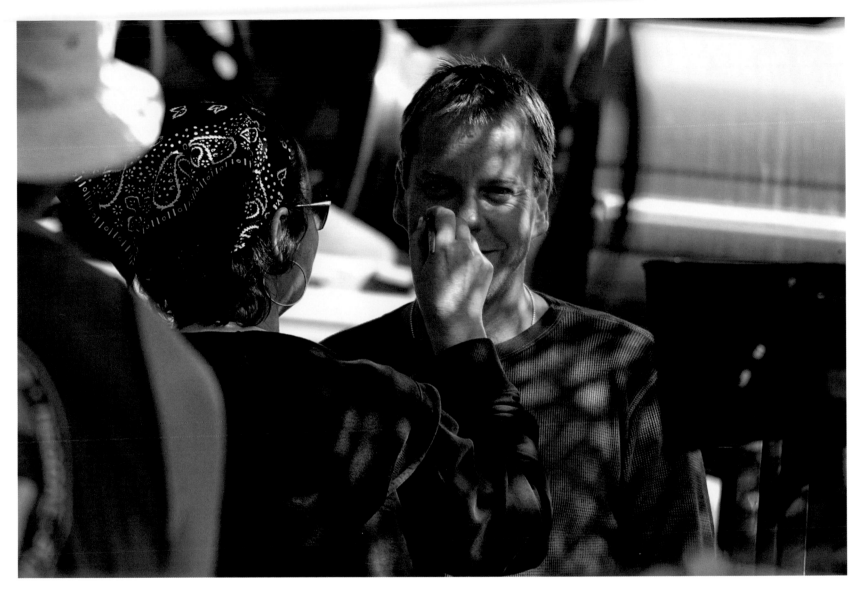

HAIR/MAKE-UP

Makeup artist Ania Harasimak puts the final touches on Kiefer's make-up just before he shoots a scene. This will be her last chance to work on him before the camera rolls and the world gets a look at him. Ania has been Kiefer's personal make-up person for all five seasons of *24,* although she also works on other cast members as well. Notice that out of the corner of his eye Kiefer caught me taking this picture, and he's giving me a big grin.

PRESIDENTIAL AIDES

Here are a couple of shots with Jude Ciccolella as presidential advisor Mike Novick and Michelle Forbes as Lynne Kresge—in character (above) and just hamming it up for the camera between takes (left). At the end of season five, Novick was still in the show, but the Lynne character, unfortunately, had been left maimed and in the hospital. On the presidential side of our plots, very little fun ever happens—it's always very serious, so it's good to see these people smiling.

THUMBS UP

Kiefer is getting ready to film a scene in which he has to parachute out of an airplane that is about to crash and has a nuclear bomb on board. Normally, in or out of the show, we would rarely see Kiefer wear any kind of hat or helmet. But he was required to wear the helmet because he had to match the stuntman, who insisted on wearing one. Jay Herron, one of our camera operators, is a funny guy, and he convinced Kiefer to strike this goofy pose with a cigarette in his mouth.

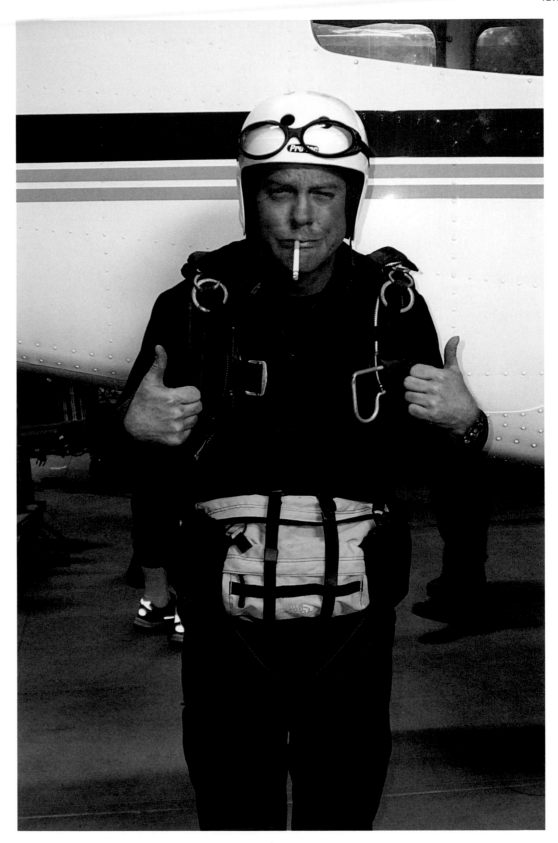

10:00 P.M.–11:00 P.M. / PLANE OVER THE DESERT
"Working with Kiefer Sutherland (Jack Bauer) is truly a unique experience. I see Kiefer as a committed professional who admires and respects the art and artists who make movies. Here Kiefer is dressed in a jump suit and parachute, which will carry Jack Bauer to safety while George Mason (Xander Berkeley) pilots the Cessna plane and bomb to its final destination over the desert. Kiefer relieves the heaviness of this scene between takes with two thumbs up." –Jay Herron

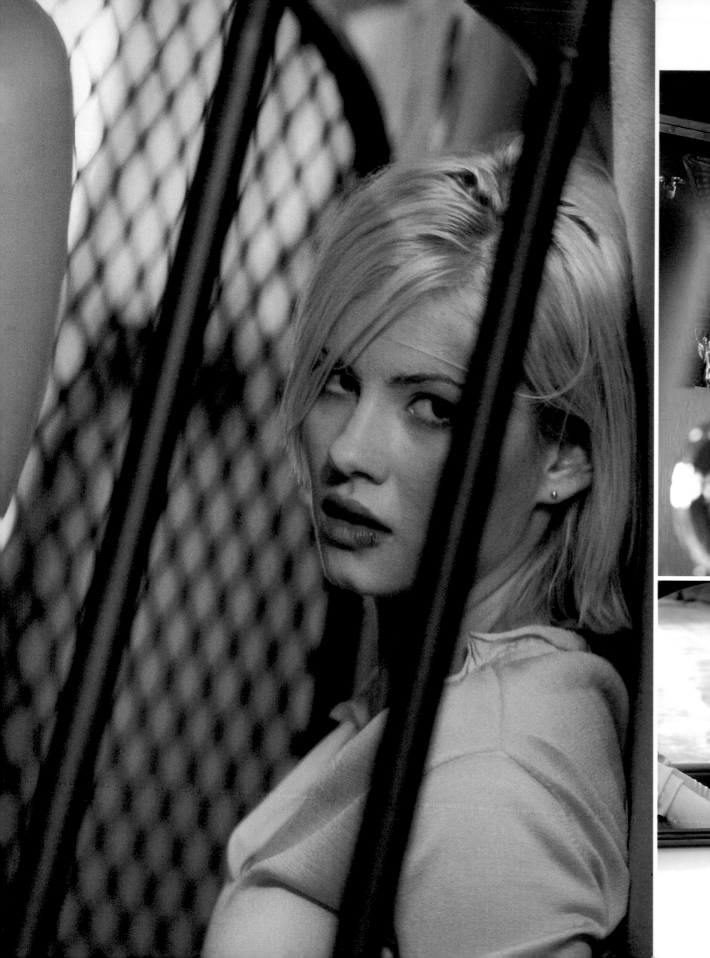
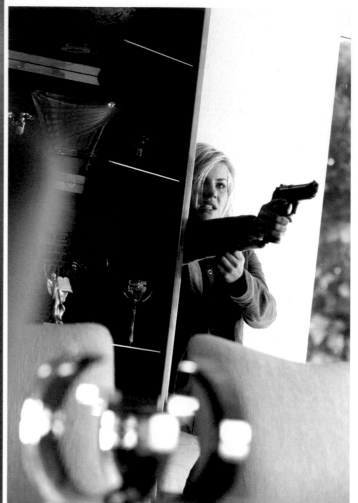

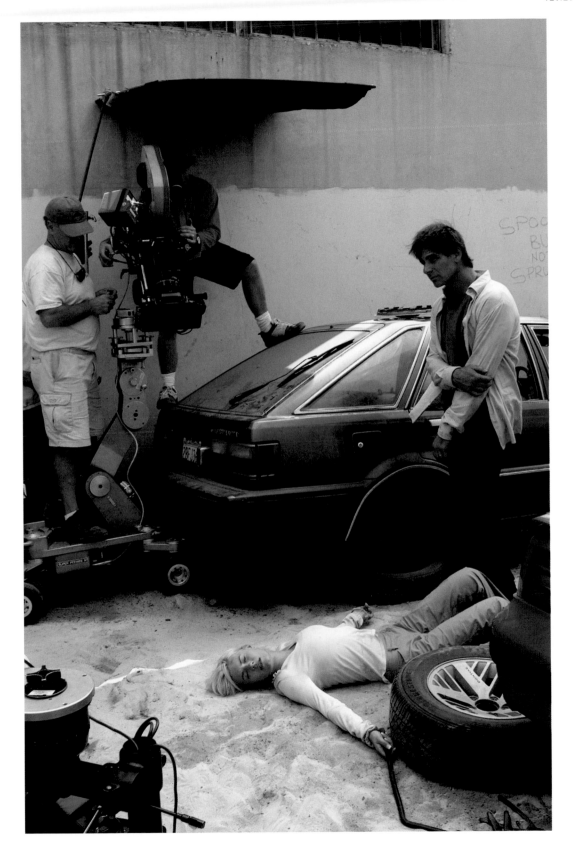

6:00 A.M.–7:00 A.M. / MATHESON HOUSE
Above: Kim Bauer defends herself in the Matheson House.

9:00 A.M.–10:00 A.M. / L.A. STREET
Left: Here Kim Bauer (Elisha Cuthbert) has her eye on the camera, not the road.

Right: B-Camera films Kim and the stunt double for Billy Burke.

L.A. COLISEUM: THE SETUP

These are some shots from filming at the Los Angeles Coliseum—the location of the big confrontation sequence we filmed at the end of season two. We don't often get a chance to shoot at major landmarks, but this was certainly one of those rare instances. It proved to be very challenging for us, especially since we flew a helicopter directly overhead.

7:00 A.M.–8:00 A.M. / L.A. COLISEUM

Opposite top: Carlos Bernard on the set to do off-camera dialogue lines with Kiefer.

Opposite bottom left: Jon Cassar, Guy Skinner, Nicole Burke, and Kiefer Sutherland between takes of the season two finale. This is the spot where Jack experiences chest pains and stops when Kingsley (Tobin Bell, not pictured) approaches to kill him.

Opposite bottom right: Director Jon Cassar explains to actor Tobin Bell and his stunt double their course of action.

19:01:59

53

SEASON 3

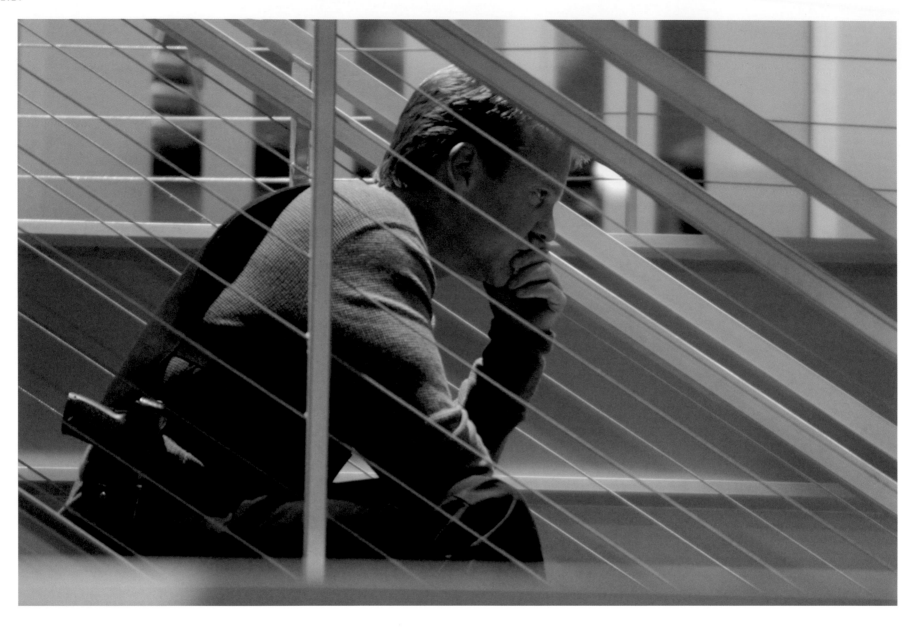

CONCENTRATING

Kiefer really prepares for each scene, and wants to be in the right frame of mind before any director calls "action." Here he is in full concentration, getting ready for a scene by going through each part of it in his head. His goal is to find Jack Bauer and be right in Jack's headspace by the time he has to take "action."

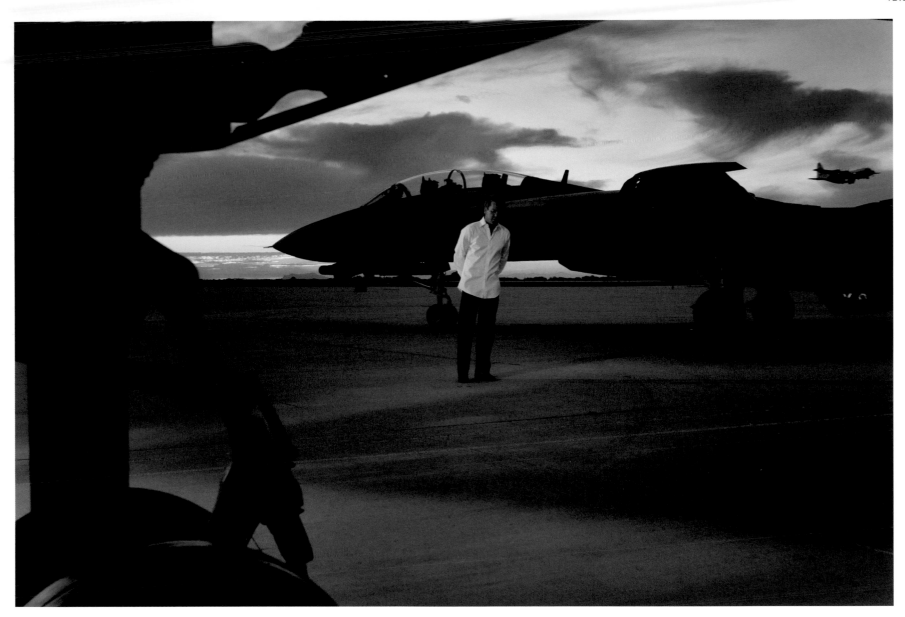

MILITARY PSA

This photo was taken when Kiefer was filming a Public Service Announcement for the U.S. Military. We get constant cooperation from every branch of the military, and they've helped us so much on so many episodes that we decided to return the favor. We shot this PSA at Naval Air Station, Point Mugu, on a tarmac full of jet planes. The plane directly behind Kiefer is an F-14 Tomcat. Rodney Charters managed to take this photo as Kiefer was preparing to say his lines, and you can see he snapped it at the moment a jet was taking off over Kiefer's shoulder, right as the sun was setting.

STIFF UPPER LIP

Jack's shown here from the third season's final episode. You can't tell, but Kiefer is actually "playing in pain." He had had an accident shortly before this episode was shot—he tripped on the stairs going into his trailer and twisted his ankle so badly that he had to wear a cast. In the episode, he has to chase a bunch of bad guys around a building, so we painted his cast black and put a special boot over it that was designed to look exactly like a shoe. We shot the scene so that you can't see his feet for more than a microsecond, but if you could see it clearly, you would notice that one of his feet is double the size of the other one. Kiefer still had to run for the scene, so he specifically created a "limp-run" that we could use for his close-ups. If you ever see the episode on DVD, be sure to freeze a couple of frames to get a glimpse of his cast.

12:00 P.M.–1:00 P.M. / School

Above: Jack Bauer (Kiefer Sutherland) combs the school hallways looking for bad guy Rabens (Salvator Xuereb) and the virus in the season three finale.

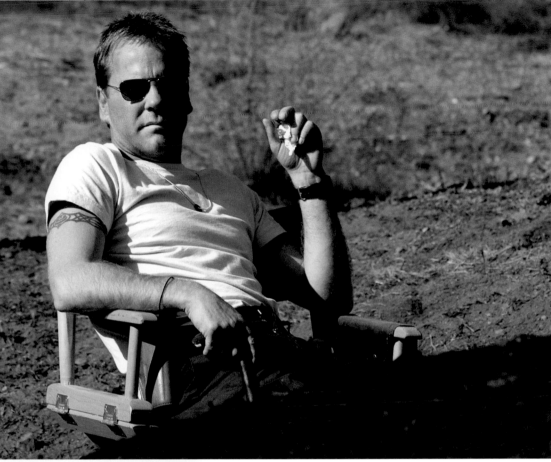

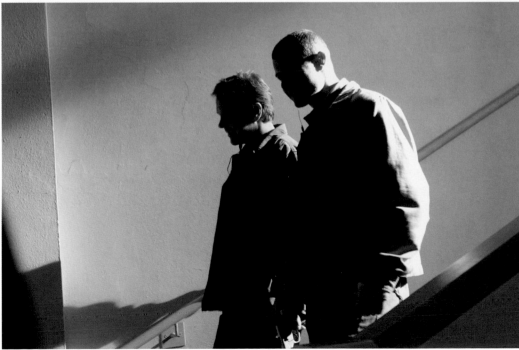

5:00 A.M.–6:00 A.M. / School
Left bottom: Kiefer Sutherland and James Badge Dale rehearse a scene at the school where their characters Jack and Chase have tracked Rabens (Salvator Xuereb) with the virus.

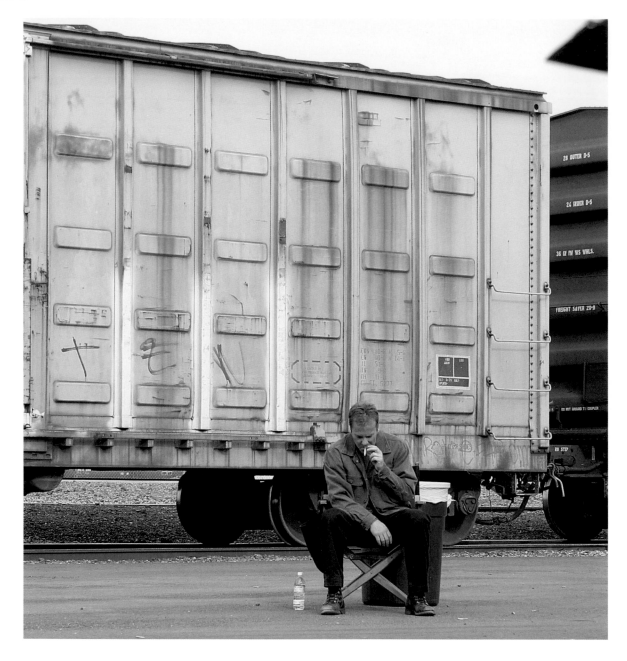

CHAPPELLE'S EXECUTION

You'll see in this collection some gorgeous pictures of glamorous places, beautiful sunsets, and exotic locales. But most of the places where we shoot on location are much grittier: train yards, industrial zones, freeways, and parking garages. Here, Kiefer is killing time at a train yard before shooting the famous scene in which Jack Bauer is forced to kill CTU Supervisor from Division, Ryan Chappelle, to avoid a terrorist attack. While it may look pretty cool, it doesn't have much glamour. People think working in TV is a glamorous business, and maybe it is when you go to awards shows, but most of the time, these are the kinds of places where we work.

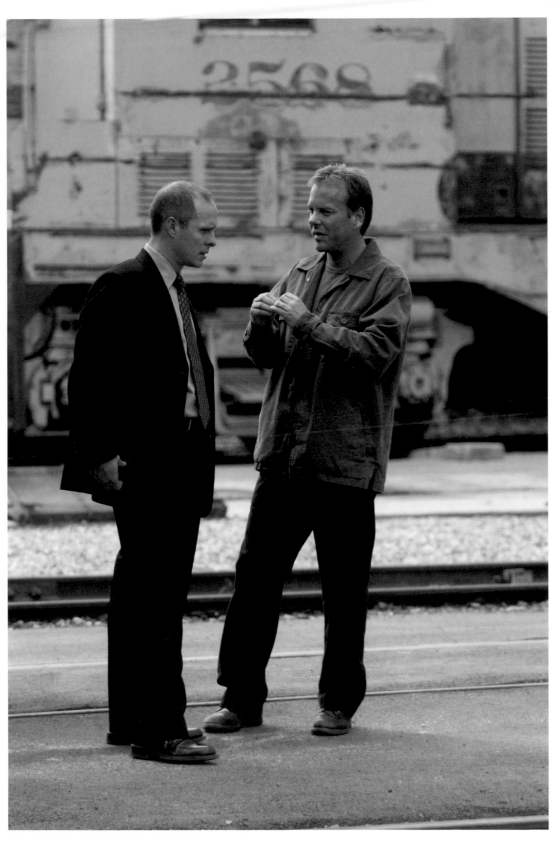

6:00 A.M.–7:00 A.M. / TRAIN YARD, DOWNTOWN L.A.
This is also an important moment because it precedes the filming of what may have been the most shocking scene in 24 *history—the scene in which Jack Bauer executes his boss, Ryan Chappelle (Paul Schulze), in order to prevent a massive terrorist attack. Kiefer and Paul are engaged in a passionate discussion about how to play the scene. It was an unbelievable moment, and what I'm most proud of was the character buildup of Chappelle: a great testament to our writers and actors. We had introduced him as a fairly unsympathetic supervisor at CTU, one of the many we've had over the years. But by the time the plot had moved to this point, the viewer somehow found himself pleading with Jack not to pull that trigger.*

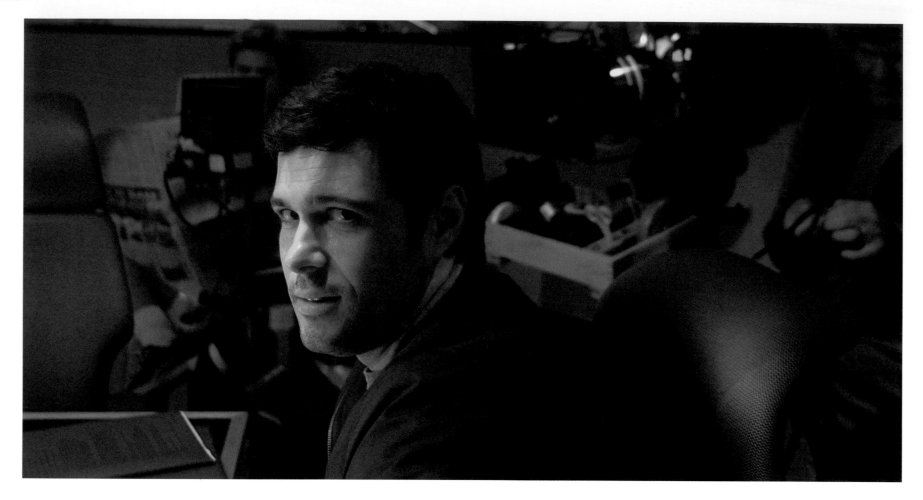

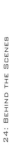

IN THE EYE

It's so exciting that Carlos' character, Tony, has ended up with such a huge fan base. In this shot Carlos was looking right at me as I took the picture. Note the bandage on his neck, from when his character got shot in season three. Carlos is fun to be around and we became very good friends during his time on *24*.

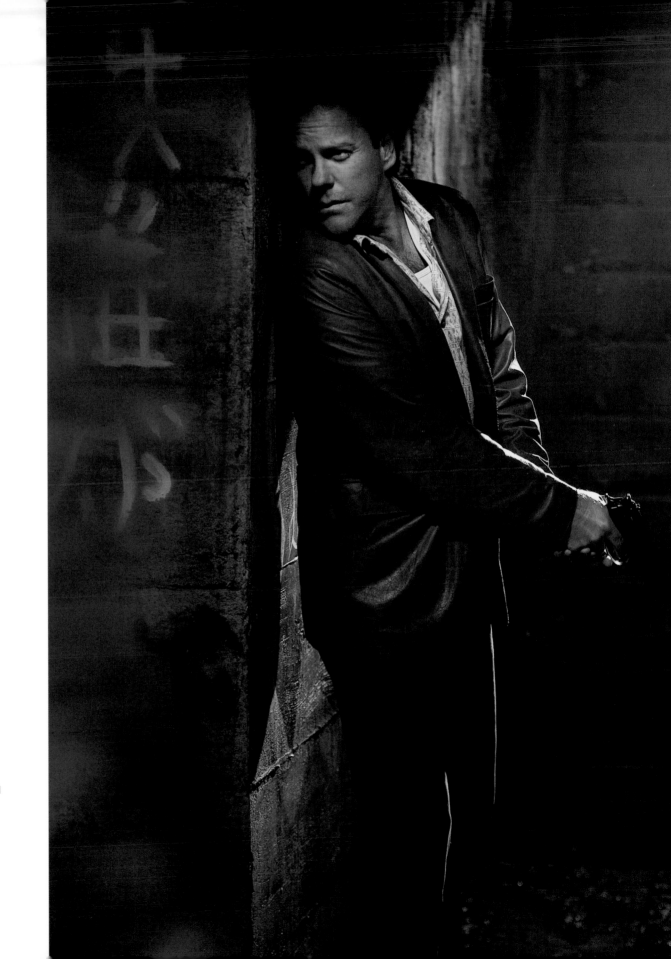

JACK ATTACK

This shot of Kiefer Sutherland as Jack Bauer was picked up as the cover photo of *American Cinematographer* magazine for a feature story on our amazing director of photography, Rodney Charters. Rodney, a cinematographer with high standards, got to light and shoot this photograph for the article. This striking image perfectly exemplifies Jack Bauer in action.

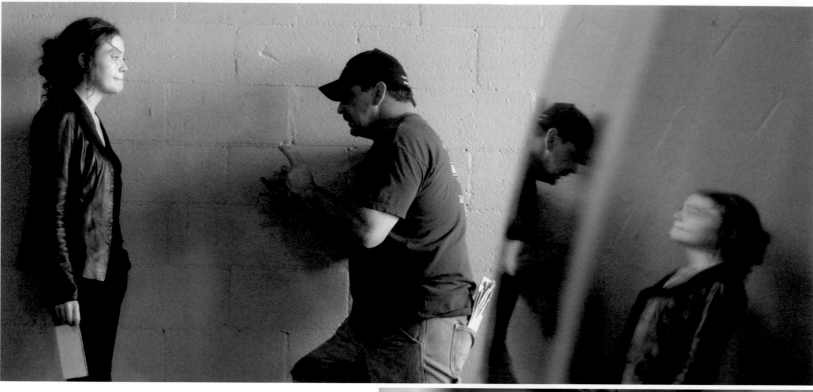

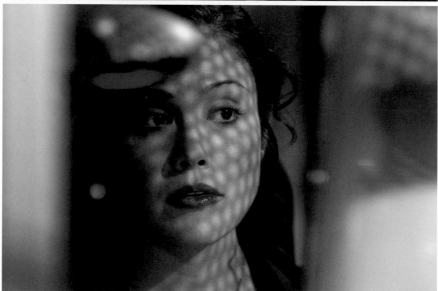

FIELD AGENT

Roiko Aylesworth was happiest when we got her character out into the field and into the action. Here she's getting some instruction on gun use by our prop assistant, Michael Pat Lugar. Their reflection off the van creates a very nice effect. Reiko really enjoyed this story line—a lot of actors who sit behind a desk on our show are always bugging us about getting out into the action and carrying a gun. Reiko was no exception.

MICHELLE DESSLER

Here are some beautiful photos of Reiko Aylesworth as Michelle Dessler. See how amazingly the light wraps around her face. Between takes, she's always smiling; it's nice to get candids like this, because you usually don't want the actor smiling in publicity photos—you want them in character.

12:00 A.M.–1:00 A.M. / CTU
Michelle Dessler, played by Reiko Aylesworth.

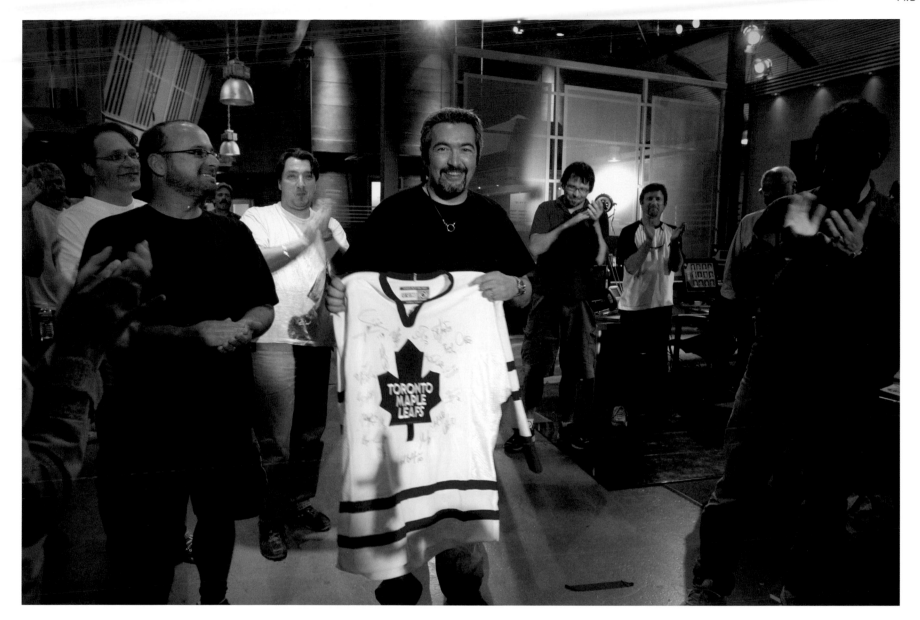

JON'S BIRTHDAY

Since we have a crew of over 200 people, every few days there is a very good chance that someone is having a birthday, and we have a *24* tradition that when it is someone's birthday, we present them with a birthday cake on set. This time around it was my turn, and they took a moment to stop shooting and bring out my cake. But Alicia Bien, Michael Pat Lugar, and Kiefer had a big surprise for me. They happen to know I'm a huge hockey fan, and so they went out and got every member of the Toronto Maple Leafs to sign a jersey for me. It was one of the nicest presents anyone has ever given me, and right now it's framed and hanging in my office. Both Canadians, Kiefer and I, as well as a few other guys, talk a lot about hockey on set, especially during playoff time. During playoffs we always have a third monitor on set—two monitors show the scenes we are shooting, and the third one shows the playoff game (with the volume turned off, of course). We've gotten some other members of the crew turned on to hockey.

12:00 P.M.–1:00 P.M.
Jon Cassar, a big Toronto Maple Leafs fan, receives a signed jersey for his birthday.

7:00 A.M.–8:00 A.M. / UNIVERSITY LIBRARY, SANTA BARBARA
*Opposite: Sporting a dark wig and wielding a weapon, Kim (Elisha Cuthbert) goes undercover as the
daughter of Stephen Saunders (Paul Blackthorne)*

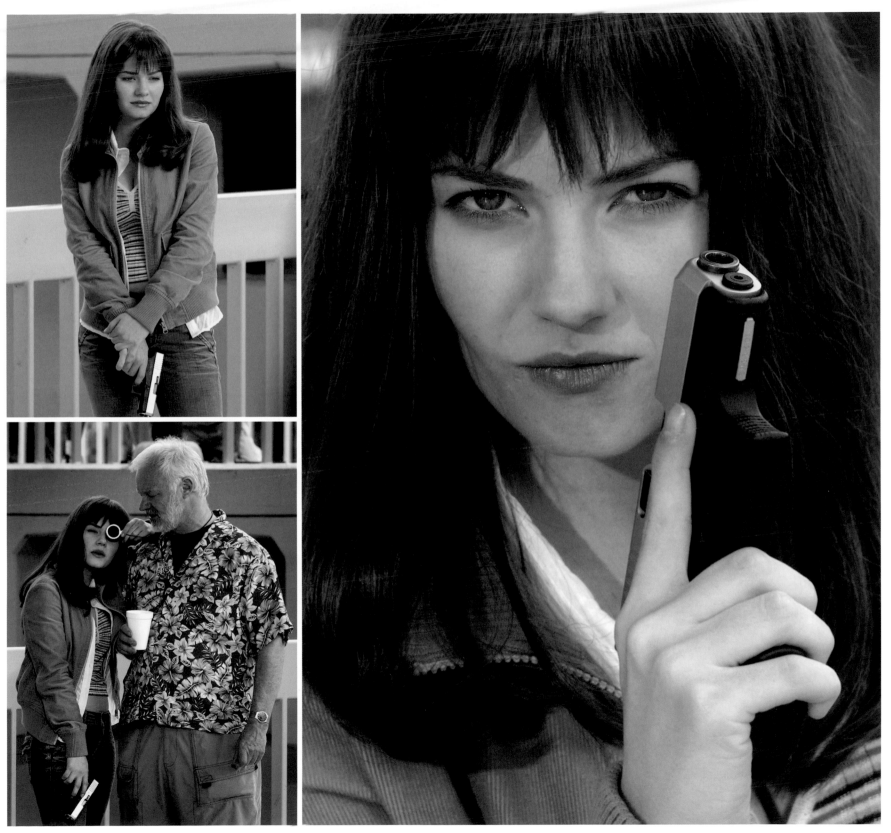

7:00 A.M. – 8:00 A.M. / UNIVERSITY LIBRARY, SANTA BARBARA
Elisha Cuthbert (Kim Bauer). Bottom left, with Rodney Charters, director of photography

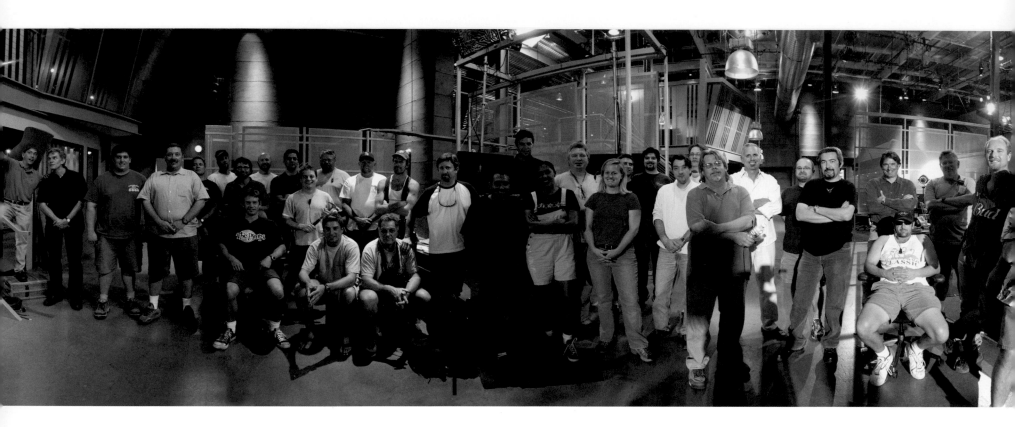

FULL PRODUCTION STAFF

Rodney Charters used an ingenious method of stitching together still photos to create this 360-degree panorama of the crew, cast, office staff, and producers from season three. A couple of guys decided to have some fun and shifted spots to make sure they were in each of the separate photos that would be edited together. If you look closely, you'll find they appear a few times in this image.

CHLOE O'BRIAN

This image shows Mary Lynn Rajskub on her first day as Chloe O'Brian. Chloe has become an incredibly popular character for us. In this photo Mary Lynn gave me that wry smile while she was kidding around—she is a comedian by trade, after all. I'll never forget that first day: she was playing a scene with Kiefer right off the top, and his character was really chewing her out. I don't think she was ready for the intensity, since her background is comedy. It took a little getting used to for her, but she fit right in pretty quickly. All credit for casting Mary Lynn as Chloe, by the way, goes to Joel Surnow. He really has an eye for offbeat casting. He brought her in for an interview after seeing her in *Punch-Drunk Love* with Adam Sandler. It was the only time I'm aware of that he hired someone on the spot, as soon as he met her, without even asking her to read for us first. When he told her she had the part, she asked, "Don't you want to talk about it?" He replied, "I don't want to talk; you've got the part."

Set electrician Christopher Whitman talks with Mary Lynn Rajskub, who is hanging out on set between takes in season five.

CHASE EDMUNDS

In season three, James Badge Dale played Chase Edmunds, a character who is essentially a young Jack Bauer and who is in love with Jack's daughter, Kim. I love this picture because he's so macho in it—he's planning to go in after Jack, alone, rejecting backup from the CTU SWAT team, and he's also planning an attack. It's a beautiful shot of a true hero. In the picture to the right, Badge sits deep in thought between takes, contemplating his next scene. Notice how beat-up he is, since his character has been roughed up pretty good down in Mexico. We always talk about bringing Badge back to the show—he's a great actor. It's always a question of how to find a story line that works within the context of everything else we have going on. But Chase is one of the characters who managed to survive our writers' murderous pens, so who knows? We might see him again.

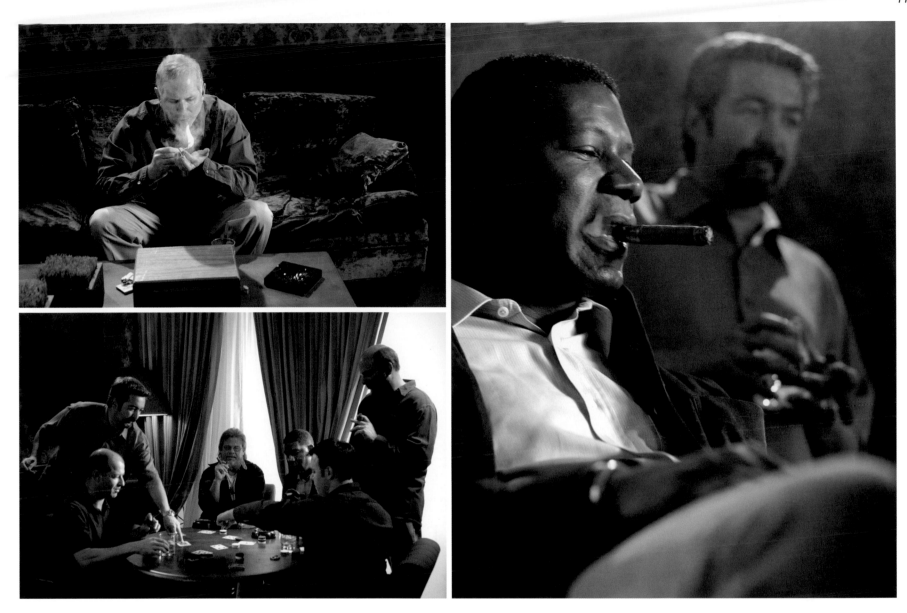

SMOKIN'

One of the habits our writing staff developed over the years is smoking cigars as a way to relax. That eventually translated into an actual cigar room, where they and other crew and cast members go to relax, let their guards down, have a few laughs, and brainstorm about the show. It's a congenial, joking, social atmosphere, and everyone who enjoys smoking cigars has been in there at some point along the way.

CLAUDIA

In season three, we had Jack involved in an established relationship with the character Claudia, played by Vanessa Ferlito, a relationship that started when he was working undercover. It was a dangerous affair because she was a drug lord's girlfriend, but there was a lot of strong chemistry between them. Vanessa is absolutely beautiful and she certainly added a lot of heat to the show. We liked her character very much, and she might have done more episodes, but Vanessa had a feature-film scheduling conflict so we had to kill off her character. We were all very sad to see her go.

NINA MYERS: LADY VILLAIN

Jack Bauer's worst nightmare, traitor Nina Myers, was played brilliantly by Sarah Clarke
until Jack finally terminated her during season three. Sarah made the character deliciously
evil—no doubt the most hated character in *24* history.

ON THE BEACH IN MALIBU

Our story took us to Malibu, where we prepared to shoot the events leading up to the murder of Sherry Palmer. The gentleman behind me in the red shirt is Zoli "Sid" Hajdu, our dolly grip. It was a special treat for us to shoot in Malibu that day, since usually our locations are industrial parks, train yards, or dark, dirty back alleys. In this case, though, our crew took full advantage of the location—many of them went surfing or had lunch on the beach that day. It was a great shoot, but unfortunately, if you study the percentages, we won't be getting out to the beach anytime soon. In fact, come to think of it, this may have been the only scene we've ever shot by the beach, even though our show is filmed throughout the greater Los Angeles area. Featured this day was Penny Johnson Jerald as Sherry Palmer, President Palmer's self-absorbed, double-dealing wife, when we filmed her character's not-so-untimely demise.

MICHAEL KLICK

First assistant director Michael Klick checks the time—helping the director "make the day" by making sure no time is wasted on set. The second second assistant director, Mark Rabinowitz, looks on. Michael is a good example of how fortunate we've been to have wonderful, hardworking people who could stay with the show for so long and be able to move up over the years. Michael started on *24* as a first assistant director, and now he's a producer: that's a huge jump, and he's doing an amazing job. A lot of people move up around here. That's because we have amazingly talented people on our team, and also because we've been lucky to be on the air long enough to be able to promote people. A lot of shows come and go before crew members get that opportunity.

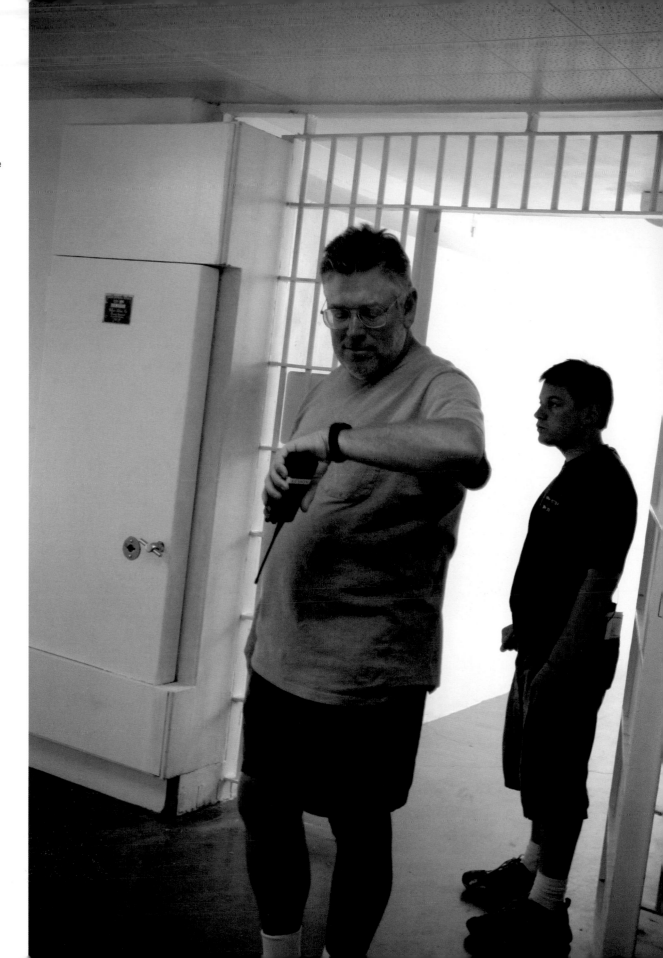

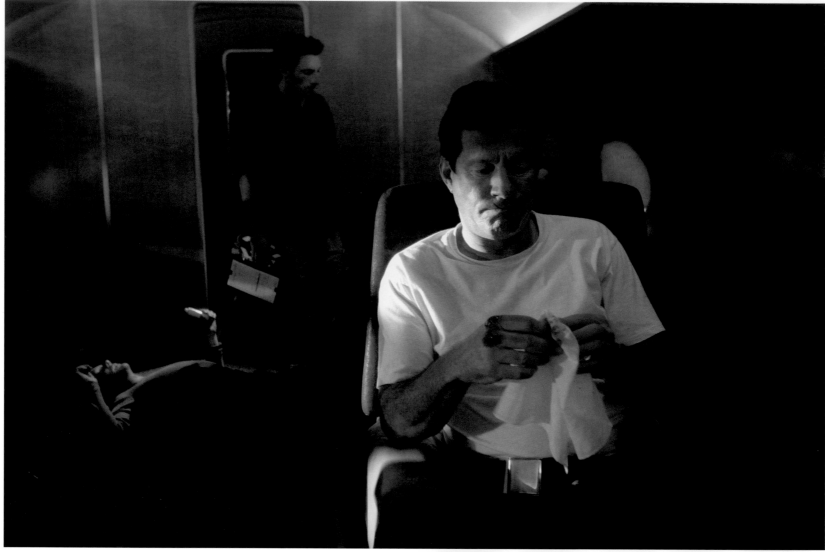

RAMON SALAZAR

On the right is a shot of Joaquim de Almeida, as Mexican crime boss Ramon Salazar, in his prison cell. Jack Bauer breaks him out of prison as part of Jack's plan to infiltrate Salazar's organization. We shot that scene in a real jail—a former women's prison—and we found that if you close a cell door in a real prison, the actors play the part very efficiently and soberly, because they want to get out of there as soon as possible. In the picture above, Salazar makes his getaway on an airplane. This was shot between takes, and if you look closely, you'll see Kiefer on the floor, tied up for the scene we were shooting, which would resume in a few minutes.

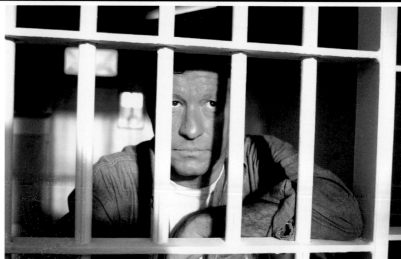

2:00 P.M.–3:00 P.M. / SALAZAR RANCH, MEXICO
Hector Salazar, played by Vincent Laresca.

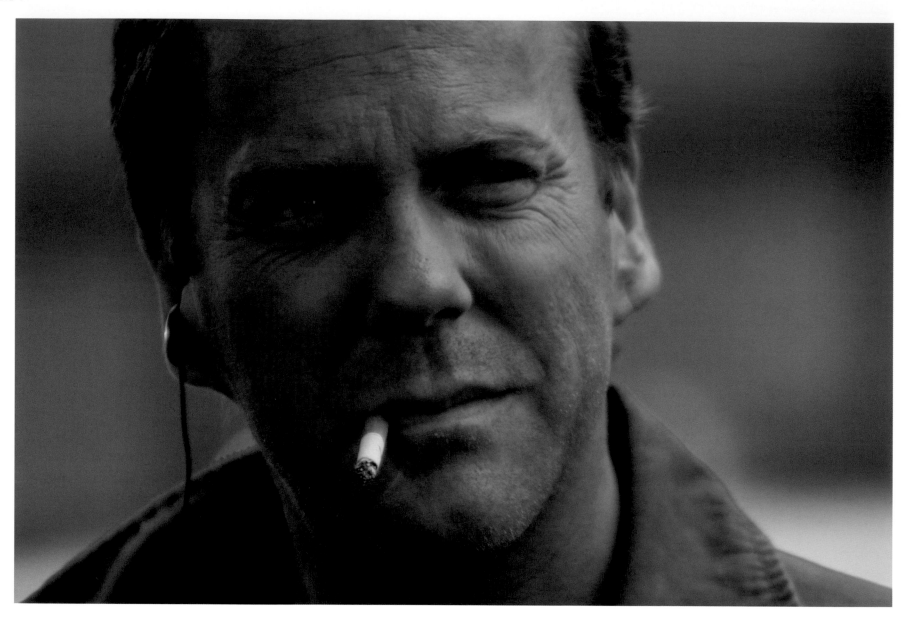

Kiefer Sutherland (Jack Bauer) in the moments before the cameras roll.

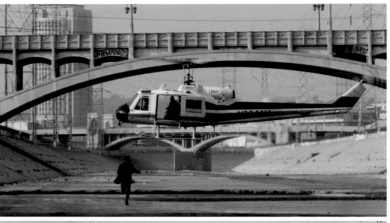

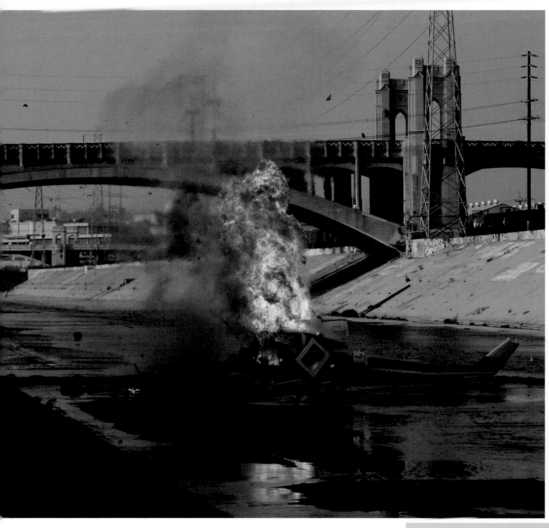

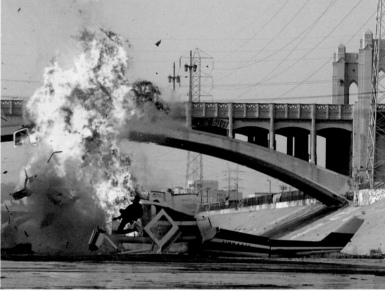

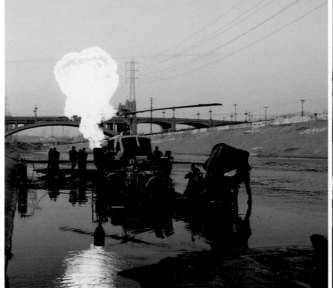

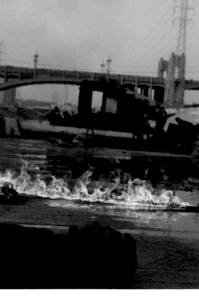

10:00 A.M.–11:00 A.M. / L.A. RIVER

Shooting in the L.A. River is always memorable. Here our talented special effects department, headed by Stan Blackwell and his brother Scott, create a fire effect to show that this helicopter, which was supposed to whisk bad guy Stephen Saunders (Paul Blackthorne) to safety, had been shot down by two military F-14s which flew as backup for Jack Bauer (Kiefer Sutherland).

3:00 P.M.–4:00 P.M. / KYLE SINGER'S APARTMENT
Kiefer Sutherland (Jack Bauer) tries to cool down in his anti-virus suit

7:00 P.M.–8:00 P.M. / Salazar Private Jet
Peering at a captured Jack Bauer (Kiefer Sutherland) through the window of the Salazar private jet.

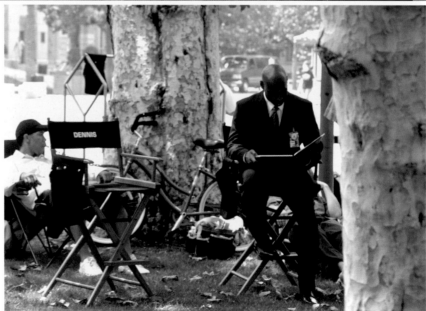

THE IDEAS NEVER STOP COMING

Above, Executive producers Joel Surnow and Howard Gordon stop to discuss yet another possible story point, on their way to their cars.

1:00 PM - 2:00 PM / USC CAMPUS
DB Woodside, who plays Wayne Palmer, the brother and advisor to President Palmer (Dennis Haysbert), reviews the script.

TONY IN ACTION

This shows Tony (Carlos Bernard) in another action sequence. This time he is trying to rescue his wife, Michelle, from the terrorist Stephen Saunders (Paul Blackthorne) when all hell suddenly breaks loose. It was fun to get Tony out of CTU and into the field. He was so thrilling to watch, and he and Jack made a terrific team together.

SEASON 4

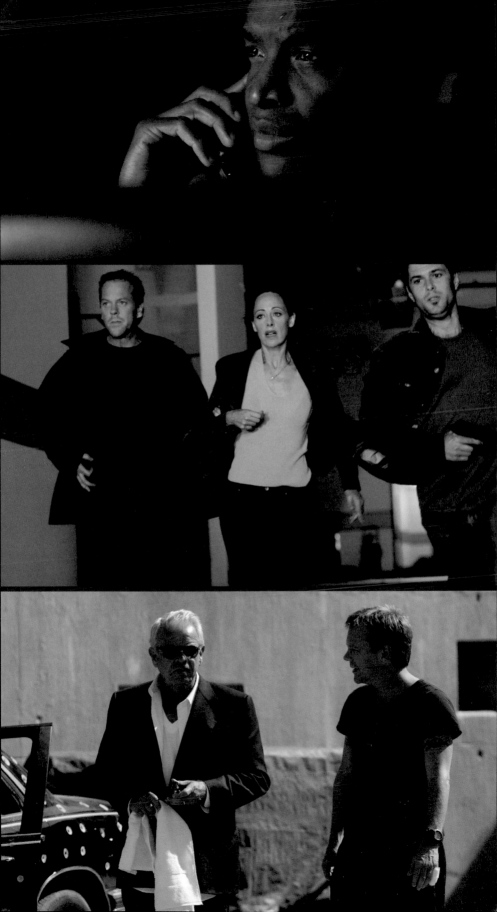

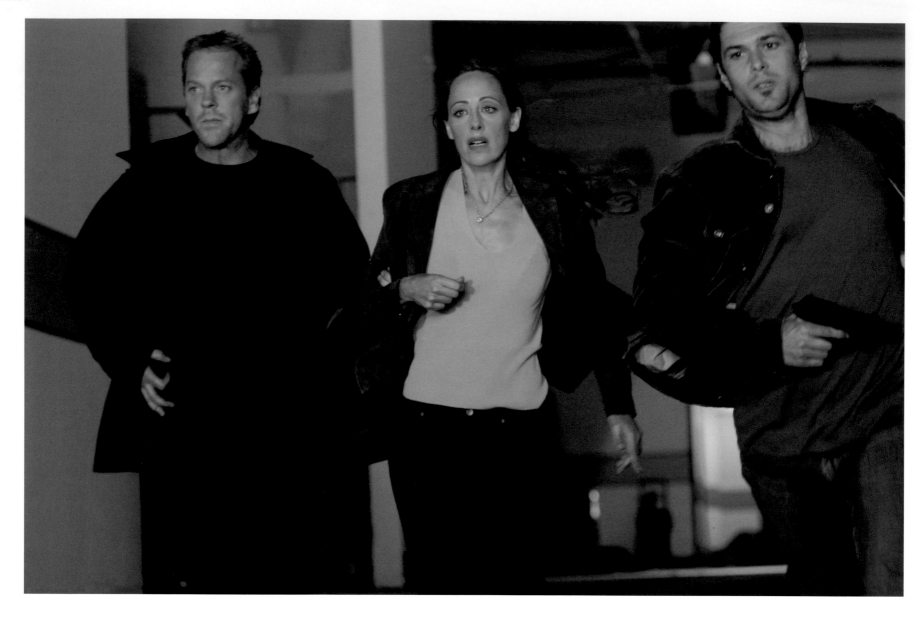

THE MOD SQUAD

This is another cool moment from *24* history—a shot taken during production on a key scene from season four. I call it "The Mod Squad" because it reminds me of the way the three characters from that classic show were filmed. The photo comes from the scene in which Jack Bauer and Audrey Raines (Kim Raver) get rescued by Tony Almeida (Carlos Bernard) just as all hope seems lost and certain death looms. It was a big moment because it was how we brought the very popular Tony character back into the story line. Before this scene, Tony was on the couch, watching sports and drinking beer. But when Jack suddenly called him, he jumped up, ran out, and saved the day. Fans ate it up.

6:00 A.M.–7:00 A.M. / PRESIDENTIAL BUNKER
This is our A-camera operator, Guy Skinner, filming Dennis Haysbert as David Palmer during a scene in which he comes to meet with President Logan. Look at the floor: even though Dennis is sitting down, you can still see the lengths we had to go to because of his height. Guy is shooting with a handheld camera, which makes it hard to film Dennis at head level when there is so large a height difference between Dennis and the cameraman. We used apple boxes, gaffer tape, and screws to build a makeshift stage for Guy to stand on while he was shooting over Dennis's shoulder.

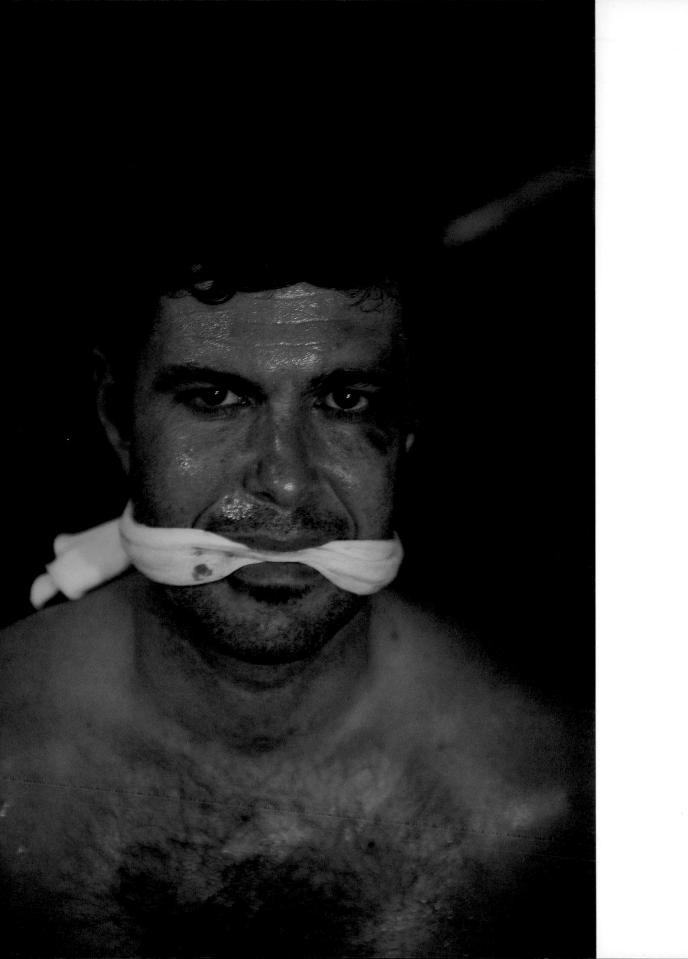

These pictures were all taken to be used as props on the show.

Far Left: This photograph of Tony was sent by Mandy to Michelle on her phone.

Left: This is a shot of Michelle Dessler (Reiko Aylesworth) at CTU. We needed Mandy to see a photo of Michelle in the newspaper, so we pulled this one out, cropped it, degraded it, and put it in a mock newspaper.

Above: For that same story line, we also manufactured a photo that Mandy would find in Tony's wallet, which is how she discovered that Tony had a relationship with Michelle. Although we never showed the photo itself in the final episode, we did show Mandy staring at a picture. To be as realistic as possible, however, I had taken the two actors outside our stage, put them in different clothes, changed Reiko's hair, and shot a few photos to be kept in Tony's wallet.

DEPTH OF FIELD

Actor Reiko Aylesworth may be best known for playing the wife of Carlos Bernard's Tony Almeida. Notice the size and depth of our CTU set behind them, with the two actors in the foreground. In the show we don't use many wide shots like this one. Here you can see the impressive range of the set, which was designed by Joseph Hodges, our production designer and lit by Rodney Charters, our director of photography.

EDGAR STILES

Louis Lombardi and Reiko Aylesworth pose for this shot. Lombardi plays Edgar Stiles, another offbeat, popular character loved by our fans, and another brilliant casting choice by Joel Surnow. We got a lot of angry emails when his character died during the nerve-gas attack on CTU. I still have a bruise on my arm from when my wife hit me after we killed Edgar. She's a true fan and doesn't come to the set or read the scripts, so she was as surprised as everyone else. That is one of the beautiful things about our show: no character is safe.

8:00 A.M.–9:00 A.M. / CTU
*Right: Mary Lynn Rajskub (Chloe O'Brian) and Louis Lombardi
(Edgar Stiles) work with the camera crew to get their focus marks.*

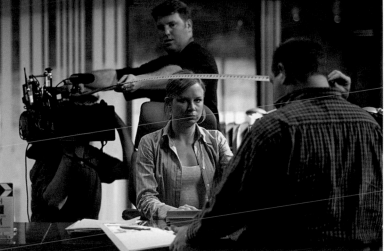

DEFENSE SECRETARY JAMES HELLER: SHOOTOUT

This is William Devane as Secretary of Defense James Heller, right after his character is rescued by Jack Bauer. Here he and Kiefer are just chatting between takes. William did such an impressive job with us that we brought him back late in season five. That's part of the *24* mystique: bringing characters back when viewers least expect it. William has the distinction of having worked both with Kiefer and his dad, Donald Sutherland, with whom he co-starred in the Clint Eastwood film *Space Cowboys*. Note the bandage on Kiefer's left hand. He cut it doing his own stunts that day, but he just had it wrapped up, went right back to work.

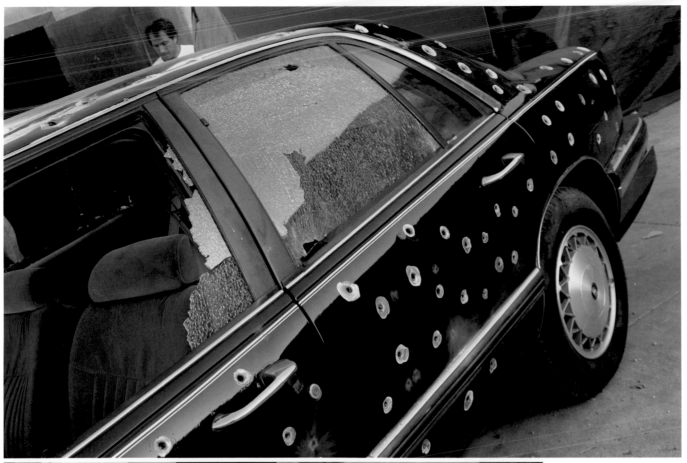

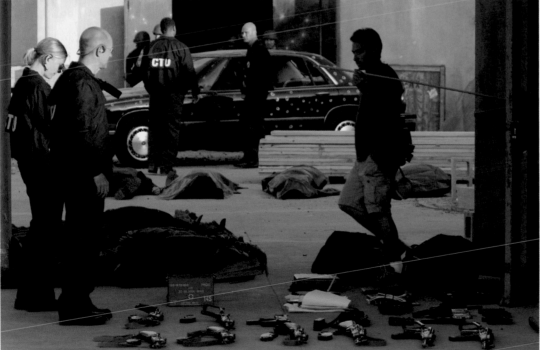

12:00 P.M.–1:00 P.M. / TERRORIST COMPOUND

The bullet damage to this car from the shootout scene in which Jack Bauer rescues Defense Secretary Heller and his daughter Audrey Raines from terrorists was strategically planned in great detail. I directed the episode and wanted a Bonnie-and-Clyde-style shoot-up of the car, and Stan Blackwell's special-effects team once again delivered. But they didn't do it by shooting up a car, which would have violated safety standards. In a movie, you can have several different cars already rigged with different kinds of damage, but on our budget and schedule, we can only have one car, so we had to take a different approach. What we did instead was to establish the damage in specific sections on the one vehicle. In one part of the scene, one part of the car is seen damaged, and then another part in the next shot, and so on. What our f/x team does is drill little holes in the car metal, place explosive putty into the holes, and then plaster and paint over the holes. Then later, while we film, they blow the holes out in stages. It's very effective, as you can see. Notice all the dead terrorists on the ground, and our camera assistant, Eric Guerin, in the shot with his trusty tape measure, lining up camera shots to make sure the focus is accurate.

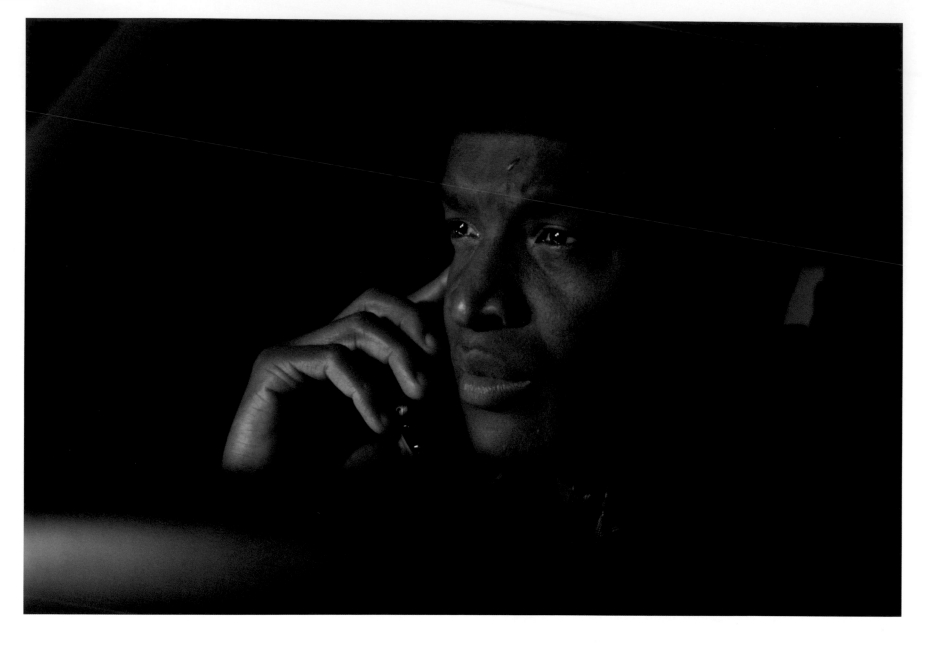

CURTIS MANNING

Roger Cross as Curtis Manning drives while talking on the phone. Thank goodness for cell phones! They have allowed the writers to create scenes for characters who are constantly in transit to and from CTU, allowing them to stay involved in the story.

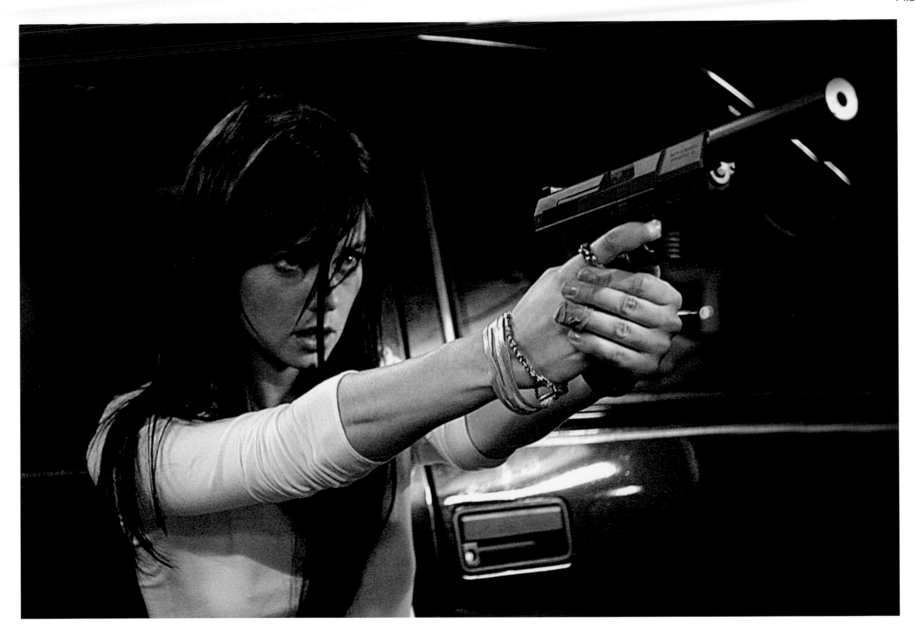

MANDY

Mia Kirshner played coldhearted assassin Mandy in a couple of different episodes; first, in the pilot episode, and then in season two, when she tried to poison President Palmer. Her character is interesting to me, because although she is totally evil, she is also an unbelievably strong woman. *24* has a reputation for strong female leads who know how to take action. She's a real butt-kicker, and she's become a huge favorite on the show. She got herself a pardon and disappeared in season four, so you never know when she might come back to haunt Jack Bauer and CTU again.

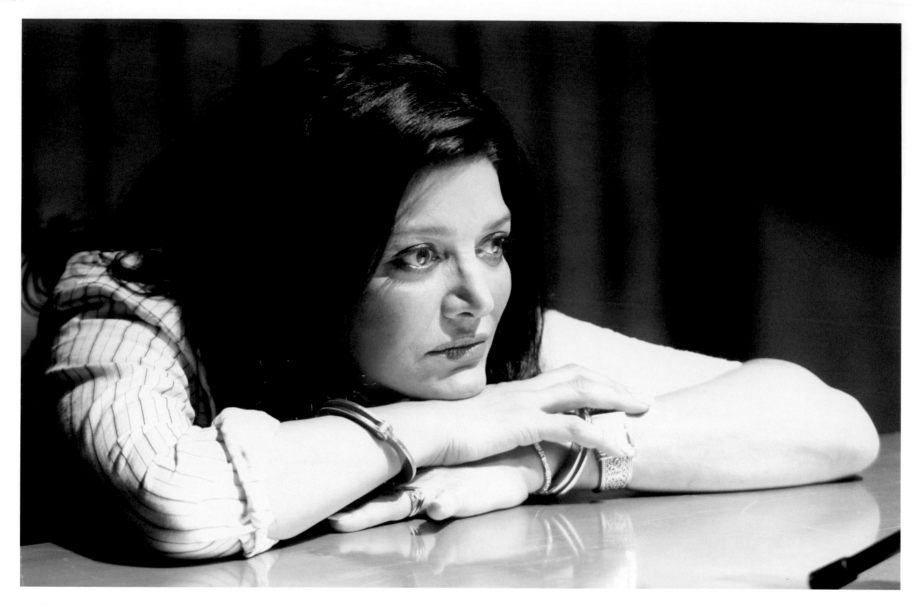

THE TERRORIST FAMILY

We were fortunate to have Academy Award-nominated actress Shohreh Aghdashloo join our cast as Dina Araz—a wife, a mother, and a key member of an underground terrorist cell in Los Angeles. Her son, Behrooz, was played by Jonathan Ahdout, who also played her son in the feature film *House of Sand and Fog*—the movie that earned Shohreh her Oscar nomination. Here she's simply waiting between takes during the filming of a crucial interrogation scene. On the opposite page, you see a beautiful portrait of the two of them—they really do look like mother and son, and I remember they were both very happy to be able to work together again. I can't begin to describe what a wonderful actress Shohreh is; she actually managed to bring compassion to an evil character. She was a murderer, and yet, when it came to her own son, she was willing to do anything to protect him. She was able to very convincingly express this dichotomy in her character's psychology. As we try to portray terrorists, we don't have much information about what they are really like. If you want to play a doctor, you can do research by going and observing doctors—but you can't observe terrorists. We wanted this character to be real and human, despite her willingness to do evil, and I think Shohreh pulled that off magnificently.

6:00 A.M.–7:00 A.M. / CTU

Viewers often ask what happened to Behrooz, and in the photo on the right, you see actor Jonathan Ahdout on set, waiting to film a scene in which we bring him back to CTU for interrogation. We actually did shoot a scene that shows him being brought back to CTU, but the scene was cut because, as is often the case, the final episode had a lot of story lines to wrap up, so we had to cut the scene and viewers never got to find out what happened to this young man. The truth is, we can't tie up every single story line at the end—something always has to go. Sitting next to him is his real-life mother. Since Jonathan was under 18 when we filmed, by state law he had to have a guardian with him on set, so his mom was with him every step of the way.

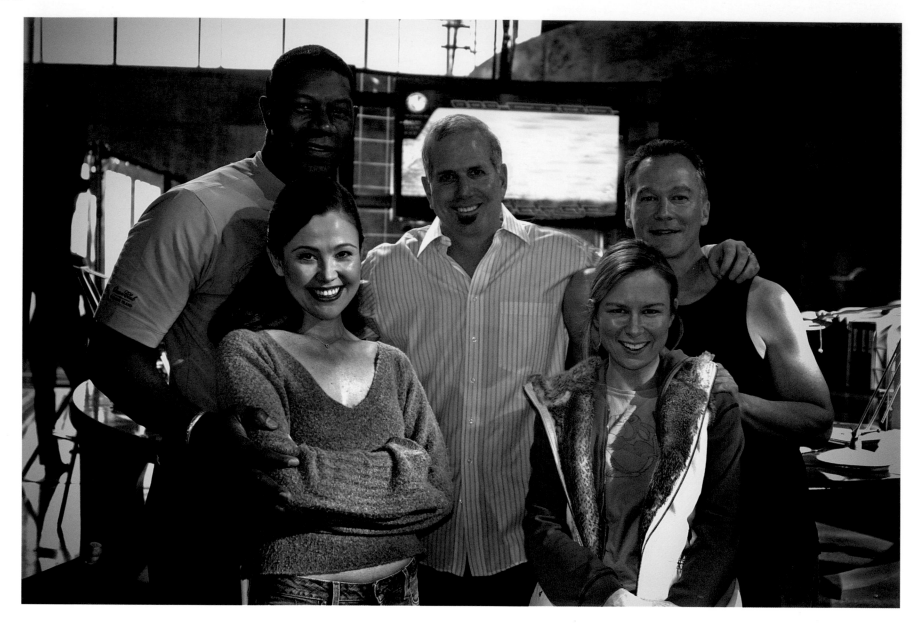

JOEL SURNOW

Our show's co-creator and mastermind Joel Surnow is surrounded by (from left to right)
Dennis Haysbert, Reiko Aylesworth, Mary Lynn Rajskub, and James Morrison during a brief
lull in action on the set.

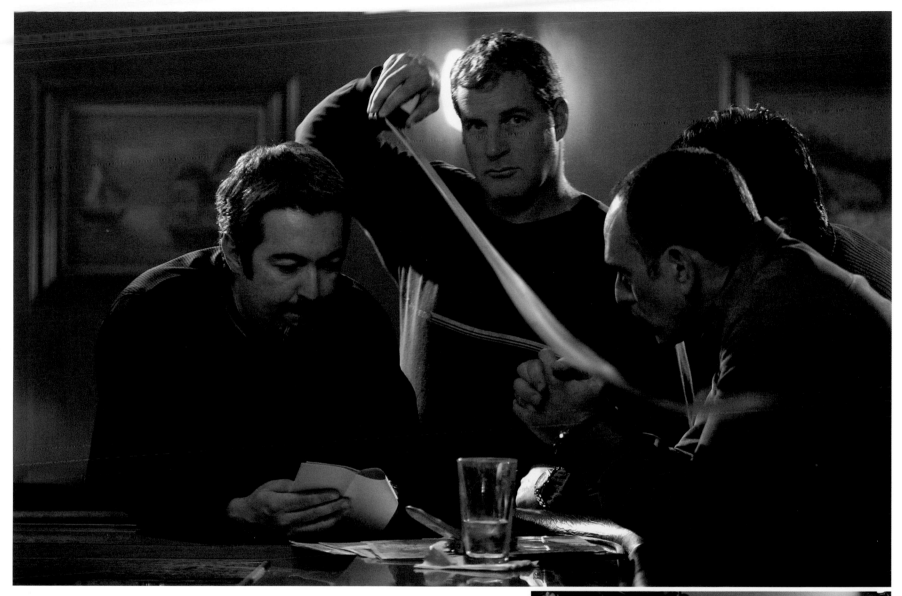

VENTURA

This is actor Nestor Serrano as Navi Araz, the father in the terrorist family. Since he was part of a secret cell, we thought it would be good to film Nestor's scene in a very public, open, traditionally American place—a local bar, which was, in this case, a restaurant in Ventura, California. We picked it because there was an old-world quality to it, and in this particular shot we added an American flag. The idea was to remind everybody that terrorists could be here, under our noses, in safe, everyday places. In the episode, you may have only seen the flag for a second or two, but that's all it takes to get our point across.

BARBECUE

Every year I host a big barbecue for the cast and crew, and this photo was taken during one of those parties. I really enjoy them because it not only allows everyone to let their hair down and relax, but we also can get people together who normally work in separate departments and don't see that much of each other. Second from left, between myself and Joel Surnow, for instance, is our brilliant music composer, Sean Callery, whose contributions are essential to the show but who doesn't work on the stage with the rest of us. Sean, Joel, and I worked together in the past, on the show *La Femme Nikita*, so we all go way back. This barbecue was a relaxed, sentimental moment for all of us.

Above: Kiefer Sutherland makes a call while his daughter, Sarah Sutherland, visits him on set.

6:00 A.M.–7:00 A.M. / RAILROAD TRACKS
Opposite bottom: The 24 camera crew shooting the final shot. Front row (l-r): Jon Cassar, Kiefer Sutherland (Jack Bauer), Isabella Vosmikova, Jay Herron, Bruce DeAragon. Back row (l-r): Rodney Charters, Eric Guerin, Jon Sharpe, Zoli "Sid" Hajdu, Guy Skinner, Martha Cargill, and Carlos Boiles.

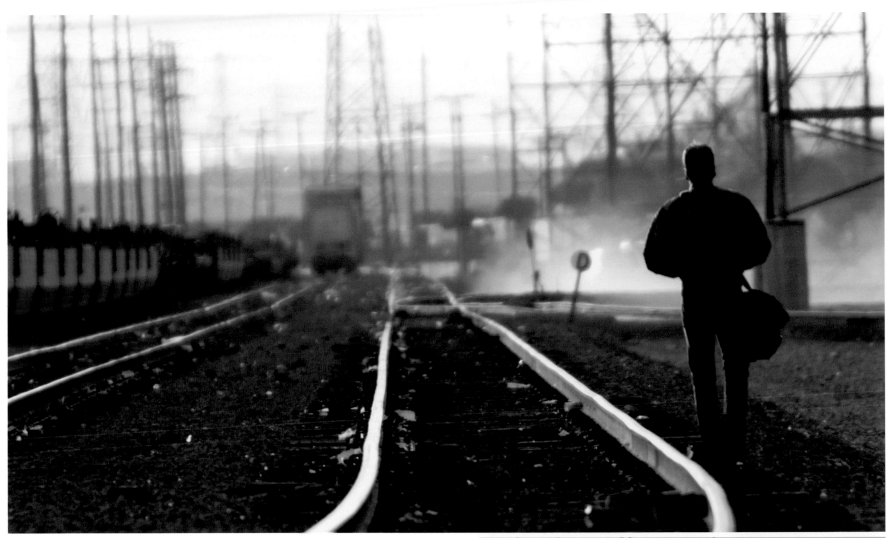

ON THE TRACKS

This famous scene was shot on railroad tracks right near our studio in southern California. That's where we filmed the season-ending shot of Jack Bauer walking down the railroad tracks. It's a celebrated image from our show, which is ironic because it came about somewhat by accident. We started out the season with a train explosion and a crash sequence, and based on that, the promotion department at Fox just happened to put together a poster of Jack's face and railroad tracks with an explosion in the background. When we were first designing the final episode of that season, the end scene called for Jack to go into hiding, and was originally written with him simply driving away in a car. I felt like that was something we do all the time, and thinking of that poster, I came up with the image of a hobo on a railroad track—and I suggested making that our last image of the season. So we scouted these tracks, and went down there to time when the sun went down. It's actually supposed to be dawn in the scene, but it's always difficult to shoot at dawn because the sun comes up so quickly. It's easier to shoot at sunset in that regard, so we timed out the sunset, and figured out when we could get a beautiful backlight. Then we sent our crew down there, praying it wouldn't be cloudy and that we could get a perfect sunset. We did get the shot, thanks to the small camera team we sent out there—all of whom are pictured in the group photo.

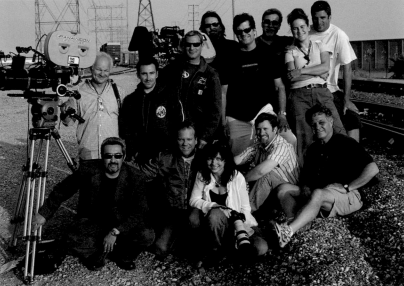

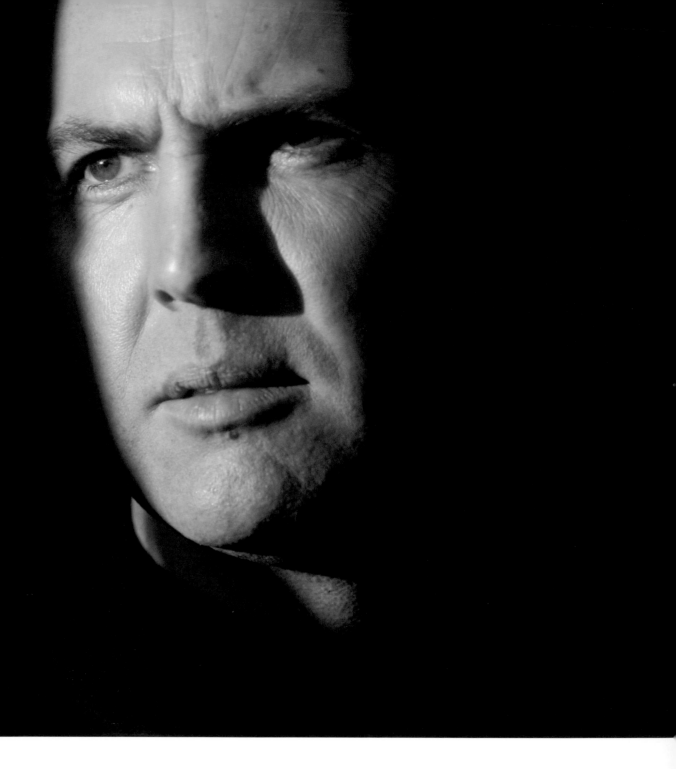

4:00 P.M.–5:00 P.M. / MARWAN'S HIDEOUT
Habib Marwan played by Arnold Vosloo.

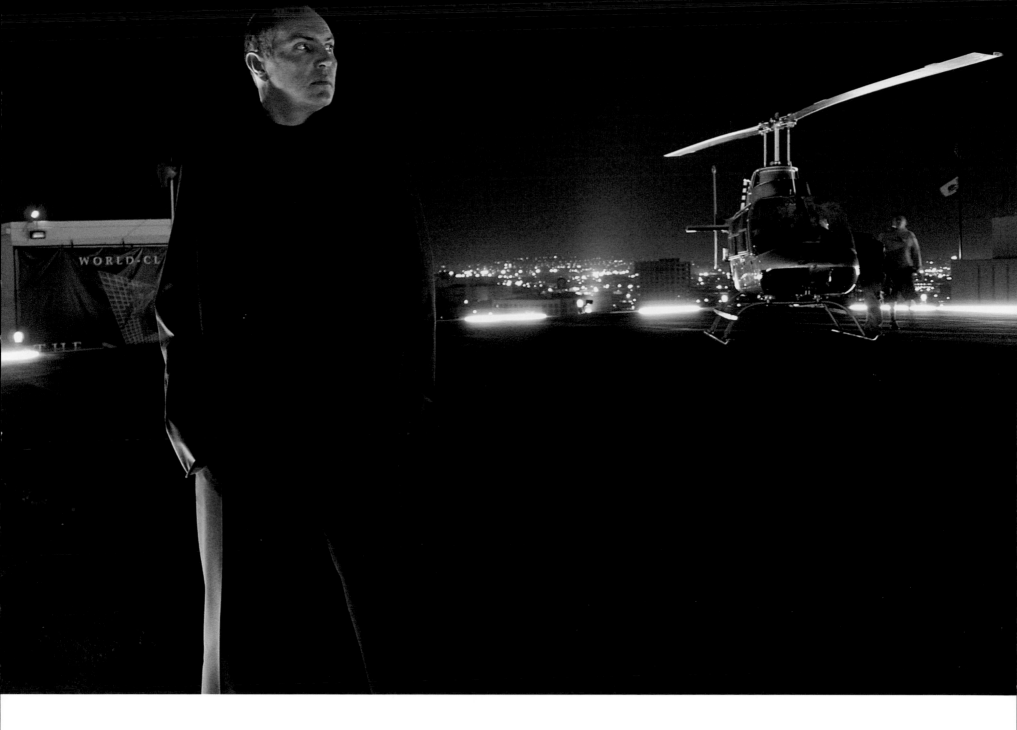

6:00 A.M.–7:00 A.M. / L.A. Rooftop

In interviews, Arnold Vosloo said that he based his character Marwan on his impressions from seeing a photo of 9/11 mastermind Mohammad Atta. Arnold felt that Atta's face conveyed total commitment to his cause. As Marwan, Arnold attempted to express that same level of commitment to his cause through his face.

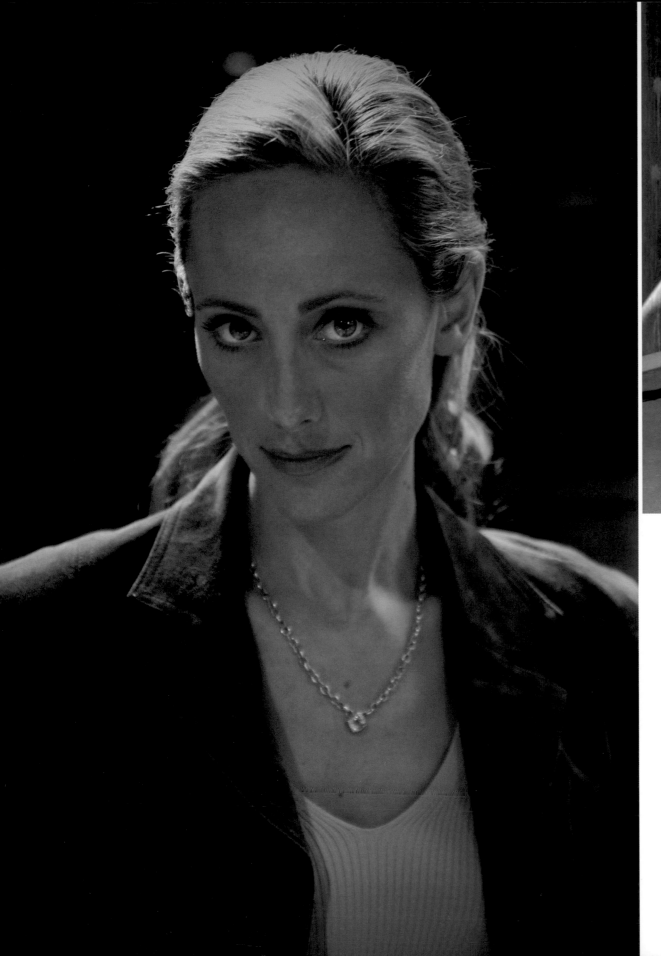

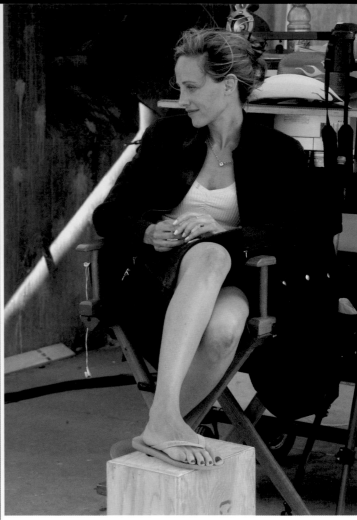

1:00 P.M.–2:00 P.M. / CTU
Left: Kim Raver (Audrey Raines) gets a costume change. The real-time nature of our show means that actors may wear the same costume throughout the season. Here Audrey is wearing a new outfit before she and Jack (Kiefer Sutherland) go to Felsted Security.

12:00 P.M.–1:00 P.M. / TERRORIST HIDEOUT
Above: Kim Raver (Audrey Raines) relaxes on location between takes.

8:00 P.M.–9:00 P.M. / TERRORIST COMPOUND
Audrey Raines (Kim Raver) waits alone in the cell, wondering where her father is.

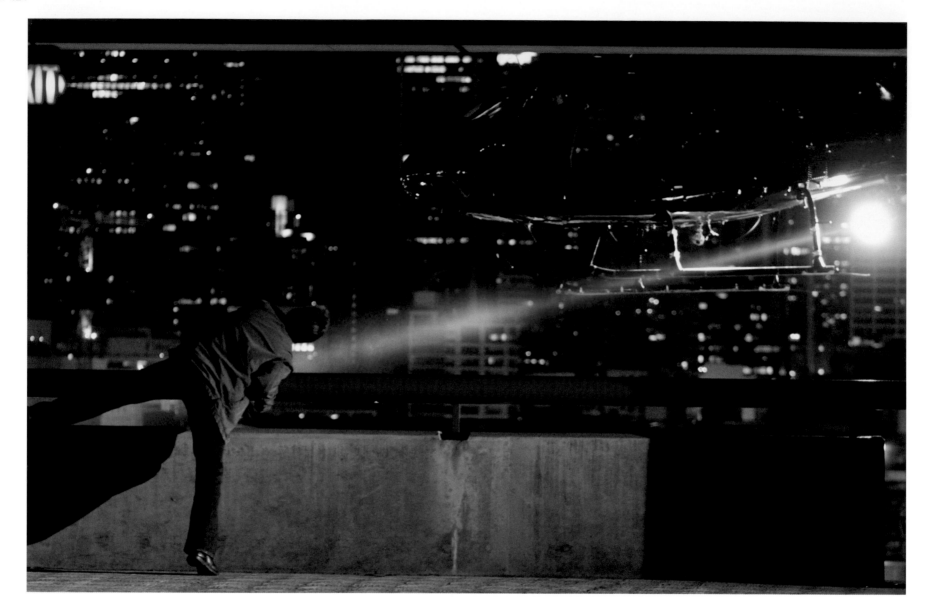

LOS ANGELES NIGHTSCAPE

This is from the season finale—shot on the top of a parking structure that included a spectacular view of the Los Angeles cityscape at night. What's especially interesting about this sequence was that for the first time in *24* history, we captured those images using high-definition digital cameras. The industry as a whole is starting to use those types of cameras for all sorts of applications, but our show's look still requires us to shoot primarily on 35mm film stock. In this case, however, we wanted a night sequence in which you could see a shimmering glow from the city lights, so we did some tests that convinced us we could shoot this scene in HD and capture much the same kind of ambiance that director Michael Mann achieved in his film *Collateral* (shot entirely on digital cameras). The sequence looked exactly as we'd hoped, but as of press time, it is too soon for us to commit to shooting the entire show in HD.

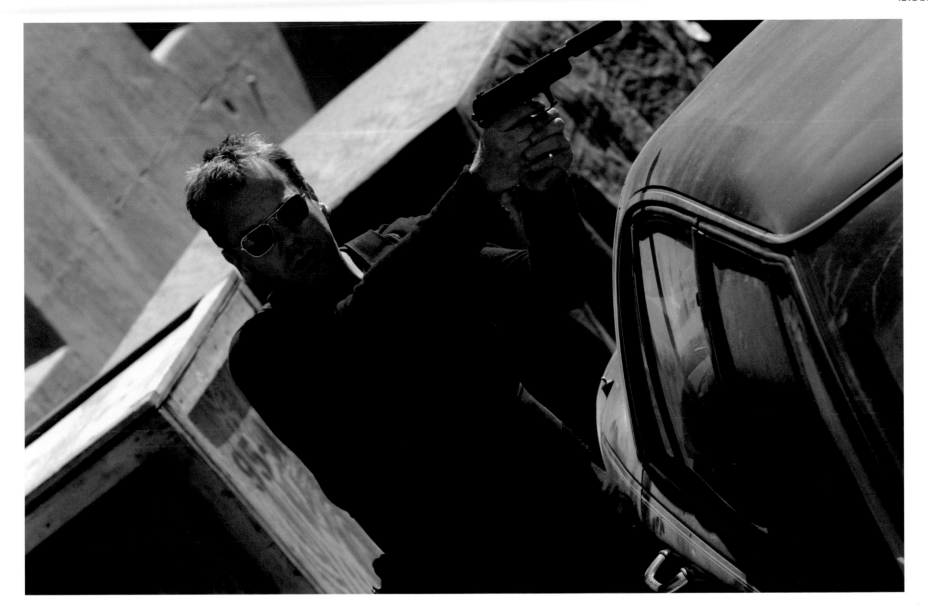

MARKSMAN KIEFER

Kiefer Sutherland is routinely seen using guns on the show, and he has had so much experience with them that he's pretty much an expert at this point. He was already very good with guns when the show began. He can pick up just about any gun, rack it, load it, shoot it. So fortunately, our star is not someone we have to spend too much time training in firearm use.

SEASON 5

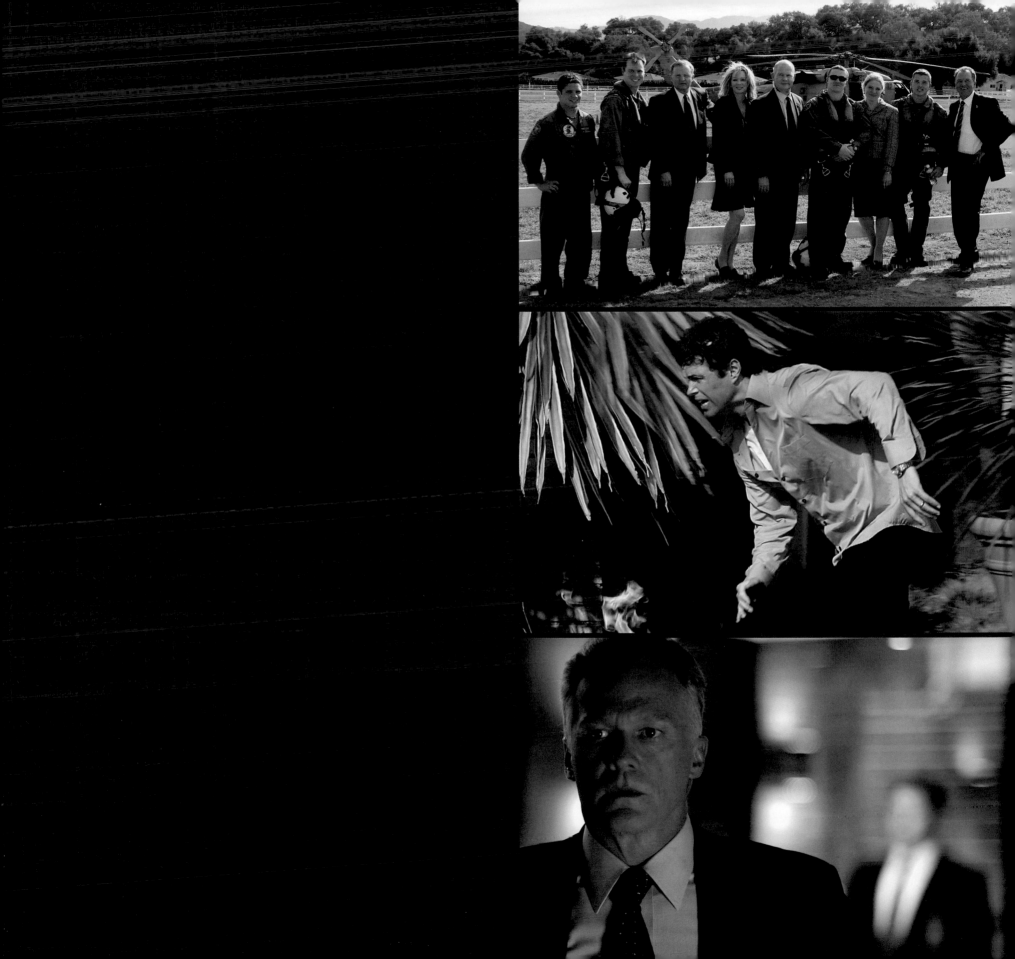

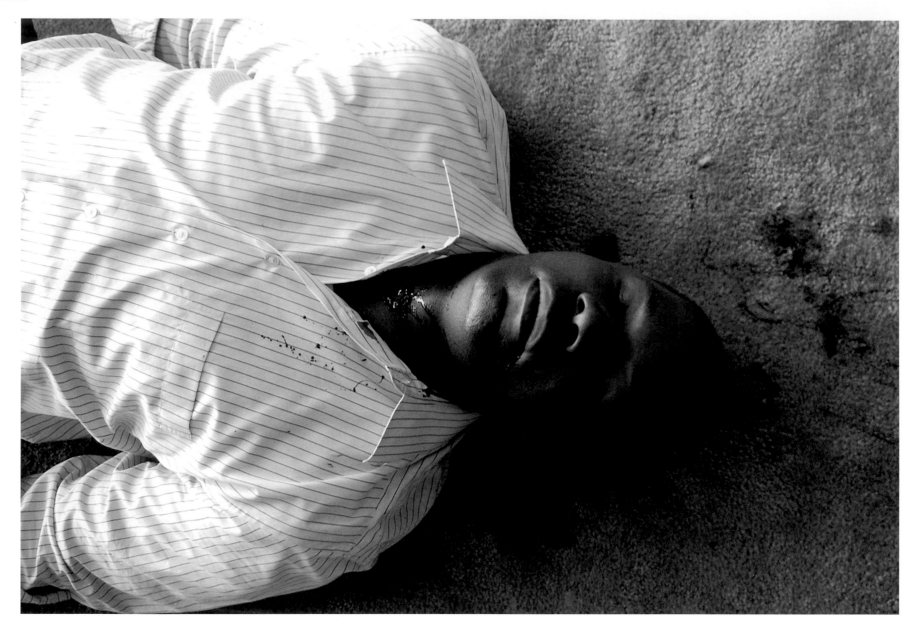

ASSASSINATION

In this scene I wanted to mirror the earlier assasination attempt. Notice that Palmer is lying in the exact position he was in at the end of season two. The one difference is that, in season two, his eyes were open as he fought for his life. Here his eyes are closed, and we as viewers know that his life has come to an end. We decided to go with a milder version of what we did in season two, so we used a camera dolly to re-create the same pull-up we'd done before. But in the edit, we chose not to use that pull-up because it was too slow for the heated pacing of that opening sequence. The black-and-white photo above was taken to be placed on a newspaper front page. You can see the blood spattered around him, far more than what you ever saw on the actual show.

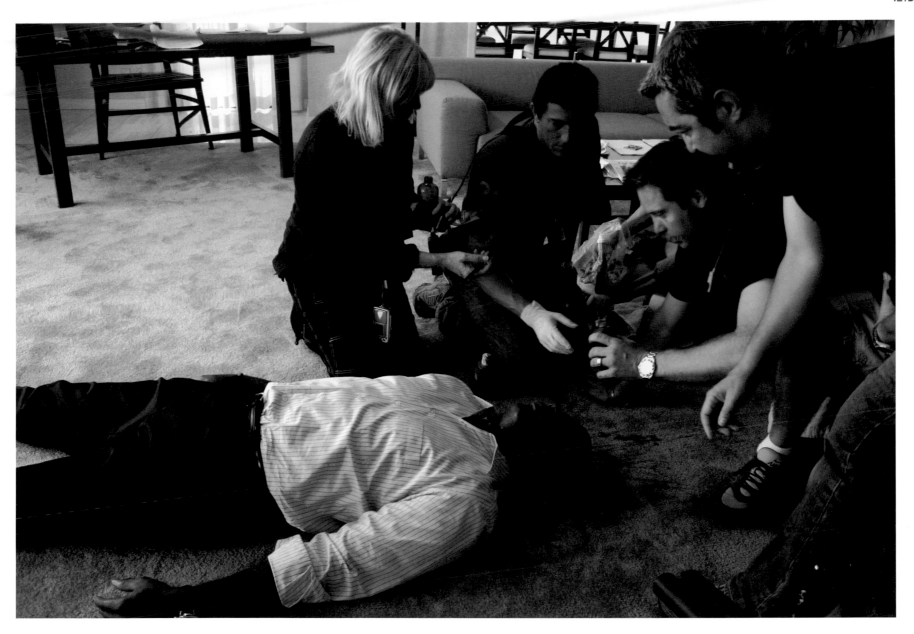

8:00 P.M.–9:00 P.M. / WAYNE PALMER'S L.A. APARTMENT

I'm directing Dee Mansano from make-up, Nick Manno from wardrobe, and Bryce Moore from props to give the scene some of the show's characteristic feeling of intense, in-your-face reality. Palmer was shot through the throat, so we had to make the scene very bloody. The bits of body matter around his head are actually just balled-up pieces of tissue dipped in stage blood.

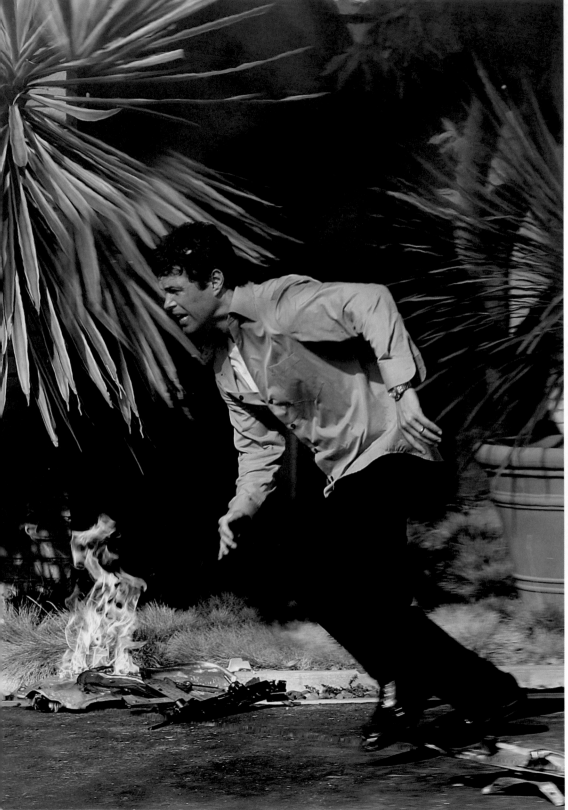

DEATH BY CAR BOMB

This is an exciting, fast-paced shot of Tony (Carlos Bernard) as he races to save Michelle (Reiko Aylesworth) when she is trapped in a car explosion. You can see bits of burning debris spread all around, each of which was separately lit on fire and strategically placed by our special-effects guys, in order to give viewers the feeling that this was a huge explosion. If you remember the scene, it starts with Tony inside, on the phone, when he hears the explosion and runs outside. In fact, we shot the exterior parts of the scene at a rented house in Los Angeles, where we staged a small explosion out front, but we shot the interior part of the scene, where he is on the phone, on a stage. We had to re-create the window from the rented house, which we then blew out on our stage to show when the explosion hit. Shooting action scenes is often just a big puzzle, and this scene was no exception. Action is more complicated to shoot than are full dialogue scenes, because you have to choreograph every aspect of it beforehand. Action has to be painstakingly thought out, shot by shot.

AUDREY RAINES

I captured this image of Kim Raver playing Jack's girlfriend, Audrey Raines, by shooting it under the crook of a crew member's arm. I like it because it is symbolic of our show—our camera often looks past or through something or someone. It's almost a cameo of her, in character and in deep concentration, because she has no idea I'm taking this photo. One of the most complicated parts of writing this show is finding the right love interest for Jack Bauer, and the Audrey character is the most important step we've taken in that direction since the death of his wife. After all, it's very hard to start a love relationship over the course of 24 action-packed hours. Realistically, in that kind of situation no one has much time for romance or falling in love. So we finally figured out that we had to get Jack involved in a relationship that was already established, and in season four we brought in Audrey and established from the first episode that they already had a strong relationship. But it's still hard to show any sort of love scene in this format, which is one reason we gave the audience a hot love scene between Jack and Audrey on the season four prequel that was released on the season three DVD.

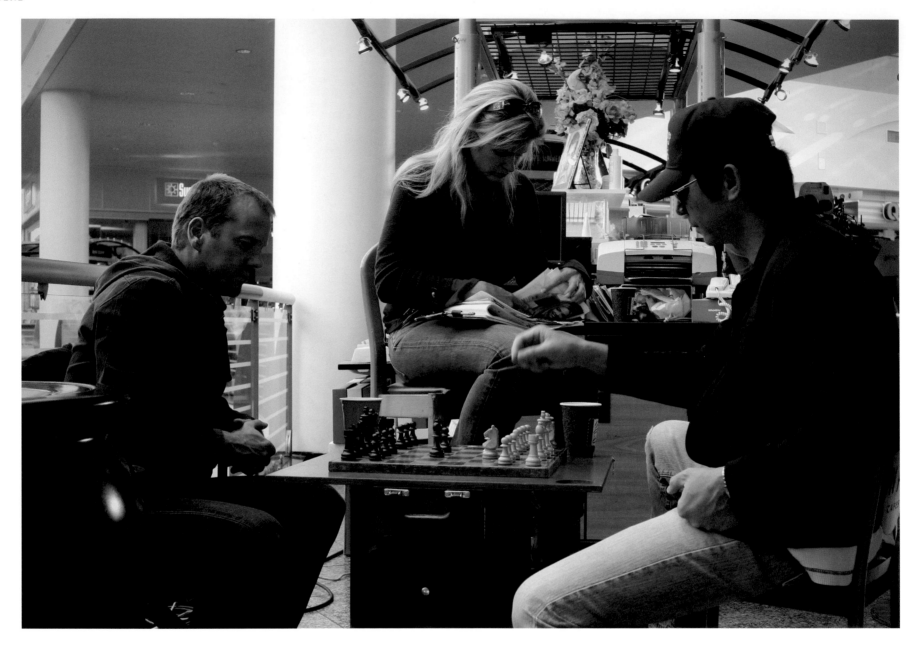

CHESS

Kiefer's big way of relaxing during his downtime on set is by playing chess with anyone and everyone who will take him on. Here he passes the time in between takes playing chess with his good friend Lou Diamond Phillips, whom he met filming the feature *Young Guns*. Although Lou worked on *24* in season one, he was back in season five to watch his young daughter Grace work in her first on-camera role: playing a fainting child whom Jack Bauer saves in the Sunset Hills Shopping Mall. Meanwhile Grace's mother, Kelly, like many people in this industry who spend countless hours on set, uses this time to sort through her mail.

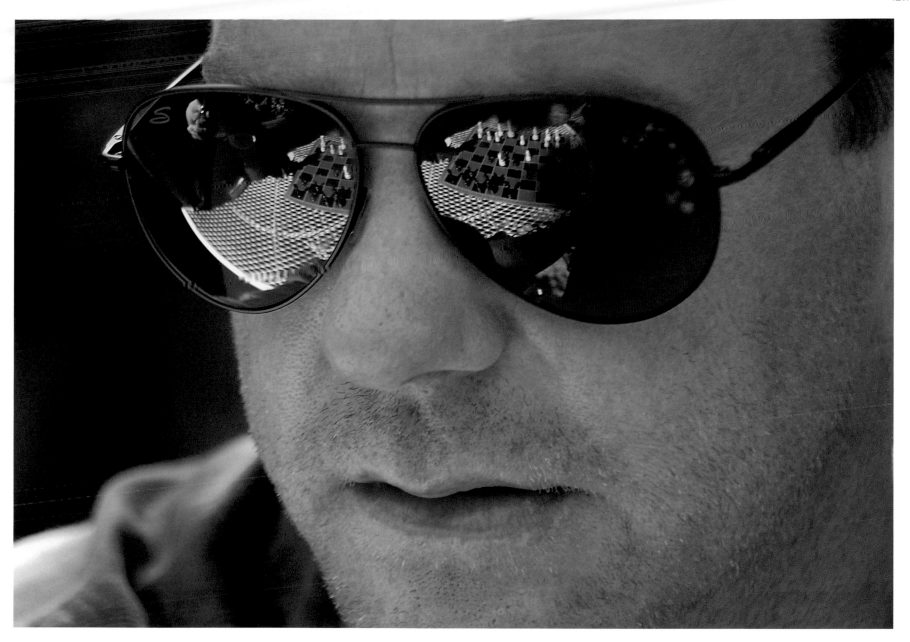

2:00 P.M.–3:00 P.M. / Sunrise Hills Shopping Mall

*Kiefer plays chess so often, in fact, that our crew built him a portable chess
table, which you can see in this shot—it folds together, with the pieces inside,
and can be set up very quickly. We put chessboards all over the set, as well
as at various locations when we're on the road. And Kiefer always finishes
the games—even if he has to stop and go shoot a scene, he'll always return to
finish what he started.*

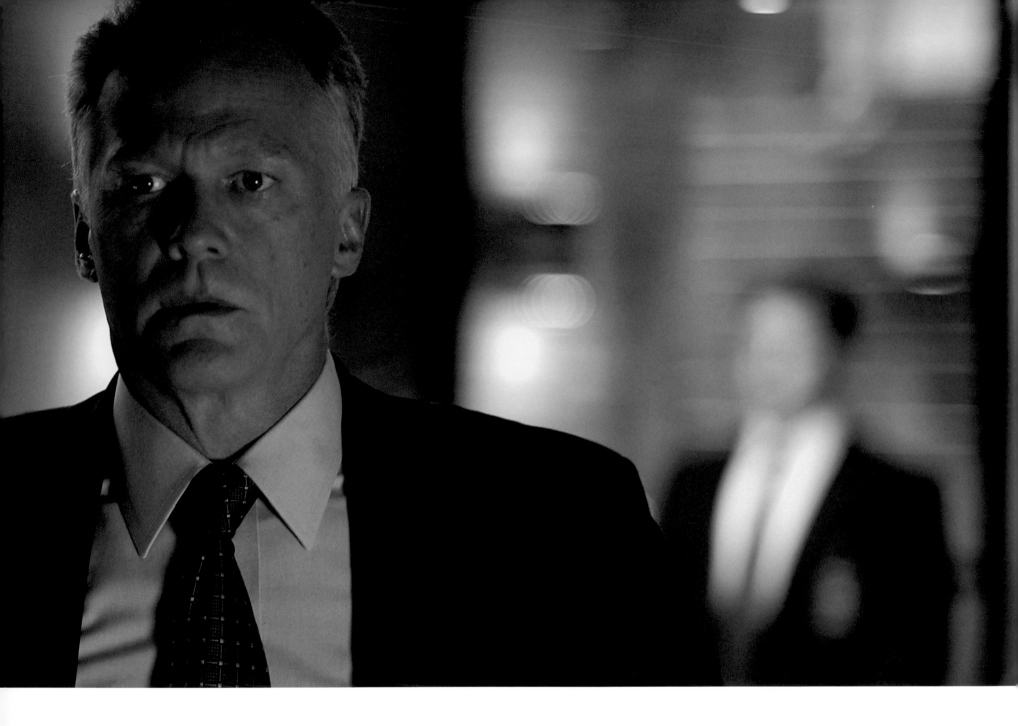

BILL BUCHANAN

James Morrison plays CTU chief Bill Buchanan—another great actor we are fortunate to have on our show. I particularly like this shot, because you can see the Lynn McGill character, played by Sean Astin, standing behind Buchanan, out of focus. That style of photography is indicative of how we shoot the show itself. We use long lenses, which makes the foreground sharp and reduces the depth of field. This technique also adds dimension to the beautiful sets designed for us by Joseph Hodges—they make it feel like CTU goes on forever.

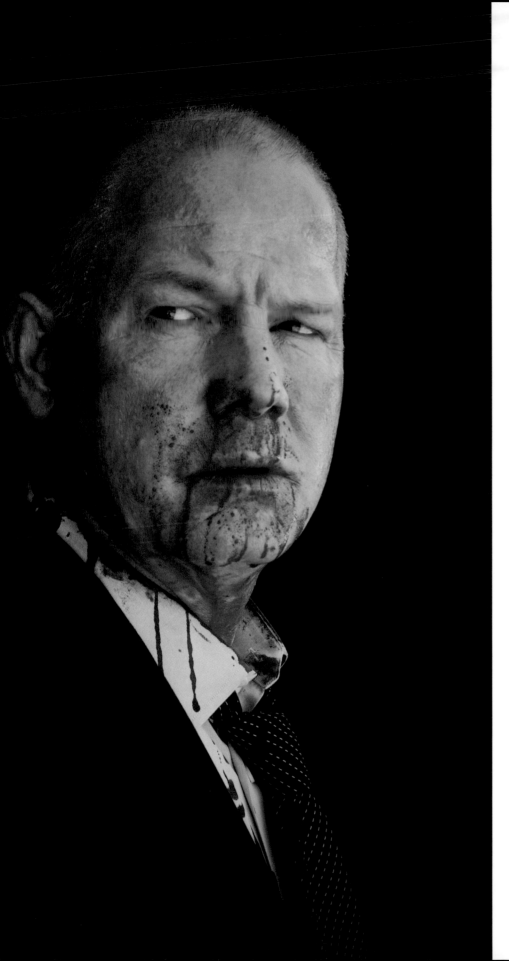

4:00 A.M.–5:00 A.M. / LOGAN'S RETREAT

Agent Pierce (Glenn Morshower) and Jack are the only characters from the pilot that are still on the show. His role this year has blossomed, as his integrity has strengthened. Here he is captured after his miraculous escape from President Logan's henchman, Agent Adams.

SEASON 5

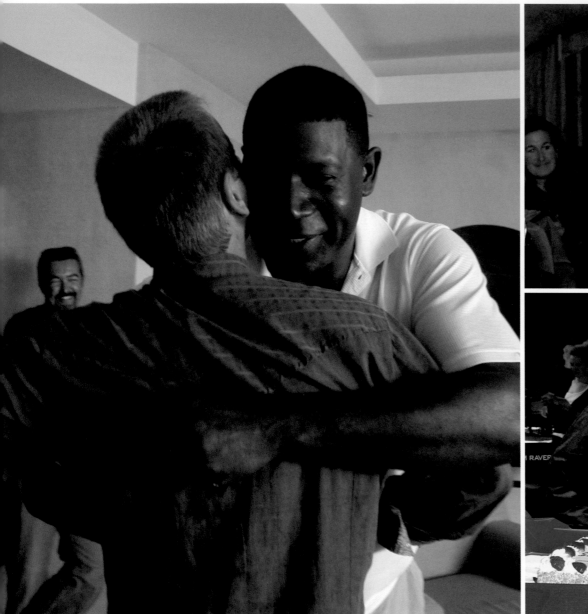

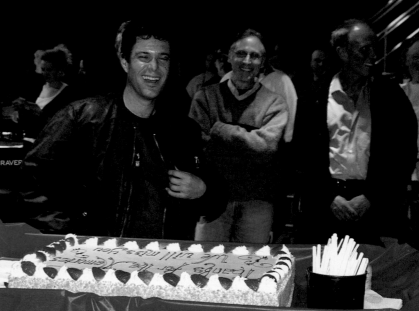

"WE LOVE YOU... DEAD"

Here we see a couple of those sad goodbyes we've all had to say on the show. This shot captures Dennis Haysbert's last day on the show. We had just finished filming his assassination in a loft on Wilshire Boulevard in Los Angeles. Whenever someone is filming their final scene, the assistant director always announces it to the entire cast and crew. Everyone applauds, to acknowledge the actor's hard work. Dennis is hugging Kiefer as we all watch. It was a very emotional moment for both of them—they had worked together for five years. The same thing happened with Carlos Bernard, shown here getting a cake and a round of applause after his final scene. Saying goodbye to these talented members of our team is definitely the hardest part of the job.

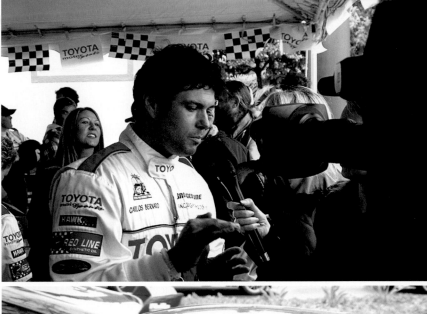

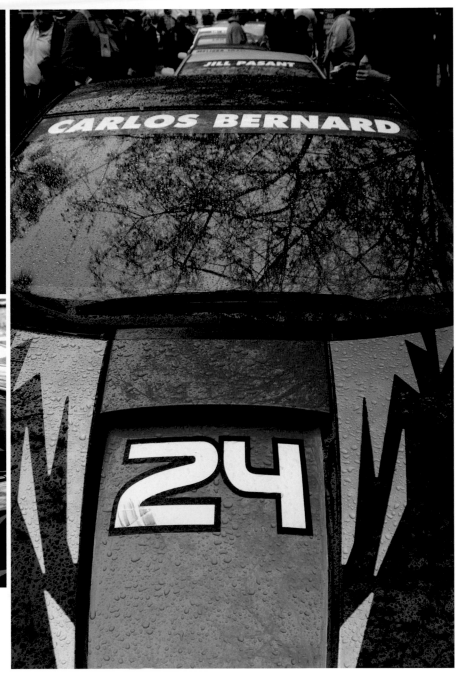

CHARITY RACE

When a show is a big hit like ours, it obviously generates a lot of opportunities for our cast members to get invited to do some very cool things. Here, for instance, Carlos Bernard was invited to participate in the Toyota celebrity car race that takes place every year before the Long Beach Grand Prix. Carlos got me a ticket, and I went down and took pictures of him having the time of his life. Beforehand they trained him for two consecutive weekends as a race-car driver, and then he got to race against other celebrities. Ironically, Sean Astin was also racing that day, although it was before he joined our cast. As I recall, Carlos ended up in the middle of the pack, which was more than enough to give him a big thrill.

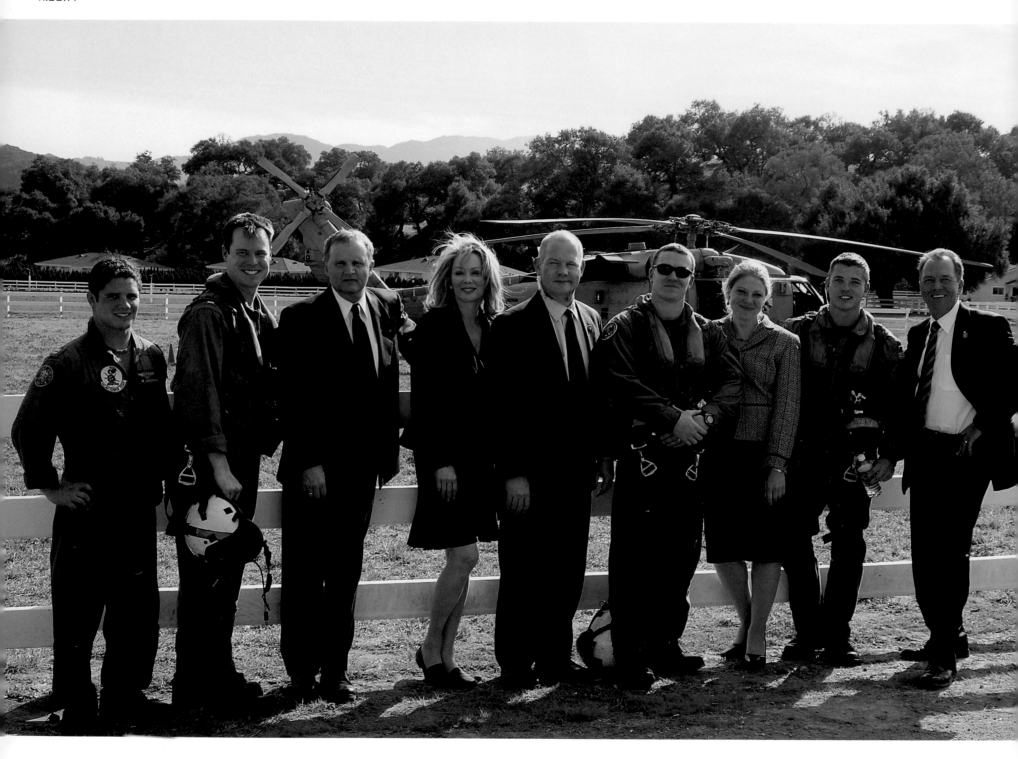

5:00 P.M.–6:00 P.M. / LOGAN'S RETREAT
(l-r in plain clothes) Nick Jameson (Yuri Suvarov), Jean Smart (Martha Logan), Glenn Morshower
(Aaron Pierce), Kathleen Gati (Anya Suvarov), Gregory Itzin (President Logan), and their crew of
Navy helicopter pilots.

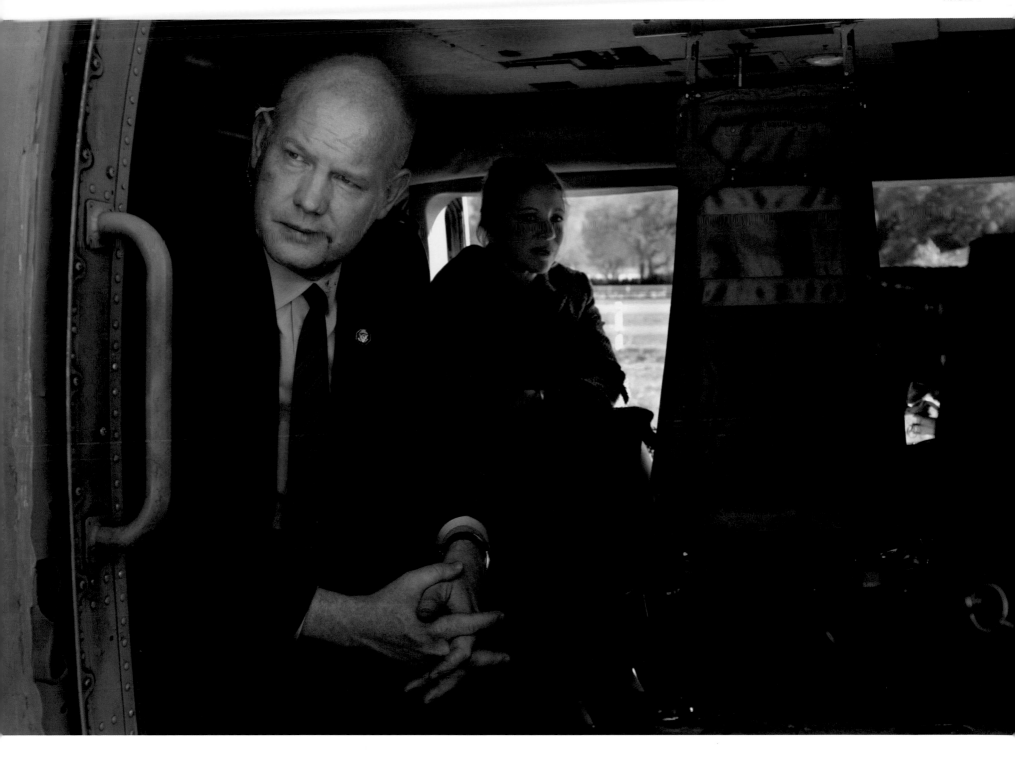

5:00 P.M.–6:00 P.M. / LOGAN'S RETREAT
Secret Service Agent Aaron Pierce (Glenn Morshower) and Russian First Lady Anya Suvarov
(Kathleen Gati) return to Logan's retreat after their motorcade is ambushed and blown up.

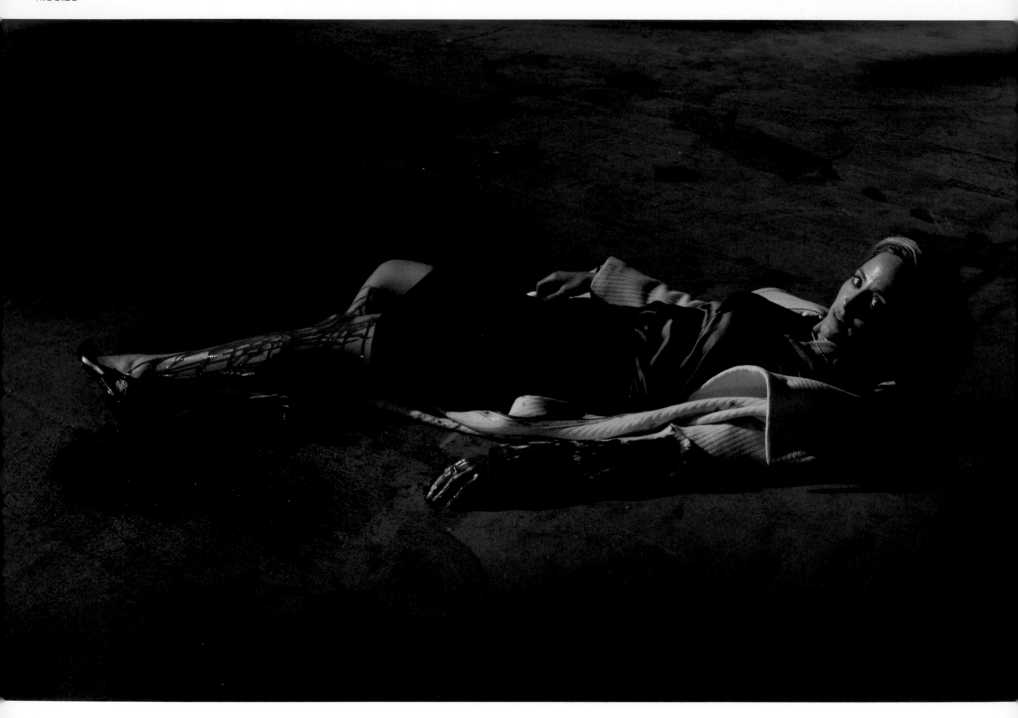

12:00 A.M.–1:00 A.M. / VAN NUYS AIRPORT HANGER
*Traitor and murderer Henderson puts a knife to an artery in Audrey's arm. Kim Raver wanted an
image of herself with all of the blood. This shot has a Cindy Sherman quality to it.*

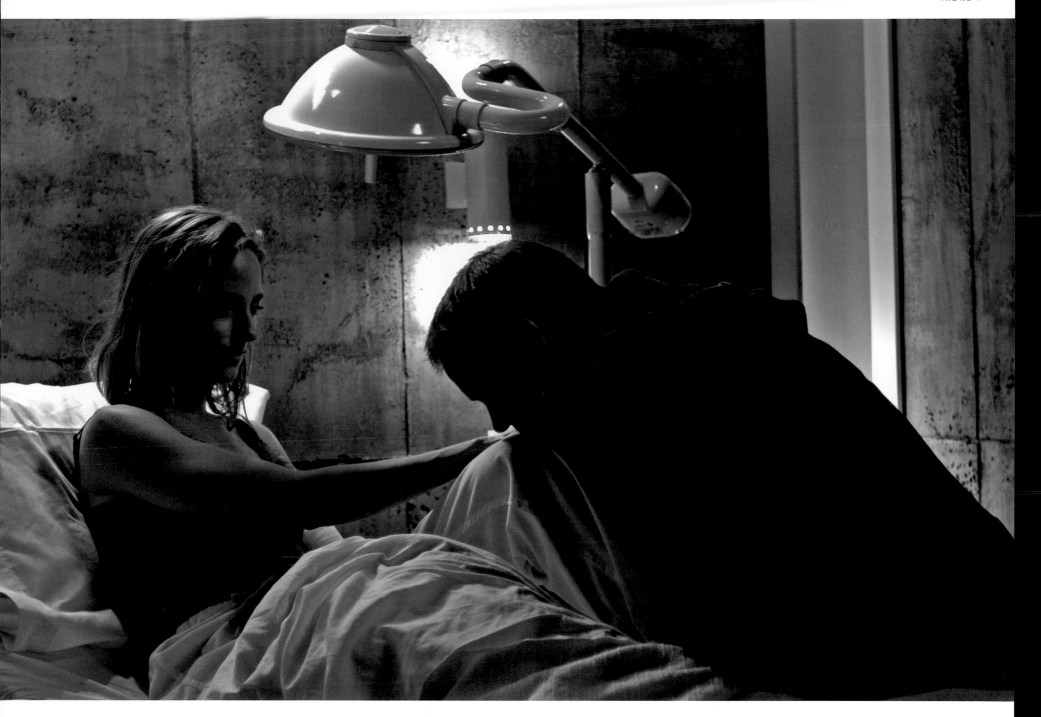

11:01:54

3:00 A.M.–4:00 A.M. / CTU CLINIC

In season five Jack, reunited with Audrey, pays her a visit in the clinic at CTU. Audrey was warmly surprised by Jack's gesture when he first touches her hand.

SEASON 5

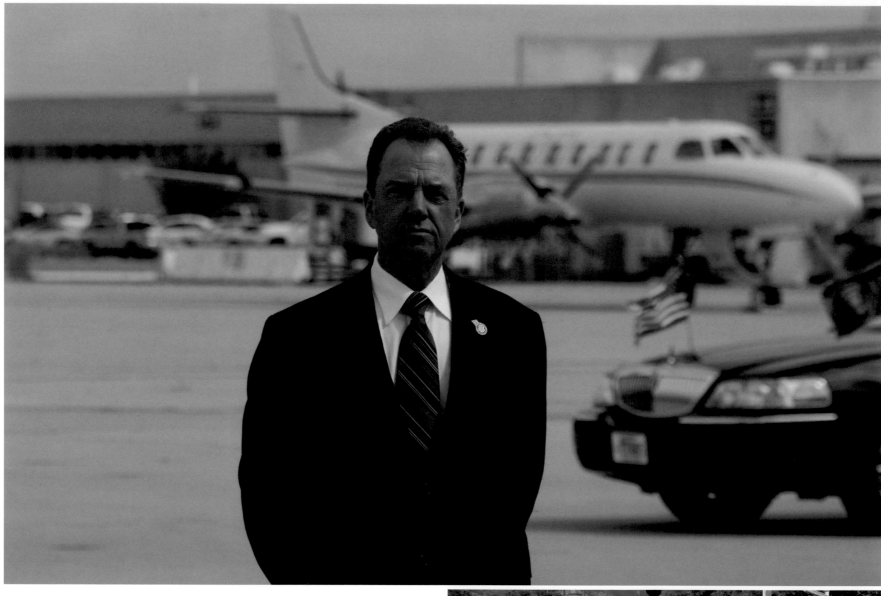

PRESIDENT LOGAN

Gregory Itzin is one of those fine actors that translates a small guest role into an Emmy Award-nominated feature role. He did such a magnificent job in season four as the newly appointed president that the writers gave him a huge part to play in season five.

6:00 A.M.–7:00 A.M. / AIRFIELD
Right: Jean Smart (Martha Logan), Jude Ciccollela (Mike Novick), and Gregory Itzin (President Charles Logan) preparing to shoot the Farewell to the President scene at the airfield.

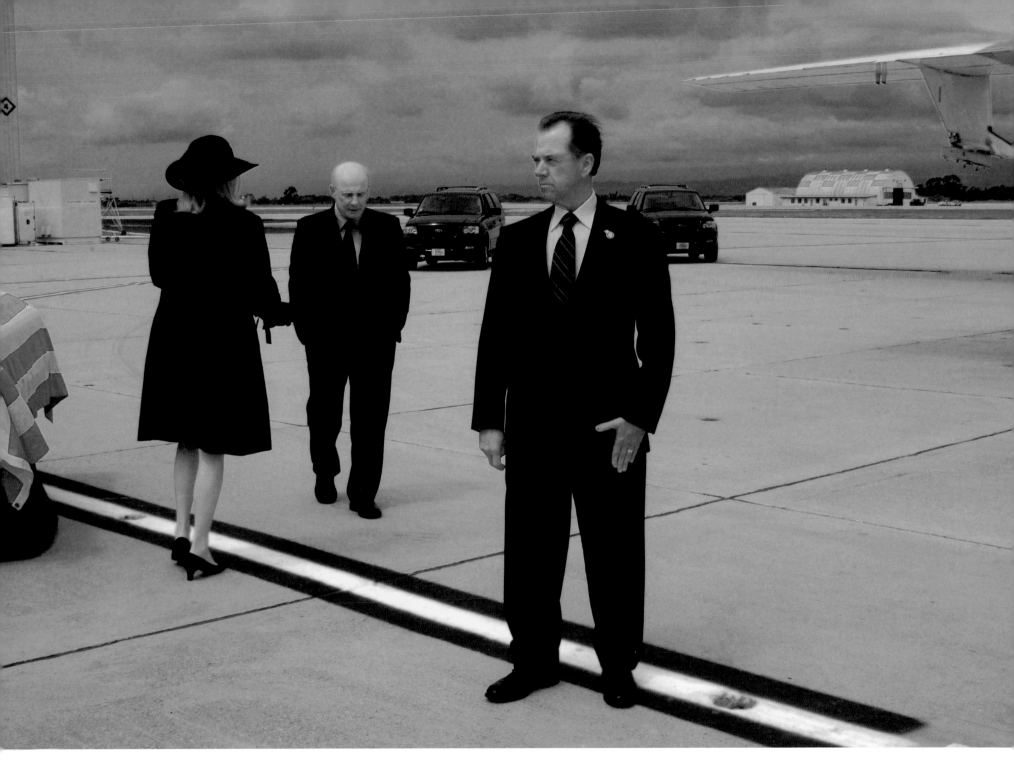

5:00 A.M.–6:00 A.M. / Logan's Retreat *As Gregory Itzin and Jean Smart play out a love scene in episode 23 of season five, they have to share their bed with camera operator Guy Skinner and focus puller Jon Sharpe. This picture shows why love scenes are never quite as romantic as they may seem.*

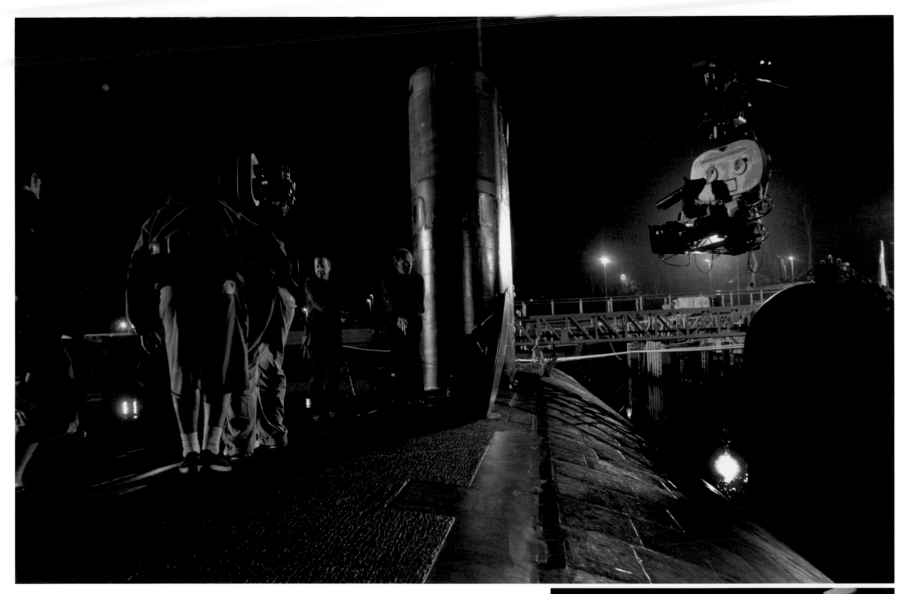

6:00 A.M.–7:00 A.M. / LOMA POINT US NAVAL SUBMARINE BASE
SAN DIEGO, CALIFORNIA
Above: "Jack and Henderson board the sub. It was an incredible experience to be able to shoot on a nuclear submarine. This one is a Los Angeles class attack sub capable of firing Tomahawk missiles and torpedoes. As we learned in the torpedo room, Toma-hawks can be fired from the torpedo tubes. We used a Technocrane because it allowed us to be based on the dock and then to extend out over the sub to a distance of 50 feet. It is carrying the C-camera mounted on a remote pan and tilt head. At the last minute it was determined we could not successfully attack a US sub on US soil so it became a Russian Sub, the Natalia."–Rodney Charters (From left to right Eric Guerin, Carlos Boiles, Guy Skinner, Kiefer Sutherland, Peter Weller)

6:00 P.M.–7:00 P.M / BIERKO HIDEOUT
Right: British actor Julian Sands plays Vladimir Bierko, the character behind the nerve gas attacks on L.A. in Season five.

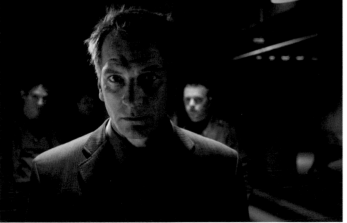

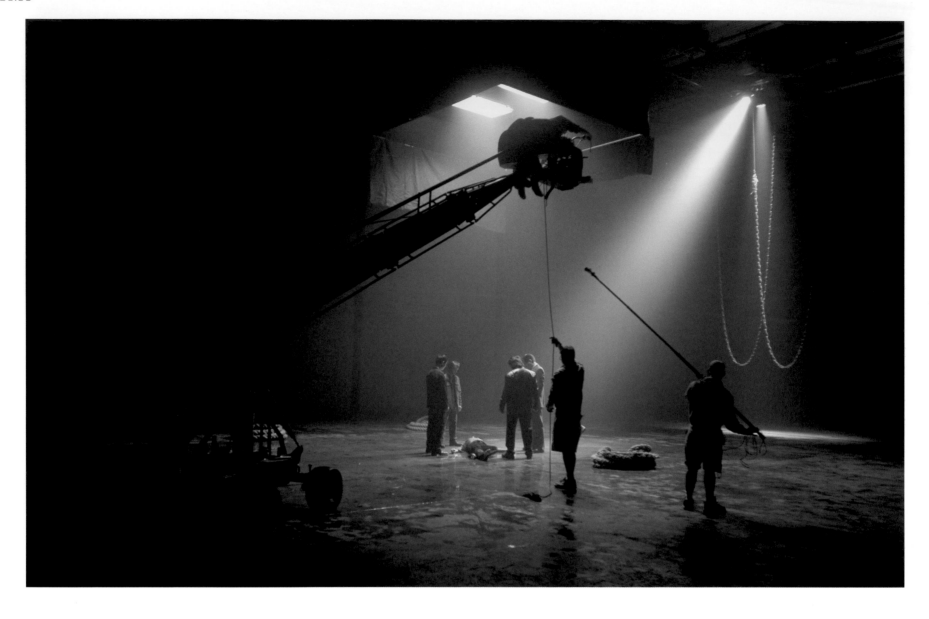

LAST DAY OF SHOOTING SEASON FIVE

This is the final scene in the fifth season. We shot it in a huge warehouse space at the old L.A. Times building that doubled well as the hold of a Chinese ship. It was cold and wet, and Kiefer had to roll around in a puddle to soak his wardrobe before each take. It was hard to watch because Kiefer was so convincing in playing the pain. The make-up too was very convincing. Ania did a fantastic job.

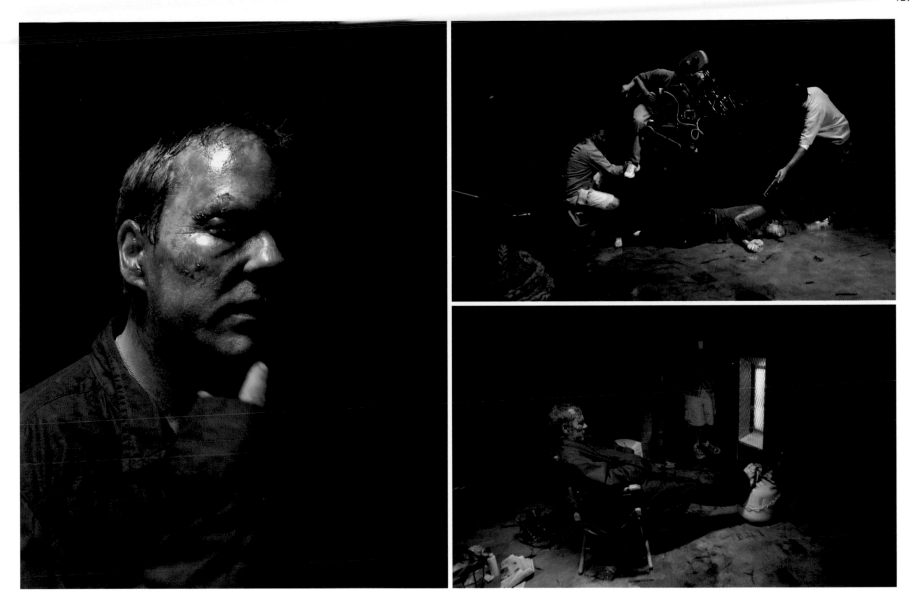

5:00 A.M.–6:00 A.M. / CHINESE FREIGHTER *Above: Kiefer in his beat up makeup. The final scene of the season called for Jack Bauer to be beaten within an inch of his life. Make-up artist Ania Harasimiak did an outstanding job, reducing Kiefer's handsome face to a bloody pulp.*

5:00 A.M.–6:00 A.M. / CHINESE FREIGHTER *Top right: To simulate the inside of a huge ocean freighter we shot inside a large warehouse in the old L.A. Times printing facility. The black marks on the ground are ink stains left over from the space's printing days. Notice the big roll of thick rope, a little visual clue for the audience to hint at Jack's whereabouts. This is another rare crane shot for 24, it was Jack's final shot of the season and I wanted it to blend into the helicopter shot of the slow boat to China.*

6:00 A.M.–7:00 A.M. / CHINESE FREIGHTER *Bottom right: Kiefer Sutherland (Jack Bauer) still in his beaten-up makeup warms up as the season winds down to its final scene. Two second assistant directors, Rebecca Gaither and Scott Remick, stand nearby.*

Top left: The happy creative team. There is always a great sense of relief when the season is finally over. Writing and creating twenty-four good epsiodes of 24 is a daunting and difficult job, with very little rest between seasons. But the smiles show that the end is in sight and now it's time for a little down time. Back row: Robert Cochran, Jon Cassar, Howard Gordon, front row: Nestor Serrano, Joel Surnow, Gregory Itzin and Sean Callery.
Left: 24 is produced by 20th Century Fox and Imagine Television. Producer Brian Grazer from Imagine visits the set and chats to actor Gregory Itzin.
Above: A great portrait of Kiefer captured by Fox producer Bruce Margolis. Bruce shot it on the last day and I think it represents Kiefer's cry for the upcoming freedom of the hiatus.

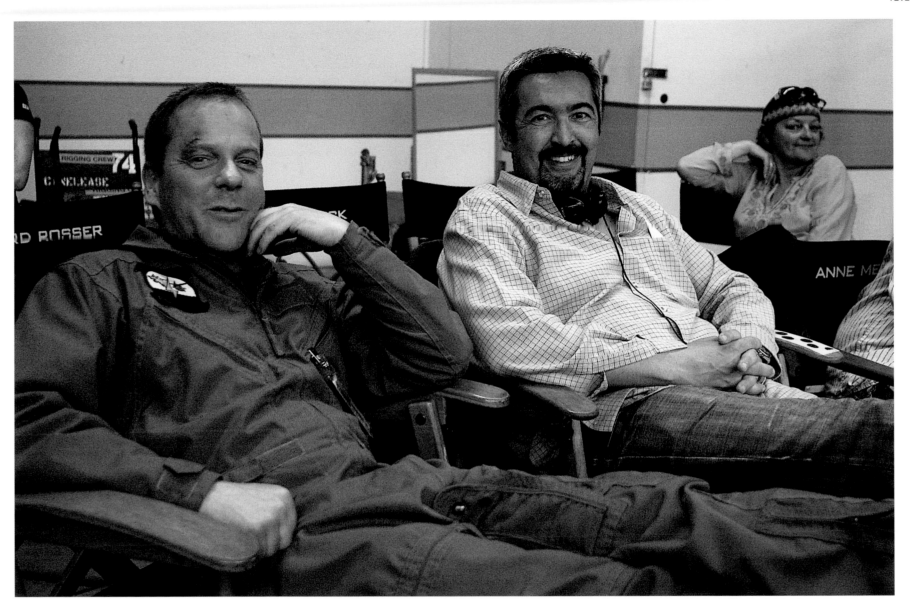

Kiefer and I are about to shoot his last scene on the last day of shooting. We both look like a huge weight has been lifted off our shoulders. We both agree it's the only day of the year when we're both not worried about the next day's shooting. Notice the tape on the arm of my chair; it's a visual countdown of how many days are left to shoot. Only one half day is left to be crossed off.

Making 24

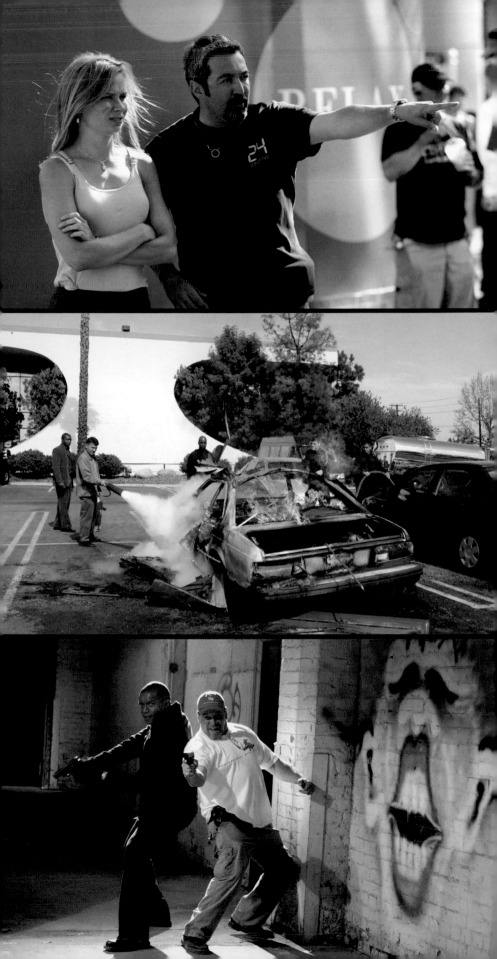

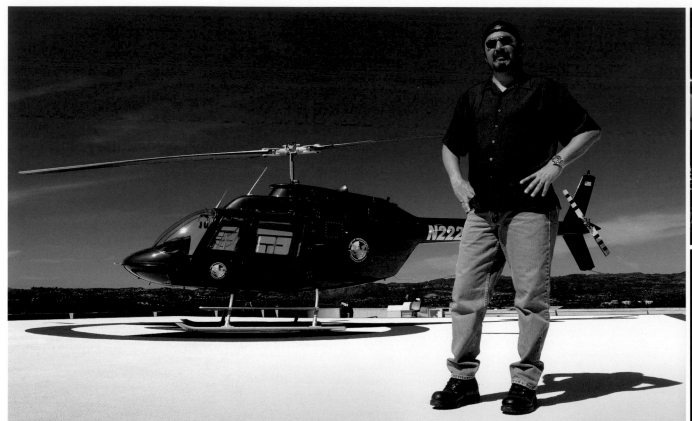

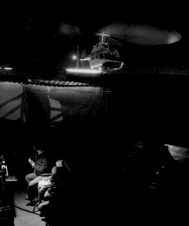

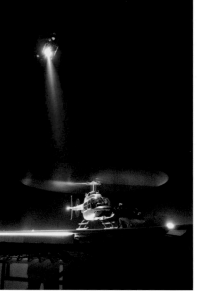

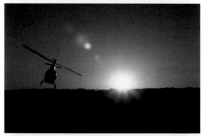

HELICOPTERS

I doubt there is a show on television that does more regular helicopter work than ours. The most important thing about filming helicopter stunts for television is to get the very best pilots, and we have the best around, John Tamburro and his brother, Chuck. They are Hollywood's leading aerial specialists when it comes to helicopters. In these photos, we were filming the climactic sequence from season four. We placed our camera crew directly under the helicopter blades, and in this shot, you can see another helicopter hovering above the first one.

Above right: It looks like the photo was put together digitally; in fact it was simply how the light was falling on that particular night. Me and a few other crew members were on one level of the parking garage watching monitors of the filming, while the helicopter landed on a pad literally right above us. When filming helicopters at night, you're limited as to how much lighting you can use, so we put down some fluorescent lights and got a little additional light from one of the adjacent buildings. As you can see, in this particular case my crew isn't so much "behind the scenes" as "just below the scenes."

Below right: The crew doing what we call "a wet-down." Anytime you work with helicopters you have to have a water truck present to wet the ground before the helicopter approaches. In this case we were shooting in the middle of the night in Valencia, California, which was doubling for Mexico. It so happened that there was this big, beautiful backlight shining when they started spraying the ground, just when Rodney was taking this picture.

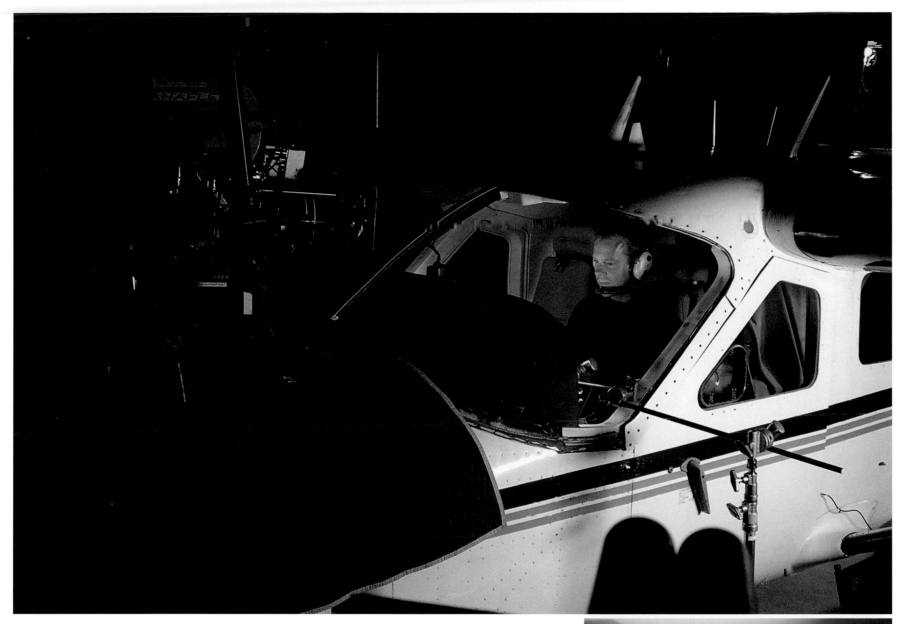

COCKPITS

Despite all of our helicopter work, we very rarely take actors other than stunt people up in flying vehicles—we almost always fake it. The picture on the right shows the regular helicopter shell that we use for filming actors "inside" helicopters—it's basically an elaborate prop, a real fuselage with no engine in it. That's the one we use when we show our actors in the air, and also when we want to show a helicopter on the ground at a crime scene or a crash. The photo above, taken from the scene in which Jack is flying a plane with a nuclear bomb on board, illustrates the same concept—this time Kiefer is in the "cockpit" of a small airplane. We put him in the shell of a real airplane, but we never had him in the air.

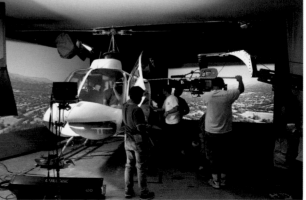

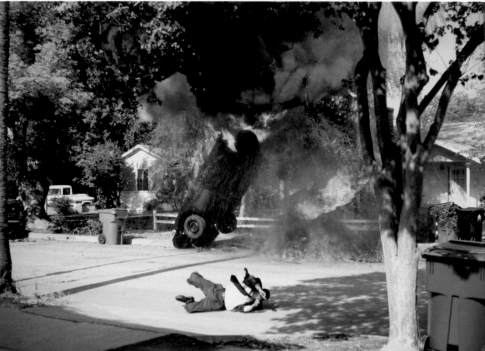

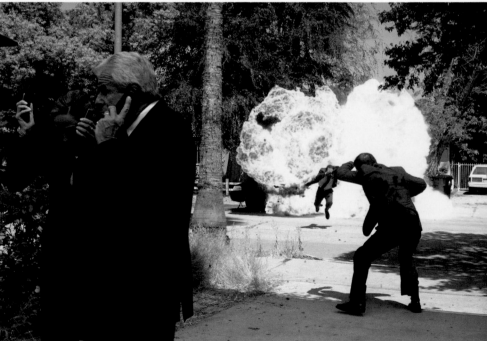

SPECIAL EFFECTS AND EXPLOSIONS

The attack on the limousine of Secretary of Defense Heller (William Devane) was a carefully staged explosion; the explosion was designed to flip the car and have it land on and crush the green garbage can on the left. The car was chained to the ground so that it would not go completely airborne. The stuntman was covered in a special cooling gel to protect him from getting second degree burns. This action occurred on a suburban street in Los Angeles when Heller and Audrey Raines (Kim Raver) went to visit Richard Heller (Logan Marshall-Green, not pictured).

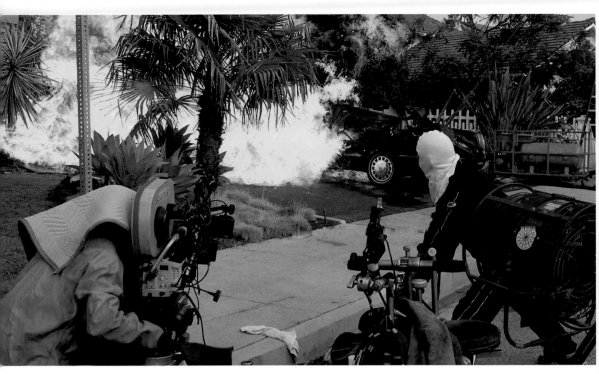

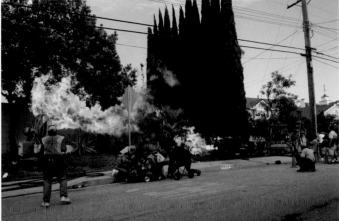

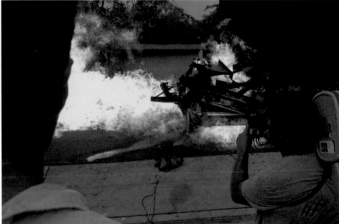

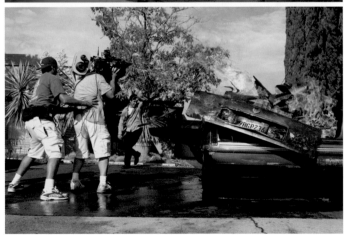

MICHELLE'S DEATH

This was a major explosion we staged for a very important sequence—the car bomb that killed Michelle Dessler. One of the hardest things to do with a sequence like this is to find a location where the scene would be both believable and safe for our cast and crew. In the photo above right, you can see a giant fan on the left side. That's used to blow fire away from the stunt people, creating a little pocket of air for them. In this case, when I called "cut," one stuntman did have some flames on him, but all stunt performers wear fire-resistant clothes, and we had safety procedures that protected him from any significant injury. You can also see that our camera operators, even the dolly grip, wore fire-retardant hoods, jackets, or blankets when filming the sequence. Even when you are well out of the way of the fire itself, the heat is extreme, so we always take the proper precautions. Still, there's no doubt that our crew can feel the heat when they're doing this work, even though it's all very safe because we don't really blow up anything in these situations—they're all just elaborate propane explosions, like in a big fireplace. A propane mortar shoots propane into the air, and we light it to create a fantastic fire effect. The wrecked car was already designed and prepared as a damaged vehicle, so we never blew up an actual car. It takes an incredible amount of planning and detail to pull off something like this, and we usually have to schedule an entire day around this kind of stunt.

SEASON 5 7:00 A.M.–8:00 A.M. / TONY AND MICHELLE'S HOUSE *The 24 film crew's perspective of the explosion's effects from behind the two cameras.*

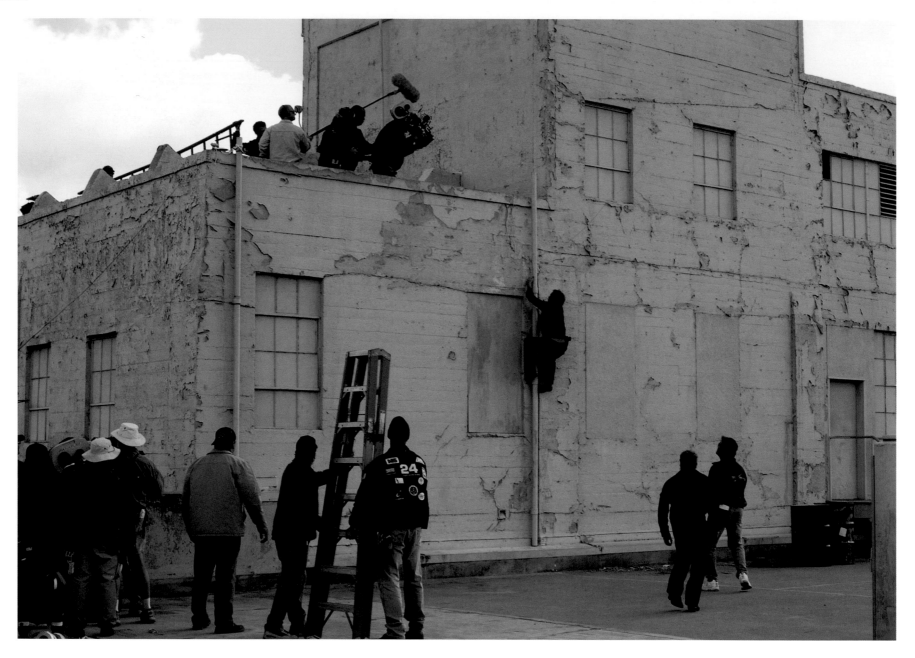

STUNTS

In the picture above, Kiefer is climbing a drainpipe; yes, that's Kiefer. He does about 90% of his own stunts. In this case, we designed and built a sturdy reinforced drainpipe to affix to the building's exterior for Jack to climb up to the second story. The original plan was to have his stuntman, Matt Taylor, do the shot (you can see him on the ground, wearing the same clothes as Kiefer and watching the climb alongside stunt coordinator, Greg Barnett), but when we got on set, Kiefer insisted on doing the climb himself. So I called "action," and he scaled that building and went right over the top in a single take.

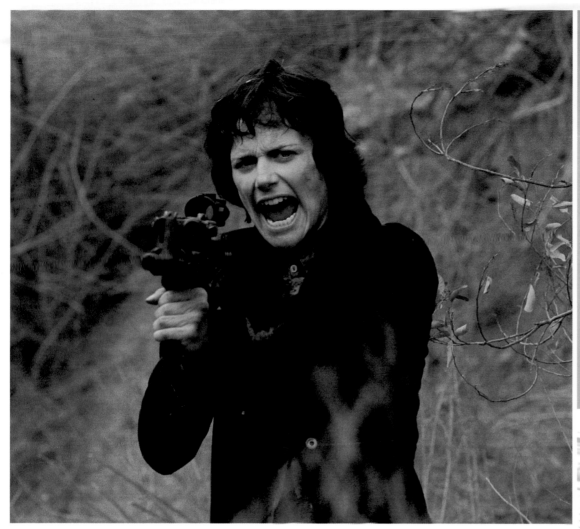

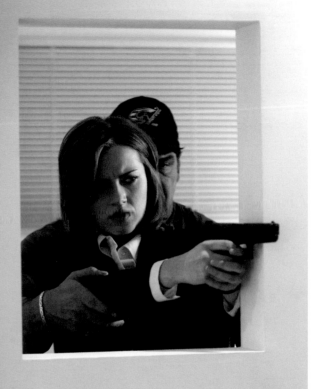

GUN TRAINING

Our prop assistant, Michael Pat Lugar, teaches actress Dagmara Dominczyk how to point and fire a weapon as if she were an expert, top right. Many cast members have very little if any experience with guns, but their characters are supposed to be spies or assassins, so we take great care in using Michael Pat's expertise to instruct them. The photograph to the right shows me directing actress Gina Torres in how to use her weapon during the crucial season three sequence in which she guns down Sherry Palmer, a pivotal story line in our show's history.

The photo above depicts Sarah Clarke, who played Nina Myers, during a scene from season two when she confronts Jack with a big, menacing gun. It's ironic that although Sarah played a ruthless, trained killer, she knew nothing about guns, and we had to train her from scratch to shoot.

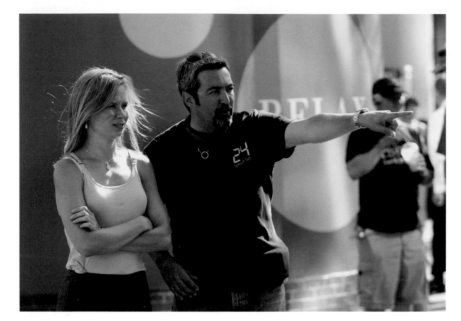

DIRECTING

When we're shooting action, the actors have to really trust their director, and here Mary Lynn Rajskub, playing Chloe, is doing just that. It's a scene in which I'm directing her to run across the street as a group of stunt drivers manage to barely miss hitting her for a sequence designed to look like a very close call. So here I am, promising her that they won't hit her and that everything will be fine. As it turned out, the sequence never made it into the episode—we cut it so that you never saw her crossing the street, which is a shame because Mary Lynn did a great job in that scene. Although she's a comedian by training, she proved that she can do some very physical action. Some characters don't get out of CTU very often, so you never know which actors can do action and which ones can't. As it turned out, she can.

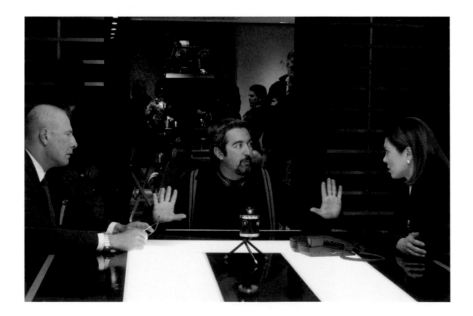

Joseph Hodges took this beautiful photo of me directing Mary Lynn Rajskub through blinds in a window on our CTU set. What I like about this picture is that Joseph photographed it the way he designs sets and the way we shoot many scenes in CTU—from the perspective of looking through something. In this case, he caught a moment in which I'm discussing the story with Mary Lynn during a rehearsal. You can tell it's a rehearsal because I'm close to her. I'm always right there with the actors during rehearsals—I'm next to the monitors only when we are actually filming.

Left: I'm giving final instructions to actors Jude Ciccolella and Michelle Forbes, who are playing presidential advisors on the opposite sides of an issue. The idea was to physically position them to represent their disagreement. It's interesting what we can do with the physicality of actors in that respect. I took the seat where President Palmer would be, and I explained to them that they were positioned as though they were opponents in a chess game. Directors must think about body placement as much as we do about the delivery of dialogue.

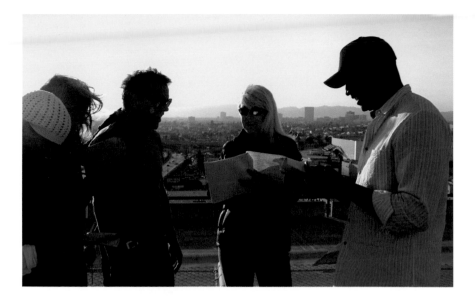

Here are some of the actors (Kiefer Sutherland and Roger Cross) and crew (script supervisor Anne Melville in the middle, assistant director Nicole Burke on the far left, and off-camera reader Marci Michelle) going over dialogue for a scene—in this case, for the finale from season four. We are rehearsing what is going to happen inside Jack's helicopter as he rushes to chase down Marwan. It will be a night scene, but we rehearse it while it's still light out so we can start shooting the minute it gets dark.

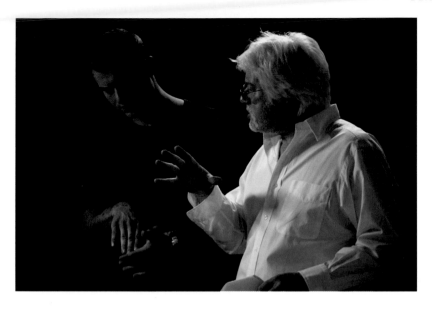

Ian Toynton, on the right, directing James Badge Dale in a scene from season three. Ian is an excellent director who worked on the show until he left to be a producer/director on *The O.C.* We were all sad to see him go because he really understood the show. You can see incredible concentration coming from both the director and the actor in this photo.

Bryan Spicer, shown here to the right of Kiefer, is one of the guest directors we really enjoy working with. Here you see him discussing how to film a scene in which Jack tries to trade himself for the character Behrooz. Again, they are planning how things will play out while it's still light, but they will start filming as soon as the sun goes down. Bryan and Kiefer are walking the scene and deciding where everyone should be placed. Kiefer normally provides a lot of this kind of input.

This is a nice portrait of Brad Turner, our show's other regular director/producer and one of the leading creative forces on *24*.

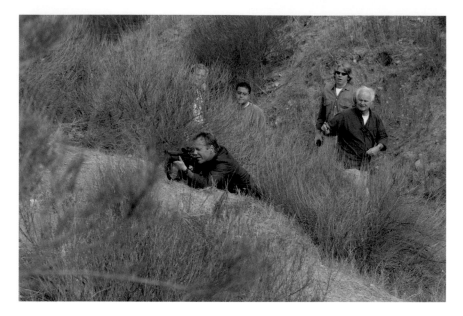

CINEMATOGRAPHY

Rodney Charters has been the director of photography on 24 for all five seasons. Not only is his job to set the lighting for every scene but he must know the cameras and the images that they can produce, and where to place them. In the picture above Rodney walks the crew through a shot over Kiefer's shoulder as he engages in a firefight. On this particular episode he was also directing.

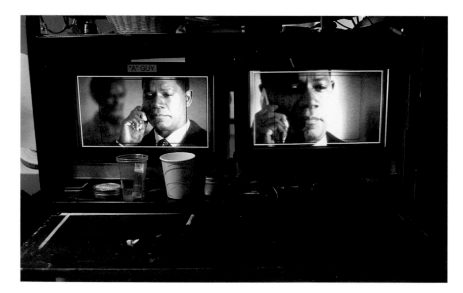

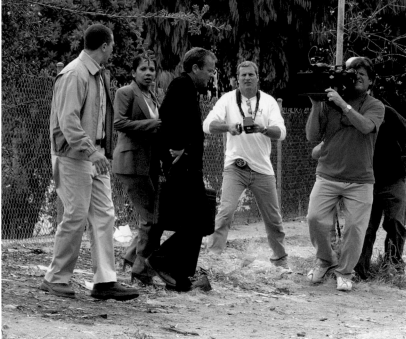

What you see here is what directors and the director of photography look at every day during production—our monitor cart. These are high-end LCD monitors that let us see every shot coming from two different cameras shooting the same scene, which makes the cart an important tool in helping us pick camera angles and placements. (You'll notice it's also a handy place to put our coffee.) Through the monitors you see here a historic shot: Dennis Haysbert as President Palmer placing his final phone call to Jack Bauer. It ended up being the last interaction between these two primary characters.

These shots perfectly exemplify what we put "behind the man," meaning Jack Bauer. When seen on television, these scenes and many like them show Jack in almost total isolation, on an empty rooftop with civilization miles away, playing cat and mouse with a deadly adversary. But while he might look isolated, there are actually probably ten or more crew members in his immediate proximity. This was a big action day, so we did a three-camera setup, and all of us were with Kiefer every step of the way.

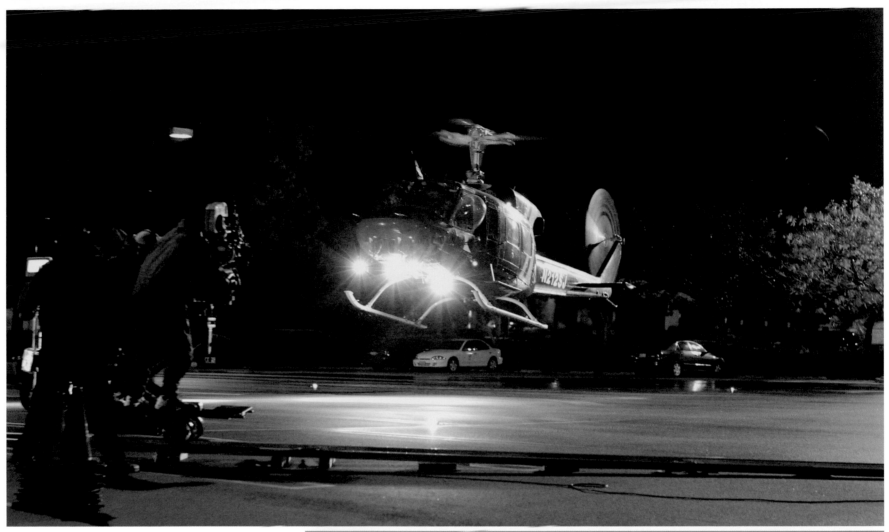

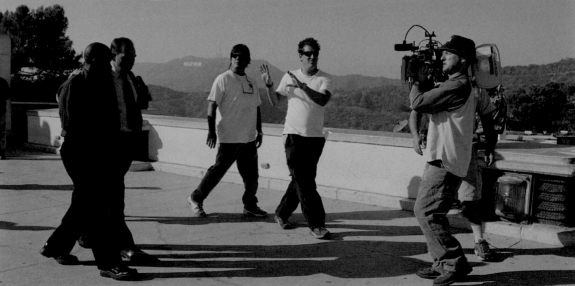

The unique feeling *24* has of "being there" with the characters is due in large part to the handheld camerawork. This means that the camera operators have to work around the actors, which is choreographed by the director and the director of photography. Here's Stephen Hopkins, our season one director/co-executive producer (hands raised) with our B-camera operator, Jay Herron (with hand-held camera) running a camera rehearsal at the Griffith Park Observatory in Hollywood. Vicellous Shannon is playing Keith Palmer. Notice the "Hollywood" sign in the background.

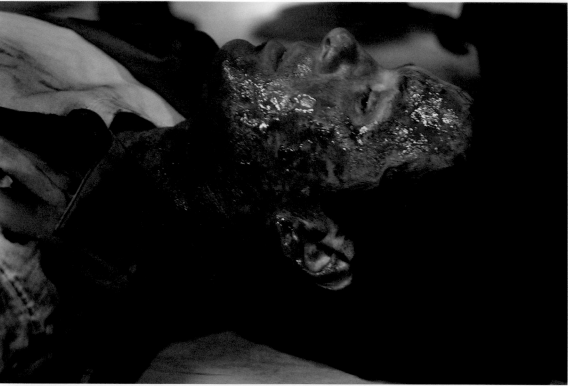

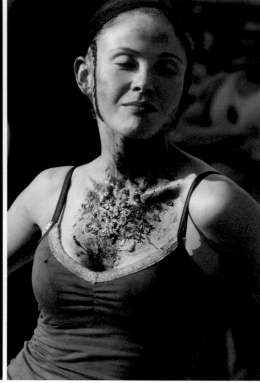

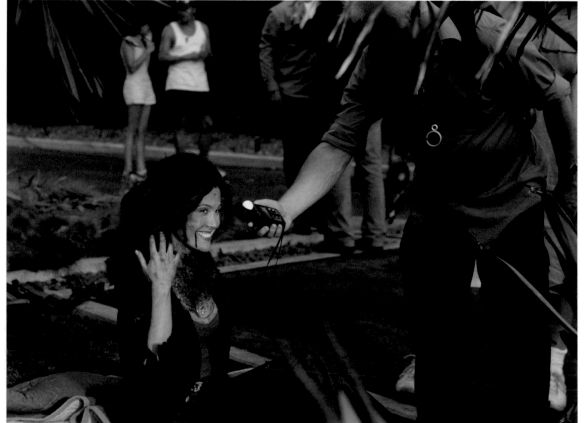

MAKE-UP/PROSTHETICS

In this sequence of pictures you can see the kind of detail that goes into things you probably only barely notice in a given episode. This is from the sequence that showed the tragic death of Michelle Dessler, played by Reiko Aylesworth. She was the victim of a car bomb, so Dee Mansano, head make-up artist in our make-up department, had to create severe injuries, which you see here in more detail than you ever did in the episode. On television, she is lying there cradled by Tony, her husband. Because of that interaction between them in her last scene on the show, we did not want to do too much to her face, so instead we built extensive chest injuries for her. We gave her prosthetic wounds, make-up, and a wig with burned hair, among other things. It's nice that we can show this to you, because on the episode itself viewers didn't get the full effect of our makeup department's hard work. We never know how much will be shown in the final edit, but we go to great effort anyway, just to cover the details for every possible eventuality.

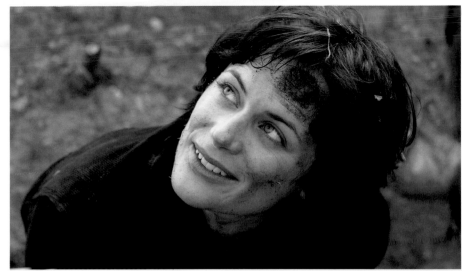

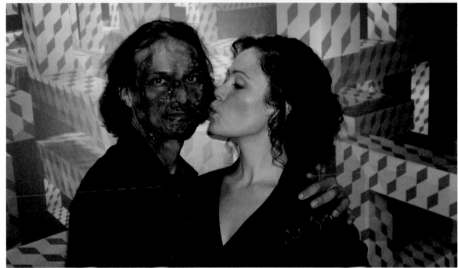

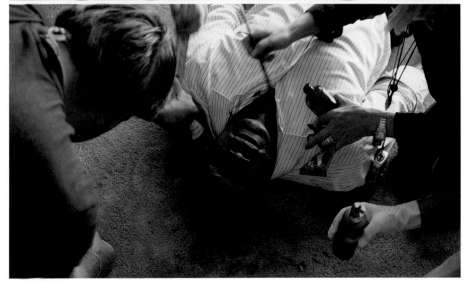

Nina Myers (top left) with a head wound delicately applied by Dee Mansano of our make-up department. I love the pictures that show our actors smiling and joking around even though they're wearing our make-up team's gruesome contusions and injuries. This was obviously snapped between takes.

Here are a few more examples of our make-up department's skills and proof that even the most horrific "injuries" don't prevent our actors from having a good time between takes. For instance, in the middle left photo Reiko Aylesworth plants a kiss on Jesse Borrego, playing Gael Ortega, despite the fact that the Gael character had just inhaled a highly toxic biological agent that would lead to his horrific and untimely demise.

PRODUCTION DESIGN

THE BUBBLE

This image gives you a look at our incredibly talented production designer, Joseph Hodges, on the set of one of his master creations—a containment unit that we all called "the bubble," which was featured during a plot thread in which teenagers, Kyle Singer and his girlfriend Linda, were exposed to a deadly germ and had to be held in isolation by terrorist kidnappers. The containment unit simply popped out of Joseph's head, and it's pretty amazing, as you can see here. The script had called for the containment area to be a simple, sealed-off room with some plastic on the doors, but Joseph wanted to really go all out and trap these kids inside a sort of an aquarium—in a sense putting them on display. So that's what he designed. It's a little futuristic, as are many of his designs, but when combined with Rodney Charters' skillful lighting, it's quite a sight. This illustrates how every member of our team contributes to our stories—Joseph added a lot of drama to an already intense story line by coming up with this amazing design idea. Agnes Bruckner, (opposite, bottom) playing Linda really looks trapped here—in this case, with the crew. The "fish" you see caught (opposite top) is actually our sound boom man, Todd Overton. He's just waiting inside the set for the action to continue.

CTU SITUATION ROOM

Pictured below is the CTU Situation Room, which Joseph Hodges got to thoroughly redesign when we moved to a new filming studio. You can't really take these sets apart and seamlessly move them to a completely different space, so Joseph created a new set for us, and central to the CTU design is the Situation Room. When you have a regular set like this one, the key design issues are how easy it is to film in and how visually interesting it is. At our old studio, the Situation Room was half the size of this one and it didn't have movable walls, which made it very difficult to film in. The new Situation Room is completely glassed in, but we can remove the glass and then film right through those "walls" when we have to. That gives the director more flexibility, and it lends a voyeuristic feel for the audience. In this shot, you see the interesting way we light the room from top and bottom, and how we use the table as a light source because it creates a beautiful fill light on the actors' faces. The light in this shot is actually coming from the table, and that also speeds up our setups, since we don't have to spend too much time working on lighting. Again, in designing a set, Joseph has to think ahead to situations in which removable walls might be necessary.

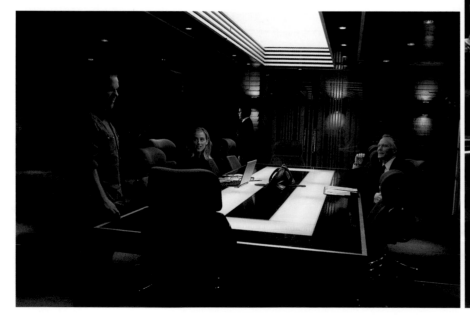

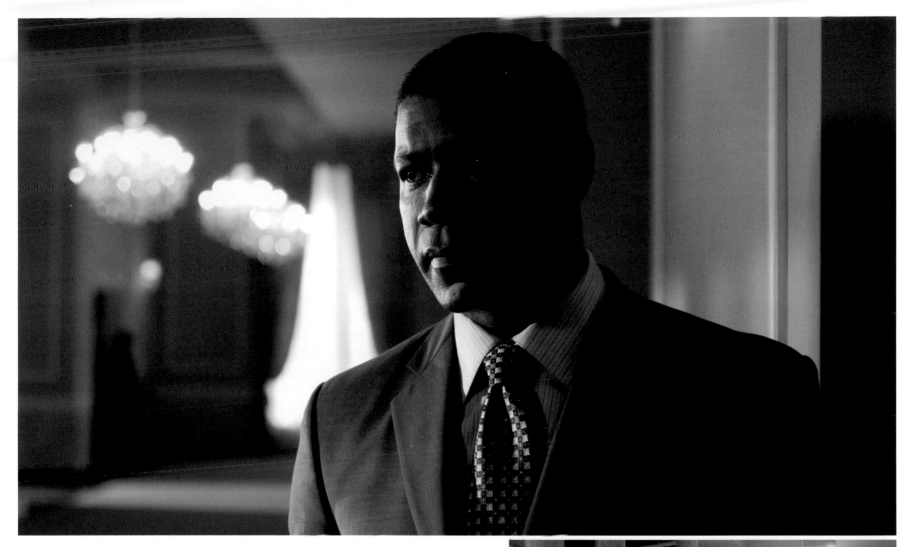

WHITE HOUSE HALLWAY

You may have noticed that, despite our continuing story lines involving the president of the United States, we rarely show any scenes inside the White House. That's primarily because there are other shows on the air that routinely show you the White House and the Oval Office, and we wanted to set ourselves apart. So our president is usually at his presidential retreat, or at some secure location—a hotel or a bunker. In this sequence we did have the president in the White House—but because of an ongoing terrorist threat he was mainly in a bunker there. When President Palmer came to visit President Logan, however, we thought it would be nice to show at least a bit of the White House itself. So, under Joseph Hodges' direction, we built this hallway in which you see David Palmer. It's a long, opulent stretch of a hallway. But as you see in this image, which shows our entire camera crew standing in that hallway, we never really built the corridor's left-hand side (which consisted of columns). We shot it at an angle specifically chosen to hide the fact that there are no walls on that left side, and we worked hard to give the illusion of a real presidential setting. So in spite of all the presidential drama on our show, it wasn't until season four that viewers got even a glimpse of the White House. I love this shot of the camera crew, because it shows you the size of our team, led by Rodney Charters, whom you can see there in the middle. The A-camera is on the left (foreground)—a rare shot of them when they are not working with a handheld camera—and the B-camera is on the right (background).

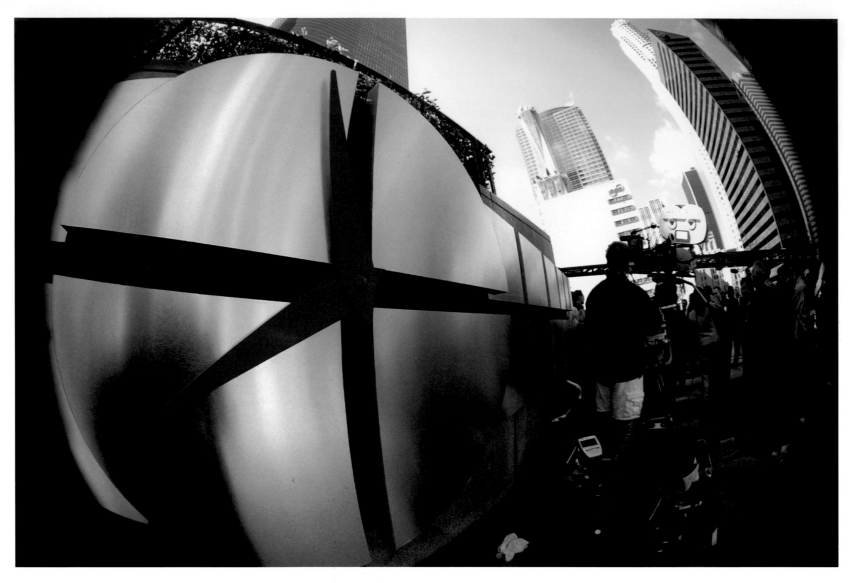

CLOCK

This was designed by Joseph Hodges to be a big graphic-art piece of advertising for a fictional watch company, with the intent of showing the clock very briefly, at 7:59, approaching 8 o'clock—the last minute of the episode. I love this photo because it reminds you who we are and what our show is all about: the clock and the swift passage of time. What's interesting is that in the first episode of season one, our director/co-executive producer, Stephen Hopkins, intentionally put a lot of clocks in various scenes, as reminders of the show's major time theme. But when we started to edit the episode and move scenes around, we realized that the clocks' times didn't make sense chronologically, and to digitally change those clock faces would have been very expensive. So now we do the exact opposite of what we did in that episode—we almost never show clocks or watches, and we are very careful about time references in general.

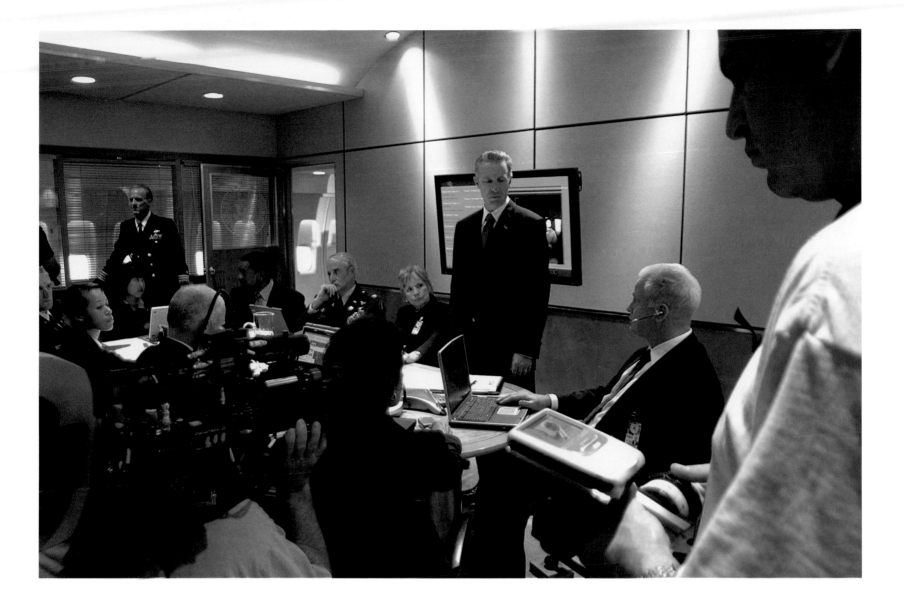

AIR FORCE ONE

This picture shows the Air Force One conference room that Joseph Hodges built for season four. We made our own mini-set for this scene, which took place on board the plane that terrorists were attempting to shoot down. There actually is a big Air Force One set built out of the shell of a real plane in Valencia, California, and we did shoot there at the beginning of that season. But it's very expensive to rent, and we were only planning a single scene in that conference room, so Joseph designed this version of the room, matching that interior for the most part. As it turned out, the set ended up solving a big problem for us, since the script originally called for Air Force One to be blown up. We were going to do that with computer animation, and we were pretty far along in the creation of that animation when the network decided they did not want to show the president being killed. It was a really late decision, so at the last minute we had to figure out how to alter the story

while still using the elements we'd already put together. They gave us permission to crash the plane as long as we didn't actually blow it up, but from a production point of view that became very complicated: We had to show some kind of wreckage while still making it clear that the president was alive, although incapacitated. A major set filled with wreckage was beyond our time frame and budget, but Joseph Hodges came up with the idea of using the Air Force One conference room. On his suggestion, we blew out the windows of the conference room and made a hole at the end of the hall showing where the plane had blown open. We put in a piece of fuselage, with large letters on it, and we shot the scene as a quick image, as rescue-camera video footage. When you see the plane in the episode, it really looks like the rescue team is inside a broken-off piece of fuselage.

CELEBRITY GUESTS

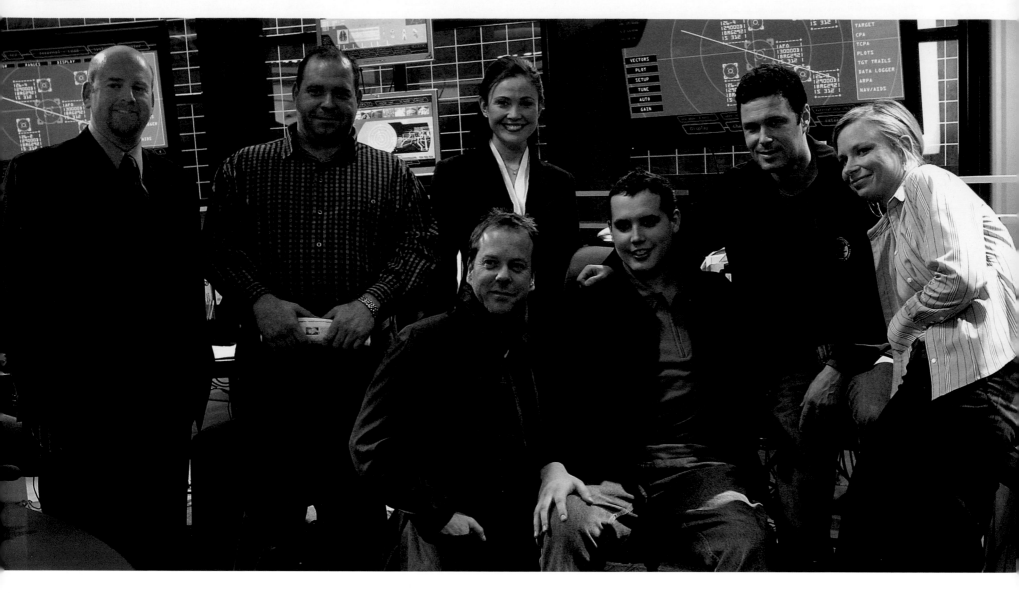

THE REAL HERO

This is a very significant photo for all of us at *24*. The young man, sitting next to Kiefer is Pete Meslow, who was battling cancer at the time this was taken. The Make-a-Wish Foundation got in touch with our producers, told them Pete was a huge fan of the show, and asked if he could visit the set and meet us. We of course said absolutely yes, and he ended up coming to the set three times. Twice we dressed him in a suit and put him in the background during some CTU scenes, which gave him a huge thrill. One of those shots made it on the air—a "box" shot where a CTU employee is handing some papers to Michelle Dessler. Sadly, he has since passed away, and we all really miss him. His last visit was just days before he died, and I thought it was amazing that even when he knew how sick he was, he still wanted to visit *24*. He was a very brave young man, and it was hard on everybody when we heard he was gone. We have a lot of celebrity fans who visit the set, but none of them ever made the impression on us that this young man did.

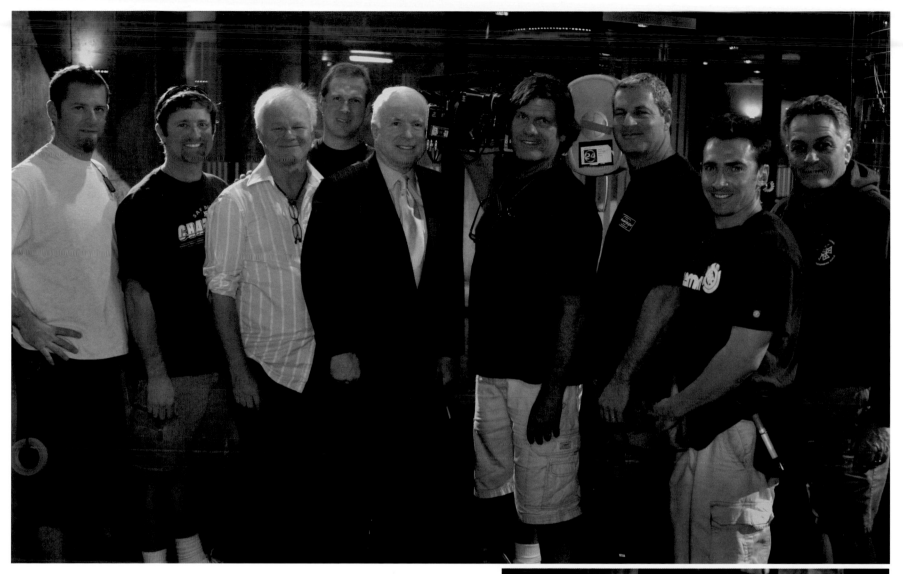

SENATOR JOHN MCCAIN

Arizona senator John McCain is watching a production shot with our director, Brad Turner (right, with headphones), and posing with our entire camera crew. It turns out he's a huge fan of the show, so in season five we gave him a walk-on part. He is someone who grapples every day with many of the serious issues we raise on our show about terrorism, national security, and torture, but ironically he says he really enjoys the fun, adventure, and escapism of watching *24*.

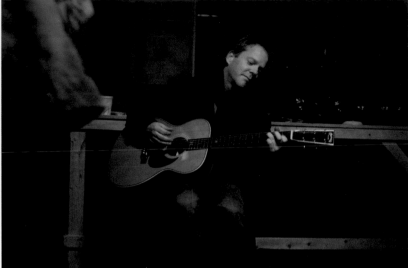

JOHN MAYER

Singer/songwriter John Mayer is another big follower of *24* and he visited the set once. He performed for the entire cast and crew, and then we returned the favor by letting him pretend he was Jack Bauer for a day. Everyone had a great time that day—except me, actually! While everyone else was having a blast listening to John Mayer entertain the crew, I was off shooting with the second unit in the pouring rain. People kept calling my cell phone to let me listen and to tease me about the fact that they were having such a good time while I was outside shooting in a rainstorm.

Right center: Kiefer Sutherland (Jack Bauer) poses with singer John Mayer and Mayer's crew.
Right top: Kiefer is playing John's guitar on set. First John played a song, and then Kiefer played one, for the entire cast and crew. It was a really fun afternoon.

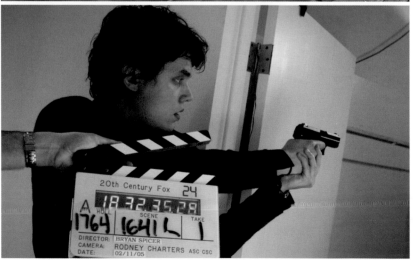

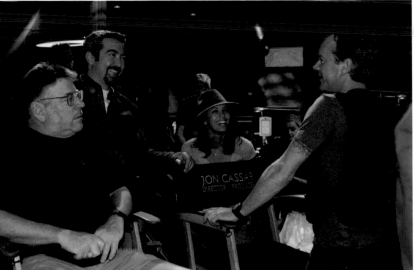

SEAL

Carlos Bernard (center) with musician Seal (left), and Seal's assistant, Laura Strayer (right). Seal is one of dozens of celebrities who are big fans of *24*. Tina Turner has asked us for tapes when she has missed episodes due to her tour schedule. Barbra Streisand is also one of our fans, and Stephen King has written about the show and sent us letters. Billy Crystal, former NFL quarterback Jim McMahon, director/actor Harold Ramis—and several others as well—have either been in touch with us or been quoted talking about how much they enjoy *24*. Their interest in our work has always been very gratifying for us.

EVA LONGORIA

Here Kiefer shares a story with unit production manager Producer Michael Klick, director Jon Cassar, and set visitor Eva Longoria. Eva and Kiefer later became costars on the feature *The Sentinel*.

RUSH LIMBAUGH

Joel Surnow (center) hosts radio talk show host Rush Limbaugh (far left) in the smoking room. Also joining the party (left to right) are Joe Tomacello, Shorhreh Aghdashloo, and writer/co-executive producer Michael Loceff

LAURA INGRAHAM

Author Laura Ingraham discusses the making of *24* with executive producer Joel Surnow and actress Jayne Atkinson (Karen Hayes).

ACTOR/CO-EXECUTIVE PRODUCER:

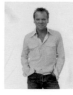

KIEFER SUTHERLAND has been portraying CTU agent Jack Bauer for five very "long" days in the 24 character's life. Kiefer burst onto the Hollywood scene in films such as Stand by Me, The Lost Boys, and Young Guns. Since then he has appeared in many other features, including Flatliners, A Few Good Men, The Three Musketeers, Phone Booth, Taking Lives, and The Sentinel. For Kiefer's work on 24 he has received a Golden Globe, two SAG Awards, and several Emmy nominations. In addition, Kiefer has toured as a team roper on the rodeo circuit—depending on the barrier, his fastest time for roping a calf is six seconds.

CO-CREATOR/EXECUTIVE PRODUCERS

JOEL SURNOW is co-creator and has served as the hit series' executive producer for each of its five seasons. Before 24 Joel served as executive producer of the critically acclaimed show La Femme Nikita. His distinguished career as a writer/producer also includes such popular television series as Miami Vice, Bay City Blues, The Equalizer, Wiseguy, Nowhere Man, and The Commish. Joel's work on 24 has brought him an Emmy for Best Dramatic Writing, a Golden Globe for Best Drama show and several Emmy nominations for Best Drama show.

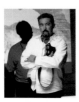

ROBERT COCHRAN is co-creator and executive producer for 24. Over the several years he's worked on 24 Robert has received an Emmy for best dramatic writing and a Golden Globe for best drama. Throughout his career, he has been nominated for four Emmys and three Golden Globes. His previous television credits include roles as an executive consultant of La Femme Nikita, co-executive producer of The Commish, supervising producer of JAG, and a writer/producer on Falcon Crest and Sons and Daughters. A lawyer by training, he began his career by writing episodes for legal shows, including L.A. Law and The Antagonists. He has also written two historical miniseries—Attila for the USA Network and Nothing Like It in the World for TNT.

CONTRIBUTING PHOTOGRAPHERS:

JON CASSAR is a director and co-executive producer of 24 He directed one-third of all episodes produced through season five. Since season two, Jon has routinely directed 10 episodes of 24 each season, while overseeing the work of various guest directors on the show and attending to his producing duties. Born in Malta, a longtime resident of Toronto, and now based in Los Angeles, Jon has had an interest in photography since he was 8 years old, when his father gave him his first camera. He worked in television and film for several years as a camera operator, Steadicam operator, and still photographer before using those skills to help him transition into directing. Jon used a Fuji S1 and a Fuji S3 digital camera to create many of the unique behind-the-scenes photographs seen in this book.

RODNEY CHARTERS, ASC CSC, is the longtime director of photography on 24 and one of television's leading cinematographers. He has been with 24 since it debuted, and in his capacity as cinematographer, he has had occasion to take literally thousands of digital still photos to use as reference material when he is lighting scenes. Some of those photos captured "portrait moments" on set with key members of the cast—many of which are published for the first time in this book. A native New Zealander, Rodney got his first camera—a Yashica Mat—from his father, Roy, who operated a photography studio for 45 years in New Plymouth, New Zealand. Rodney paid his way through university by taking commercial and editorial photo jobs for many publications, including Australian Vogue. He used an Olympus E-10, Canon D-10, and Canon D-20 digital cameras to snap many of the photos found in this book.

ISABELLA VOSMIKOVA is a veteran still photographer who took publicity photos on the set of 24 during seasons two, three, four, and five—photos used by the 20th Century Fox publicity department to help publicize and promote the show. Many more candid photos taken during her tenure on the show, however, appear in this book for the first time. Isabella's photos have also appeared in magazines, newspapers, books, DVDs, and other electronic media around the world in recent years. A native of Prague in the Czech Republic, Isabella is now based in Hollywood. At the age of 10, Isabella's father gave her a plastic, Russian-made camera called a Kiev, and she has been hooked on photography ever since. For her photos in this book, Isabella used a Canon D-20 digital camera.

DAVID ST. ONGE is a longtime gaffer for 24 and has been with the show since the pilot episode. In his capacity as gaffer, David works closely with Rodney Charters, Director of Photography, and the entire camera team to light sets—a crucial component of any kind of photography, particularly in film and television production. A native of Southern California, David bought his first camera—a Konica film camera—in 1978. His interest in photography has grown over the years as he took numerous photography courses and gained more experience in the motion-picture industry. For his photos in this book, David used Fuji S1, Fuji S2, and Fuji S3 (his personal favorite) digital cameras.

JAY HERRON is the B-camera operator on 24 and has been with the show since season one. As a TV camera operator, Jay films actors using a motion-picture-film camera mounted on a rolling dolly. However, he also takes his Olympus 5050 digital camera to the set each day, and with that camera he took many of the photos found in this book. A native of Southern California, Jay received his first camera, a Yashica Twin Reflex 21/4 film camera, when he was 8 years old. The camera was a gift to him from his cinematographer father, J. Barry Herron, who worked in Hollywood throughout the 1970s, '80s, and '90s.

MICHAEL KLICK is the unit production manager (UPM) and a producer on 24 and has been with the show since the first season, starting out as an assistant director. Part of his responsibilities as a producer is to visit the 24 set and oversee how production is progressing each day. In that capacity he routinely uses a Sony F-828 digital camera to monitor progress and capture some of the behind-the-scenes moments found in this book. A native of San Francisco, California, Michael received his first camera, a Minolta SRT 101, as a gift from his parents when he was 14.

ALICIA BIEN is the director's assistant and has been with 24 since season one. Although she does most of her work in the office, she always has her camera when she visits the 24 shooting crew on location and at 24 events. Raised in Ohio, she moved to Hollywood to pursue TV writing. She received her first 'real' camera, a Nikon N2000, from her father when she was 17 years-old. She used a Nikon Coolpix 5700 to shoot the photos in this book.

BRUCE MARGOLIS is the senior vice president of production for 20th Century Fox Television and has overseen the production of 24 since the pilot. An avid photographer who collects cameras, Bruce always has at least one with him when he visits the 24 set. Bruce used a Nikon D2X with Nikon lenses to capture the behind-the-scenes moments of 24 found in this book. Born and raised in Los Angeles, Bruce has been taking pictures since he was 10 years old.

YOSHI ENOKI, JR. is a key assistant locations manager and has been with the show since season three. One of the aspects of his job is to scout and photograph potential locations where 24 can film. Born in Tokyo, he got his first real camera, a Minolta Maxxum 7000 SLR, when he was 14 years-old. The Minolta Maxxum sparked Yoshi's interest in cameras, eventually going to film school at the University of California at Santa Barbara where he studied to become a camera operator and director of photography. Yoshi shot the photos in this book with a Panasonic DMC-LX1 and Nikon D100.

ZAK CASSAR is a recent graduate of the New York Film Academy and was working as a part-time prop assistant on 24 when he took the photographs included in this book. Zak's interest in photography started at an early age when he would inherit his father, Jon's, digital cameras when Jon upgraded. Zak loves rock 'n' roll photography and has taken many concert photographs for local Los Angeles bands.

STERLING RUSH is the prop master and has been with the show since the first season. Part of Sterling's job is to record where and how 24 props are used in a scene. A Georgia native, Sterling received his first camera, a Kodak Polaroid instant camera, from his parents when he was 16 years old. Sterling was a theater major at the University of South Carolina and he worked on The Patriot, then moved to Hollywood to continue working in the TV and film industry. Sterling used a Canon S50 and Canon F70 to shoot the photos in this book.

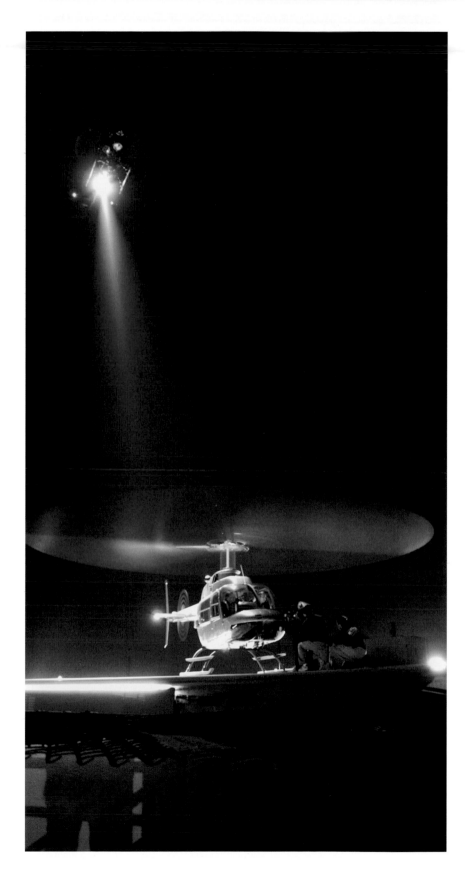

ACKNOWLEDGMENTS:

Making our TV show is both hard work and a group effort and the same can be said for publishing a book about making our TV show. My strong desire to make 24 Behind the Scenes into a book was thanks in part to the belief and work of several others. I'd like to thank Kiefer Sutherland, Joel Surnow and the 24 Family for supporting this project. I also want to thank my very talented fellow photographers; the ever resourceful Bruce Margolis; Virginia King at Fox who brought this project to the publishers' attention and has been its champion from the beginning; the excellent publishers at Palace Press—the committed and flexible Raoul Goff and hard-working always-with-a-smile Lisa Fitzpatrick and their wonderful team at Palace Press—Mariah Bear, Barbara Genetin, and Emilia Thiuri, and Robbie Schmidt; Michael Goldman; and especially Alicia Bien, I couldn't have done it without her tireless work, ideas and support.

—Jon Cassar

PHOTO CREDITS

JON CASSAR – *6 (center), 8, 15 (upper), 17, 19 (upper), 27 (all), 29 (lower), 33 (all), 39 (upper right), 39 (center right), 40 (lower), 42 (lower left), 42 (lower right), 46, 47, 50 (lower right), 51, 55 (upper), 59 (upper right), 62, 64 (upper), 65, 69 (upper left, right), 72 (all), 73, 74 (all), 76 (lower right), 80 (lower), 86 (all), 93 (all), 95 (all), 97 (upper), 101 (lower), 108 (right), 113 (upper), 113 (lower), 114, 117 (all), 119, 120, 122 (upper right), 122 (lower right), 123 (all), 124, 128 (top), 129, 130, 133 (left, upper right), 134 (lower left), 141 (left), 141 (center right), 145 (upper left), 146 (all), 149 (upper left), 149 (lower left), 151 (lower), 153 (upper), 153 (lower left), 154, 155 (lower), 157, 159 (upper), 163 (left, lower right)*

RODNEY CHARTERS – *2 (left), 3, 10, 15 (center), 15 (lower), 16 (all), 18, 19 (lower), 20, 21, 22, 23, 24, 25 (lower), 26, 31, 41, 45, 57, 63, 64 (lower), 66, 67, 68, 69 (lower left), 70-71, 75 (all), 76 (left), 76 (upper right), 77, 79, 80 (upper), 81, 84, 85, 92, 94, 101 (upper), 102, 103 (lower), 104 (upper), 105 (upper), 106, 108 (left), 118, 121, 122 (left), 125, 126, 127, 131 (all), 132, 133 (lower right), 135, 138 (lowest right), 139 (lower), 140 (upper right), 145 (upper right), 145 (lower right), 147 (lower), 149 (right), 151 (upper), 151 (center), 152, 153 (lower right), 155, 159 (center), 159 (lower), 161 (all), 162 (upper right), 162 (center right), 162 (lower right), 163 (upper right)*

ISABELLA VOSMIKOVA – *7, 9, 29 (upper), 35, 36 (upper right), 36 (lower right), 37, 39 (lower right), 40 (upper), 42 (upper), 43, 44 (all), 48 (all), 50 (left), 50 (upper right), 52, 53 (all), 55 (center), 55 (lower), 56, 58 (all), 59 (upper left), 59 (lower), 60, 61, 78 (all), 82, 83 (left), 83 (upper right), 83 (lower right), 87, 89 (all), 90, 91, 96, 97 (lower), 98, 99, 100, 103 (upper), 107, 109, 110, 111, 113 (center), 115, 116 (left), 137 (all), 138 (upper right), 138 (center right), 141 (upper right), 141 (lower right), 142, 143 (all), 144 (upper and lower left), 145 (lower left), 147 (upper), 148 (upper right, lower), 160, 162 (left), 163 (center right), 165, 168*

DAVID ST. ONGE – *2 (center), 25 (upper), 29 (center), 30, 32, 36 (upper left), 36 (center left), 38, 156*

JAY HERRON – *34, 36 (lower left), 39 (left), 49, 83 (lower center), 83 (center right), 130 (second from bottom right), 130 (upper), 149 (center left)*

BRUCE MARGOLIS – *134 (right), 135*

ALICIA BIEN – *134 (upper left)*

ZAK CASSAR – *104 (lower), 116 (center and lower right), 148 (upper left)*

YOSHI ENOKI, JR – *128 (lower)*

MICHAEL KLICK – *138 (left)*

STERLING RUSH – *140 (left, lower right)*

JOSEPH HODGES – *144 (right)*

THE 24 FAMILY:

ACCOUNTING:
Judie Hodson
Jason Huberman
Michael Jimenez
Bob Leatham
Tristan Meija
Edison Mirzaie
Angela Mock
Tony Pacheco
Stefanie Peluso
Brian Schlesinger
Sherry Williams

ART DEPARTMENT:
Maren Brown
Seth Gass
Sergei Genitempo
Bruce Hill
Joseph Hodges
Geoffrey Mandel
Joe Merino
Andrew Murdock
Jeff Ozimek
Mark Walbaum
Scott Zuber

CAMERA:
Martha Cargill
Rodney Charters
Bruce DeAragon
Eric Dyson
Yusef Edmonds
Eric Guerin
Eric Gutherie
Jay Herron
Robert Kositchek
Jeffrey C. Mygatt
Jenn Martin
Krishna Rao
Mike Saad
Jon Sharpe
Guy Skinner
Tim Tillman
Naomi Villanueva
Isabella Vosmikova

CASTING:
Peggy Kennedy
Debbie Manwiller
Rick Pagano
Leanna Sheldon

CATERING:
Jose Alvarez
Bruce Hecker
Romulo Hernandez
Manny Henriquez
Enrique Martinez
Filberto Martinez
Kamel Mehai

Julian Morales
Armando Panduro
Ramon Reyes
Larry Wasserman

CONSTRUCTION:
Alex Aguilar, Jr.
Roger Asch
John Bakken
Charles Basurto
Jay Bedore
Damon Bowden
Ed Bowen
Tre Brownell
Caine Carruthers
Chris Dale
Steve Doss
Mike Erspamer
Rolando Garcia
Steve Handt
Gary Hardy
Jason Harrel
Mike Holcomb
Thomas Houk
George Kiapos
Kakou Kiapos
Todd Larsen
James Lerner
John Mazzola
Joe Mussehl
Paul Nahale
Scott Nelson
Tom O'Connor
Marek Pater
Mark Perry
Mark Roberts
Kim Robertson
Marcel Sandoval
Rick Shock
Rick Simplicio
Jeremy Stone
Phil Stone
Dugald Stermer
Bryan Turk
Dan Turk
Danny Turk
Mike Williams

COSTUMES:
Danielle Baker
Jon Boyden
Karen "KD" Davis
Nick Heinz
Jim Lapidus
Juan Lopez
Nick Manno
Kara Owens
Jean Rosone
Deborah Slate
Chantal Thomas

Robert Velasquez
Lisa Wong

CRAFT SERVICES:
Kevin Flynn
Patty Miliotti
Steve Miliotti
Steven Miliotti
Sherry Heller

DIRECTORS:
Jon Cassar
Rodney Charters
Ken Girotti
Davis Guggenheim
Kevin Hooks
Stephen Hopkins
Tim Iacofano
Fred Keller
Winrich Kolbe
Dwight Little
Paul Shapiro
Bryan Spicer
Ian Toynton
Brad Turner
James Whitmore, Jr.

GRIPS:
Tom Adams
Doug Blagg
Sandy Bloom
Carlos Boiles
Lister Colesman
Jim "Tomcat" Downing
Craig Fetterman
Richie Galbraith
Jeremy Graham
Zoli "Sid" Hajdu
Dave Harvey
Brandy Holiday
Dave Howard
Jodon Jetset
David Levich
Mike Listorti
Richie Metcalfe
Chris Moriarity
Lloyd Moriarity
Moses Padilla
Dave Parker
Tommy O'Connell
Michael Reyes
Lee Richardson
Scott Smith
Christian Staab
DJ Tedesco
Jeff Tomhave
Anthony Vietro
Fritz Weber
Tony Widmer

LOCATIONS:
Tristan Daoussis
Yoshi Enoki, Jr.
John Johnston
Jodi Leininger
Bill McLellan
Ernesto Navas
Tony Salome
Jason Savage
Donovan Terranova
KC Warnke

MAKE-UP/HAIR DEPARTMENTS:
Raqueli Dahan
Deborah Dobson-Holmes
Lily Gart
Ania Harasimiak
Sharin Helgestad
Monica Helpman
Dee Mansano
Michael Marcellino
Susan Kelber
Tina Sims

MAKE-UP SPECIAL EFFECTS:
Ed French
Greg Nicotero

MEDIA AND MARKETING:
Jacy Merson
Day Vinson

MEDIC:
Chris Carrington
Evan Liss

MUSIC:
Sean Callery
Jeff Charboneau
Blaine Johnson

POST PRODUCTION:
Jessica Bupp
Chris Cheramie
Elisa Cohen
Cory Collings
Larry Davenport
John Dvi-Vardhana
Paul Gadd
Andrzej Kozlowski
David Latham
Aaron Mostin
Leon Ortiz-Gil
Eric Paul
Ann Parish
Scott Powell
Chris Willingham

PRODUCERS:
Jon Cassar
Robert Cochran
Robin Chamberlin
Robert P. Cohen
Manny Coto
David Fury
Gil Grant

Brian Grazer
Howard Gordon
Tim Iacofano
Evan Katz
Michel Klick
Tony Krantz
Stephen Kronish
Peter Lenkov
Michael Loceff
Sam Montgomery
Norman Powell
Joel Surnow
Kiefer Sutherland
Brad Turner
Cyrus Yavneh

PRODUCERS' ASSISTANTS:
Alicia Bien
Anne Cofell Saunders
Duppy Demetrius
Mariana Galvez
Kate Garwood
Jason Gavin
Kama Hayes
Jennifer Hodges
Robert Hull
Jenn Kessler
Jason Kissen
Monica Macer
Matt Michnovetz
Adam Neuman
Derek Pignatelli
Jenny Rosenbluth
Sesha Walker

PRODUCTION:
Seth Abel
Craig Amendola
Jason Barnoski
Sara Bartkiewicz
Mev Blount
Nicole Burke
Mike Burns
Jeff Castelluccio
Ryan Craig
Andrew Culotta
Tova Dann
Baptiste De Rivel
Helen de Vivien
Rex Dominguez
Brendan Eads
Nate Ehrman
Tim Fitzgerald
Jon Fox
Rebecca Gaither
Steve Godwin
Richard Gonzales
Adam Gorczyca
Harmony Gosspee
Jason Gutierrez
Christian Kehoe
JR Kehoe
Leah King
Jason Kissen
Michael Klick
Dave Kohut

Mara Koprowski
Ryan Lamy
Gilchrist MacQuarrie
Eric Molford
Shari Nicotero
Elion Olson
Elliott Owen
Matt Payne
Aaron Penn
Derek Pignatelli
John Poladian
Chris Porterfield
Mike Posey
Patrick Priest
Mark Rabinowitz
Steve Reese
Scott Remick
Jenny Rosenbluth
Richard Rosser
Daniel Severson
J.P. Velasquez
Todd Wasserman
Sara Woomer

PROPERTY DEPARTMENT:
David Coleman
Randy Gunter
Steven Husch
Dick Kyker
Rick Kyker
Rob Kyker
Michael Pat Lugar
Bryce Moore
Sterling Rush

SCRIPT COORDINATORS:
Nicole Ranadive
Donna Rooney
Holly Henderson
Barb Siebertz
Sheryl Johnson
Jessica Abrams

SCRIPT SUPERVISORS:
Paula Dusman
Anne Melville
Tracy Zigler

SET DECORATION:
Daril Alder
Scott Bailey
Neil Bowman
Glenn M. Carrere
Chuck Courier
Alan Day
Ron Elmer
Yukion Frierson
Bruce Fuselier
Geno Ghiselli
Chris Grantz

Jen Harris
Kurt Hulett
Cloudia Rebar
Rhea Rebbe
Ben Robertson
Sterling Rush
Mark Sakamoto
Doug Sieck
James Shumaker
Vartan "VT" Tashjian
Chris Villareal
Larry White

SET LIGHTING:
Roger Blauvelt
Roger Bolanos
Ricky Carillo
Billy Craft
Chris Eichman
Ernie Enriquez
Darryl "Sparky" Herzon
Jeff Hoffma
Trev Holmes
Tom Seber
Steve Shaver
David St. Onge
Christopher Whitman
Eric Willis

SOUND MIXING:
Gloria Cooper
Bill Gocke
Kenneth Kobett
Michael Olman
Mark Overton
Todd Overton
Corey Woods

SOUND EDITING:
Pembrooke Andrews
William Dotson
Laura Macias
Vinny Nicastro
Rick Polanco
Cathie Speakman
Jeff Whitcher

SPECIAL EFFECTS:
Scott Blackwell
Stan Blackwell
George Paine

STAND-INS:
John Andrus
Alicia Bien
Robert Bezanilla
Roslyn Bezanilla
Kristen Brennan
Brittany Burch

Brendan Eads
Stan Eckels
Jason Gutierrez
Greg Hartigan
Michael Jacey
Christian Kehoe
Steve Lanza
Rebecca Larsen
Sven Lindstrom
Scott Lusby
Christian Lutz
Samantha Maze
Marci Michelle
Karen Mingus
Faith Palmer
Rikki Rae
Emile Williams
Kevin Woods

STUNTS:
Greg Barnett
Jeff Cadiente
Eddy Donno
Matt Taylor

TRANSPORTATION:
Art Aguilar
George Alden
Nate Antunez
Sherri Arter
Mike Bangs
Chris Beans
Rod Beardon
Andy Boyd
Greg Bonner
Steve Buring
Max Delgado
Greg Dirado
Jerry "J.D." Drake
Jake Elliott
Erin Evans
Lee Everett
Skip Fairlee
Cody Frost
Sean Glenn
Dino Grossi
Wendy Hallin
Mark Holmes
Ray Joyce
Brian Kay
Jody Krieinbrink
Hal Lary
Ed Lassak
Bobby Lee
Freslet Lefrance
Fred Liberman
Jim Lundlin
Jan Marino
Mark Maymo
Doug Miller

Dennis Milliken
Chuck Montgomery
Kenneth Murray
Steve Nickle
Steve Polan
Patty Rust
Sam Seccomb
Mike Shaw
Lowell Smith
Tommy Ray Smith
Lee Stepp
Rick Suggett
Jim Sullivan
Marshall Taylor
Troy Tomerlin
Lana Vermillion
Eddy Lee Voelker
David Wheaton
Harold Woods

VIDEO PLAYBACK:
Olivier Benamou
Matt Bosson
Bernie Druckman
Rick Dungan
Bob Johnston
Simon Knights
Mark Marcum
Dan Murbarger
Tim Whittet

WRITERS:
Remi Aubuchon
Michael Chernuchin
Robert Cochran
Anne Cofell Saunders
Neil Cohen
Elisabeth M. Cosin
Manny Coto
Duppy Demetrius
David Ehrman
David Fury
Gil Grant
Howard Gordon
Lawrence Hertzog
Maurice Hurley
Chip Johannessen
Evan Katz
Stephen Kronish
Peter Lenkov
Michael Loceff
Matt Michnovetz
Steve Mitchell & Craig Van Sickle
Sam Montgomery
Andrea Newman
Nicole Ranadive
Joel Surnow
Virgil Williams

20th CENTURY FOX
TELEVISION:
Chris Alexander
Arlene Getman
Jeffrey Glaser
Gary Hall
Sharon Klein
Gary Newman
Bruce Margolis
Tony Martinelli
Steven Melnick
Jennifer Nicholson-Salke
Jim Sharp
Dana Sharpless
Dana Walden

FOX:
Robin Benty
Gail Berman
Peter Chernin
Dianne Cooper
Craig Erwich
Ted Gold
Josh Governale
Missy Halperin
Jonathan Hogan
Michelle Hooper
Peter Ligouri
Tom McGovern
Marcy Ross
Russell Rothberg
Marcia Shulman
Pam Smith
Trae Williams

IMAGINE:
Skip Chasey
Robin Gurney
Brian Grazer
David Nevins
Tony Krantz
Robert Kwak
Erin Nowocinski
Sonja Piper Dosti

And others we may have
accidentally omitted.
Thank you for five wonderful years!

COLOPHON

The body of this book was set in Berthold Akzidenz Grotesk. This typeface was designed in 1896 by Günter Gerhard Lange for the Berthold company, and is the forerunner of the popular Helvetica. In German, Akzidenz refers to a commercial typeface; grotesk means sans serif.

The display heads use Bank Gothic, a Bauhaus-influenced face designed in 1930 by Morris Fuller Benton for the ATF company.

This book was printed in four color, with an offline dry-trapped spot gloss varnish.

Publisher & Creative Director: Raoul Goff
Executive Directors: Michael Madden, Peter Beren
Acquiring & Developmental Editor: Lisa Fitzpatrick
Executive Director, Fox Licensing & Merchandising: Virginia King
Project Supervisor: Alicia Bien
Editor: Michael Goldman
Art Director: Iain Morris
Designer: Barbara Genetin
Design Assistant: Gabe Ely
Executive Editor: Mariah Bear
Production Manager: Lisa Bartlett
DVD Production:
Interviews: Sparkhill Entertainment
Mastering: Emaginate

Insight Editions would like to thank Monika Lasiewski